D0498266

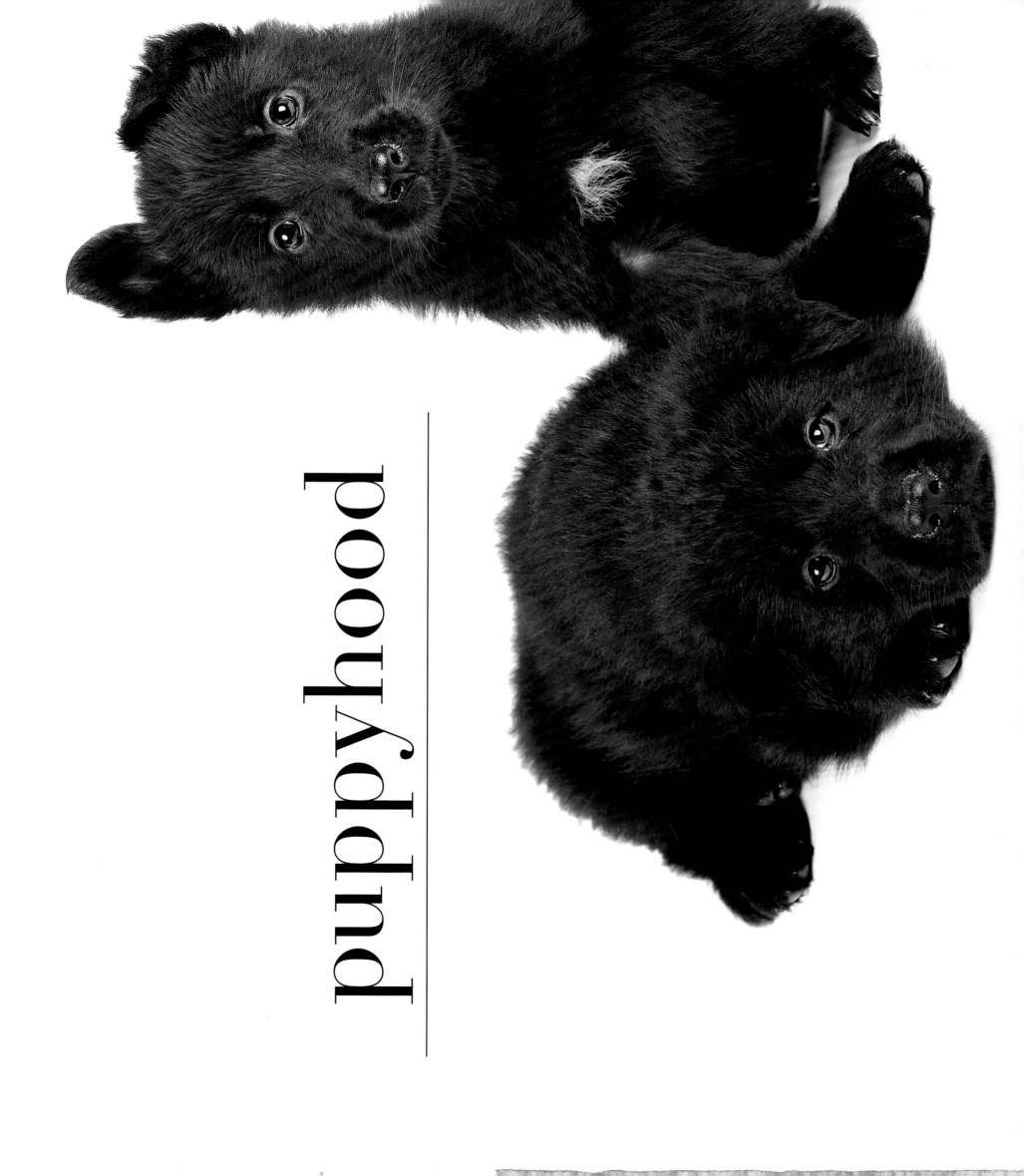

puppyhood

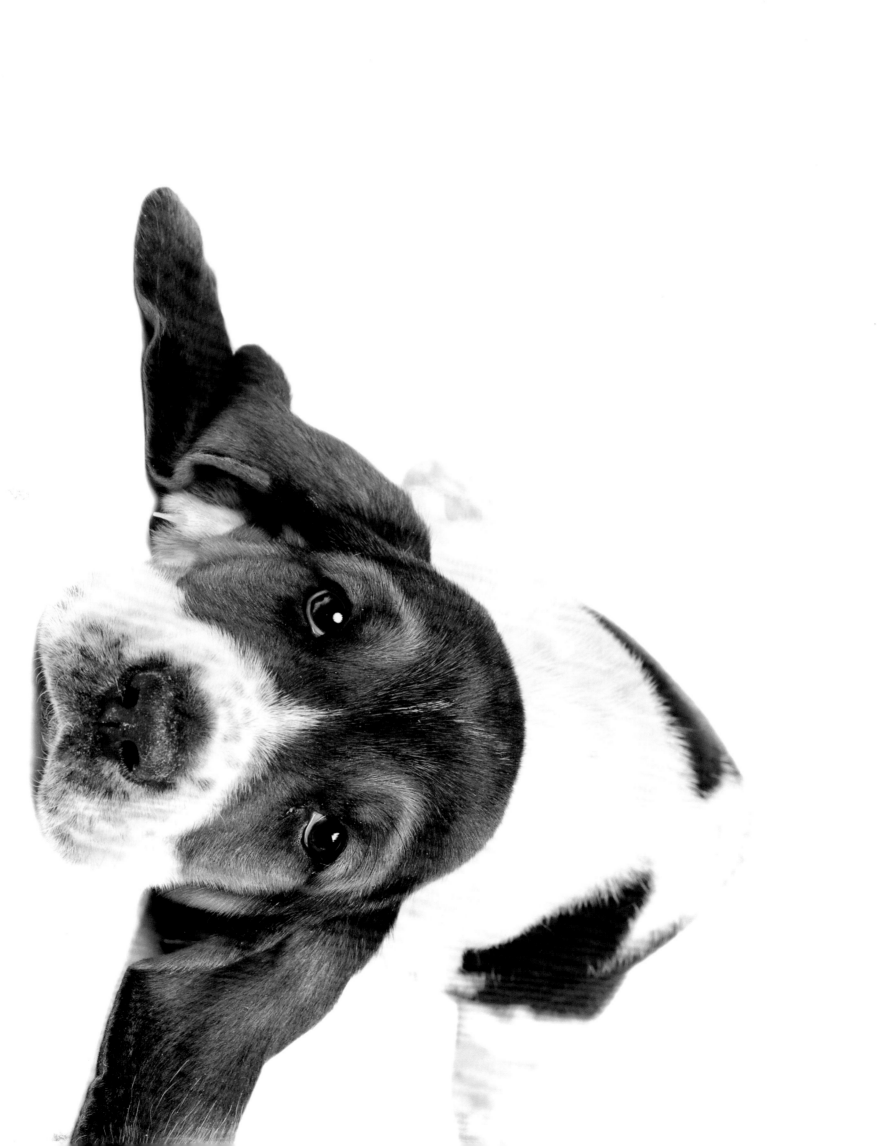

Smith, J. Nichole.
Puppyhood : life-size
portraits of puppies at
2012.
33305227793654
1a 05/16/13

puppyhood

LIFE-SIZE PORTRAITS OF PUPPIES AT 6 WEEKS OLD

J. Nichole Smith

stewart tabori & chang

New York

Published in 2012 by Stewart, Tabori & Chang
An imprint of ABRAMS

Copyright © 2012 J. Nichole Smith

All rights reserved. No portion of this book may be reproduced, stored in a retrieval system,
or transmitted in any form or by any means, mechanical, electronic, photocopying, recording,
or otherwise, without written permission from the publisher.

Cataloging-in-Publication Data has been applied for and may be obtained from the Library of Congress.

ISBN: 978-1-58479-984-9

Editor: Samantha Weiner

Puppyhood is produced by becker&mayer!, Bellevue, Washington.
www.beckermayer.com

Design: Katie Benezra
Editorial: Dana Youlin

10 9 8 7 6 5 4 3 2 1

Printed and bound in Hong Kong

The text of this book was composed in Berthold Akzidenz Grotesk, Linotype Didot, Gill Sans, and Refrigerator.

Stewart, Tabori & Chang books are available at special discounts when purchased in quantity for
premiums and promotions as well as fundraising or educational use. Special editions can also be
created to specification. For details, contact specialsales@abramsbooks.com or the address below.

ABRAMS
THE ART OF BOOKS SINCE 1949

115 West 18th Street
New York, NY 10011
www.abramsbooks.com

For Olivia, the giant, pink-nosed, cow-spotted puppy
who found me eight years ago and has inspired me daily ever since

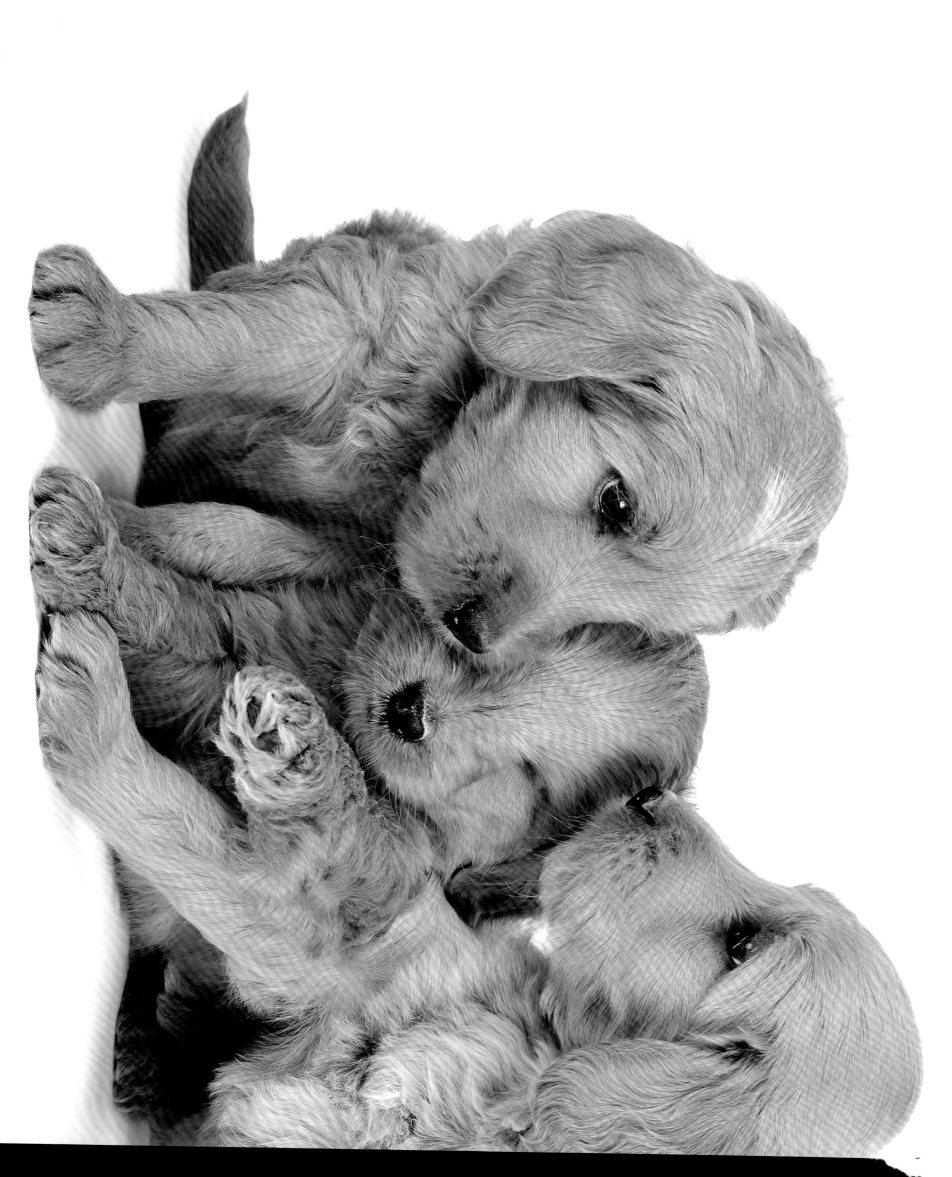

BREED LIST

- Labrador Retriever
- French Bulldog
- Shih Tzu
- Great Dane
- Papillon
- English Bulldog
- German Shepherd
- Miniature Pinscher
- Basset Hound
- Bullmastiff
- Cavalier King Charles Spaniel
- Labradoodle
- Lhasa Apso
- Boxer
- Dachshund
- English Springer Spaniel
- Pomeranian
- Husky
- Yorkshire Terrier
- Irish Setter
- Saint Bernard
- Coton de Tulear
- Weimaraner
- Golden Retriever
- Yorkipoo

INTRODUCTION

There are many qualities that make puppies so fiercely irresistible that when you're in their midst, it's nearly impossible to choose a favorite. Having recently spent an abundant amount of time with these perfect little monsters, I'll attempt to sum up their best attributes.

Most obviously, their features are minuscule and blunt: their muzzles, paws, bellies, tails, ears, and other parts all have an exceptionally rotund and stubby quality to them.

The noises they emit are slight, squeaky, and precious. If measured on a scale of sounds biologically impossible to dislike, puppy chatter would be somewhere in the realm of cooing human baby or slow, rolling ocean surf.

Once you're near enough to feel the downy softness of their brand-new fur, notice the perfect freshness of their plushy paws, or catch a peek at their bald, pink little bellies, you're probably in trouble.

Then, of course, there's the signature "puppy hug" maneuver: When you pick them up, most puppies instinctively crawl up your chest toward your shoulder, snuggling into your neck, wrapping their small paws over your shoulders.

Once they're near your face, you're subject to the famously intoxicating, horribly addicting "puppy breath," and it's all over—you're hooked.

But the most profoundly amazing bit of all is in the wiggle of their fleshy, six-week-old bodies and the profile of their tiny faces; you can see the potential they possess, the full-size dog they'll one day become.

These are the reasons this book exists, a tribute to every quality that makes any puppy such an exceptional work of art.

DETTA, JAKE, ROLAND & OY

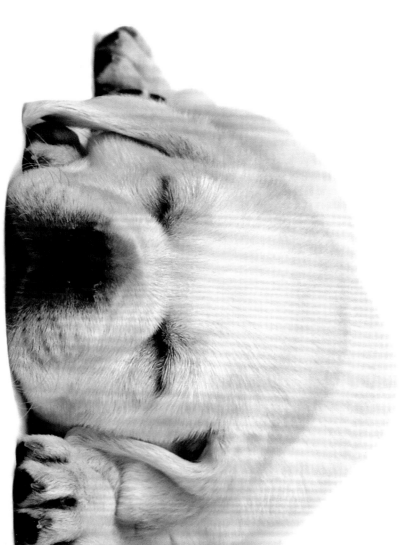

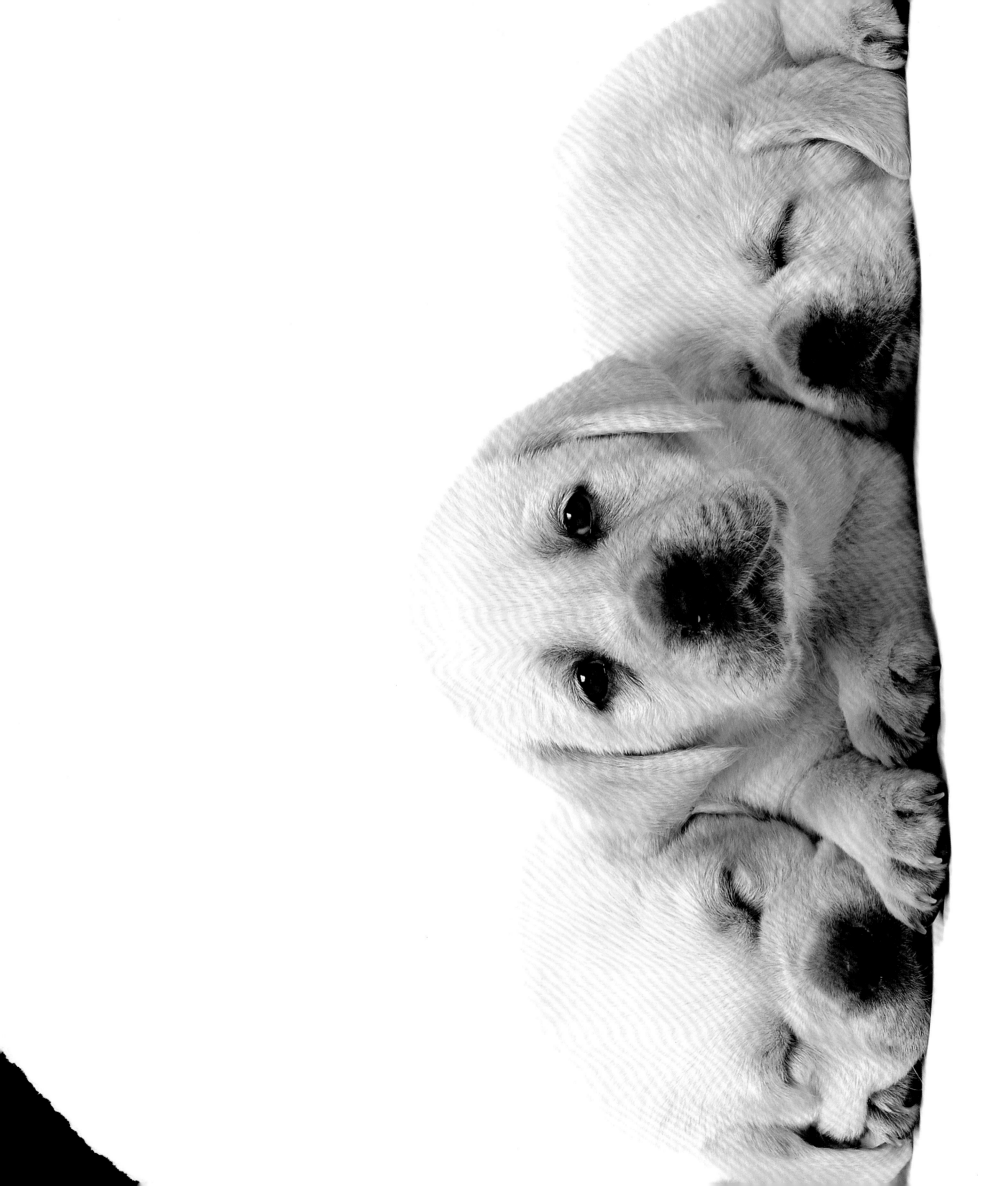

I have had the distinct privilege of sitting lens-to-nose with over one hundred six-week-old puppies in just a few months' time.

I spent hours watching puppies boldly explore the white seamless paper they were photographed on, and I waited patiently time after time as tired little littermates climbed, squeezed, pushed, rolled, and nosed their way into snoring piles.

I admit it is terribly unfair that I get to call this "work."

Every squirmy personality I photographed for this project had been experiencing this big, wide world for the same amount of time: exactly six weeks.

Each six-week-old pup develops similarly: the pups in each litter were just starting to understand the social constructs of being a dog—being schooled by their mothers and one another in the rules of play and rank. Each puppy was just about ready to have a first toenail trim, to explore the outside world for the first time (after final vaccinations), and some were already starting to potty train.

Our models were old enough to be curious about the strange high-pitched noises I was making to get their attention, but not old enough to understand the association of the word "treat" or to have fear responses that would inform them that they shouldn't walk straight off the table they were being photographed on! (Luckily, we were there to make sure this didn't happen.)

But despite their many similarities, there was one obvious difference from breed to breed: their size!

The life-size photographs on each breed introduction page in this book offer a dramatic glimpse at twenty-five different litters of six-week-old puppies and all the characteristics that make each one so disarmingly special . . . the many bits, big and small, that make each puppy mighty.

RIGHT: BONITA FOLLOWING: ARTURIUS

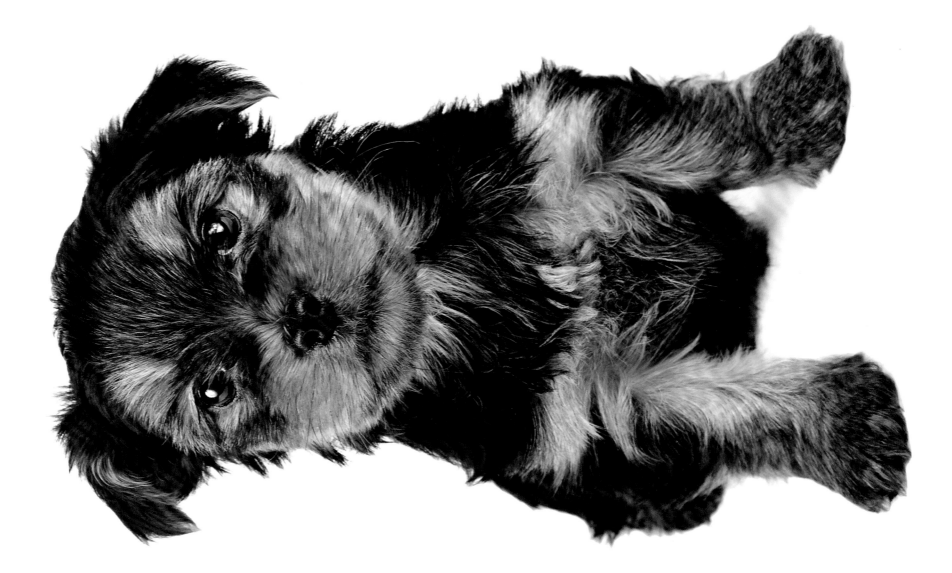

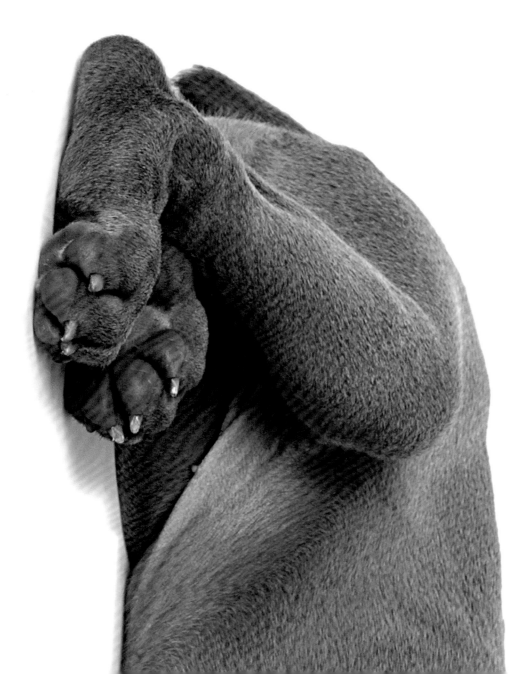

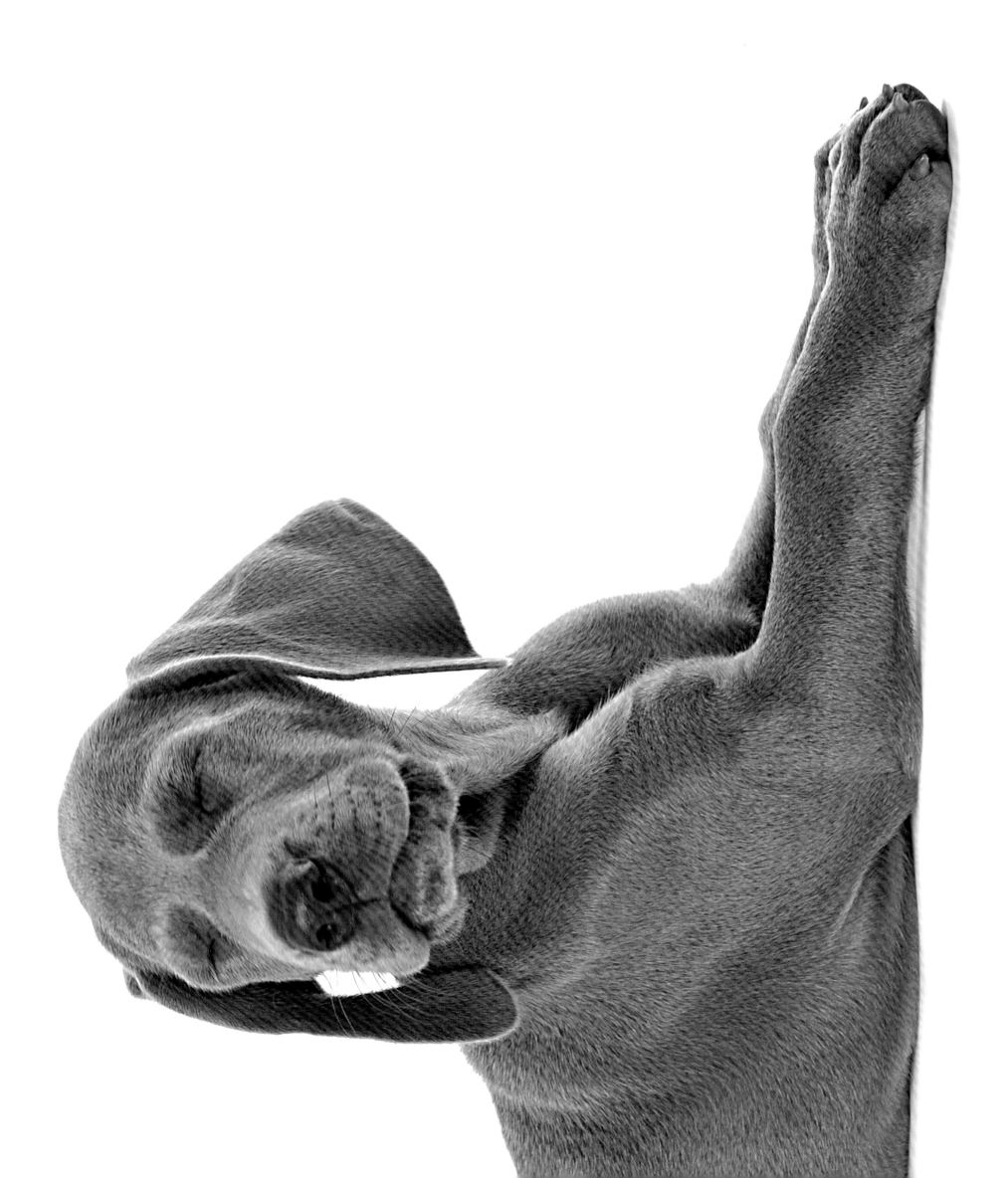

ROLAND

LABRADOR RETRIEVER / 6.5 LBS

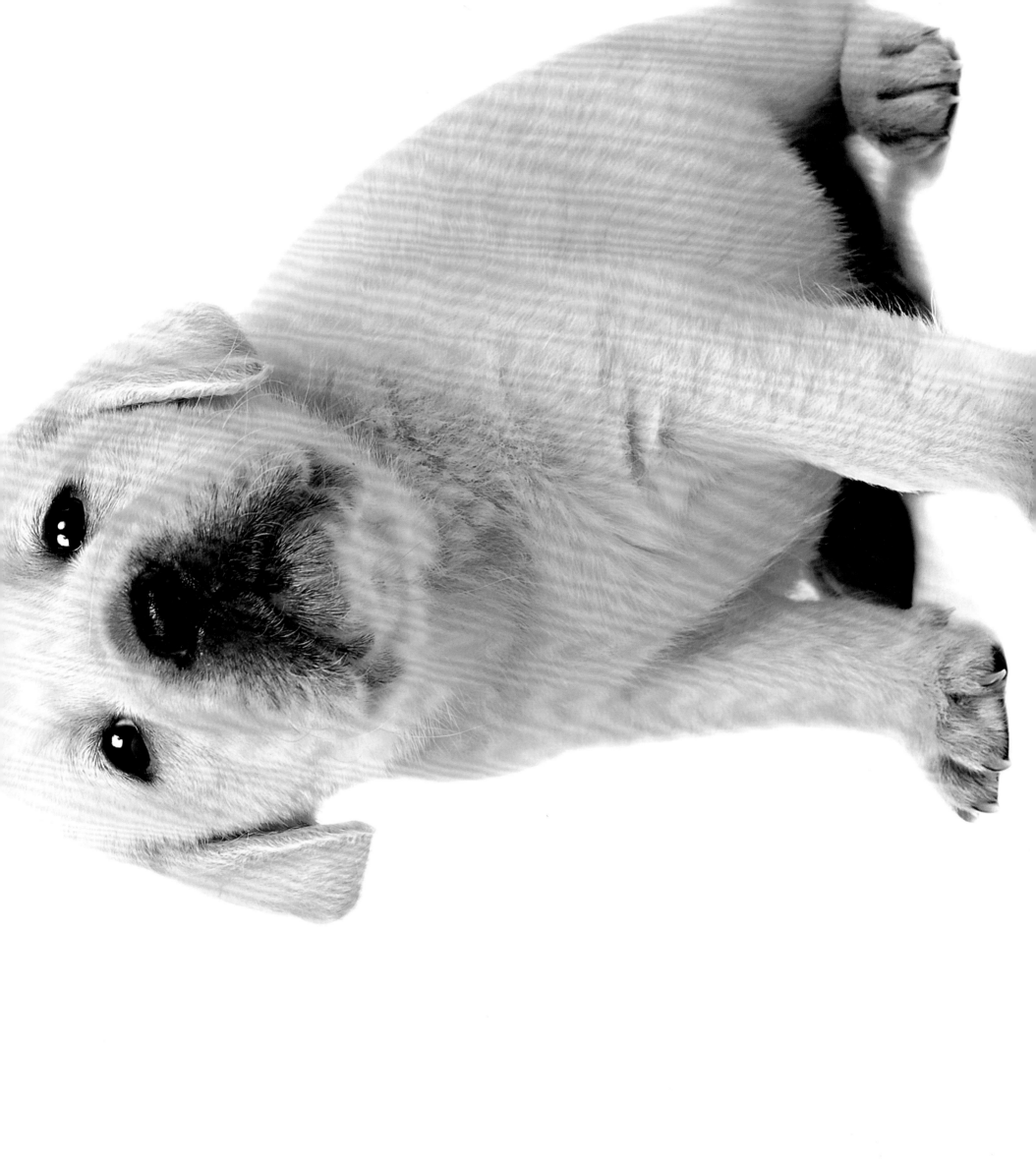

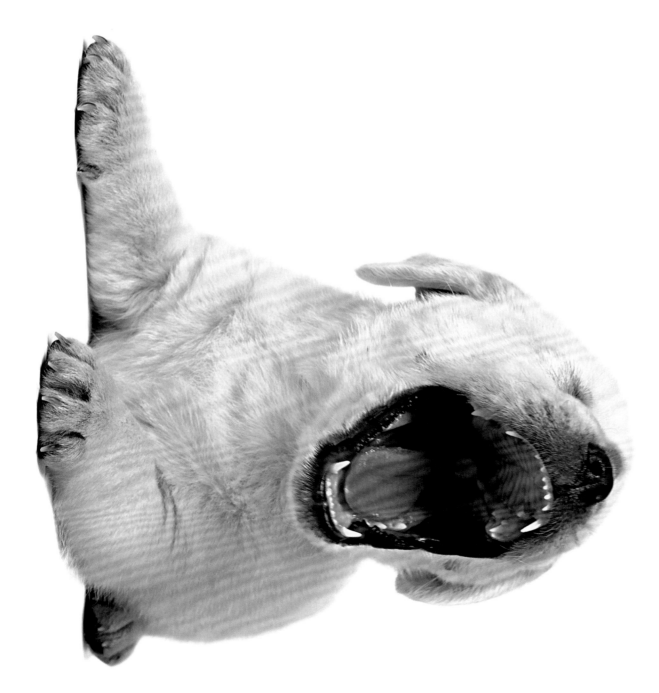

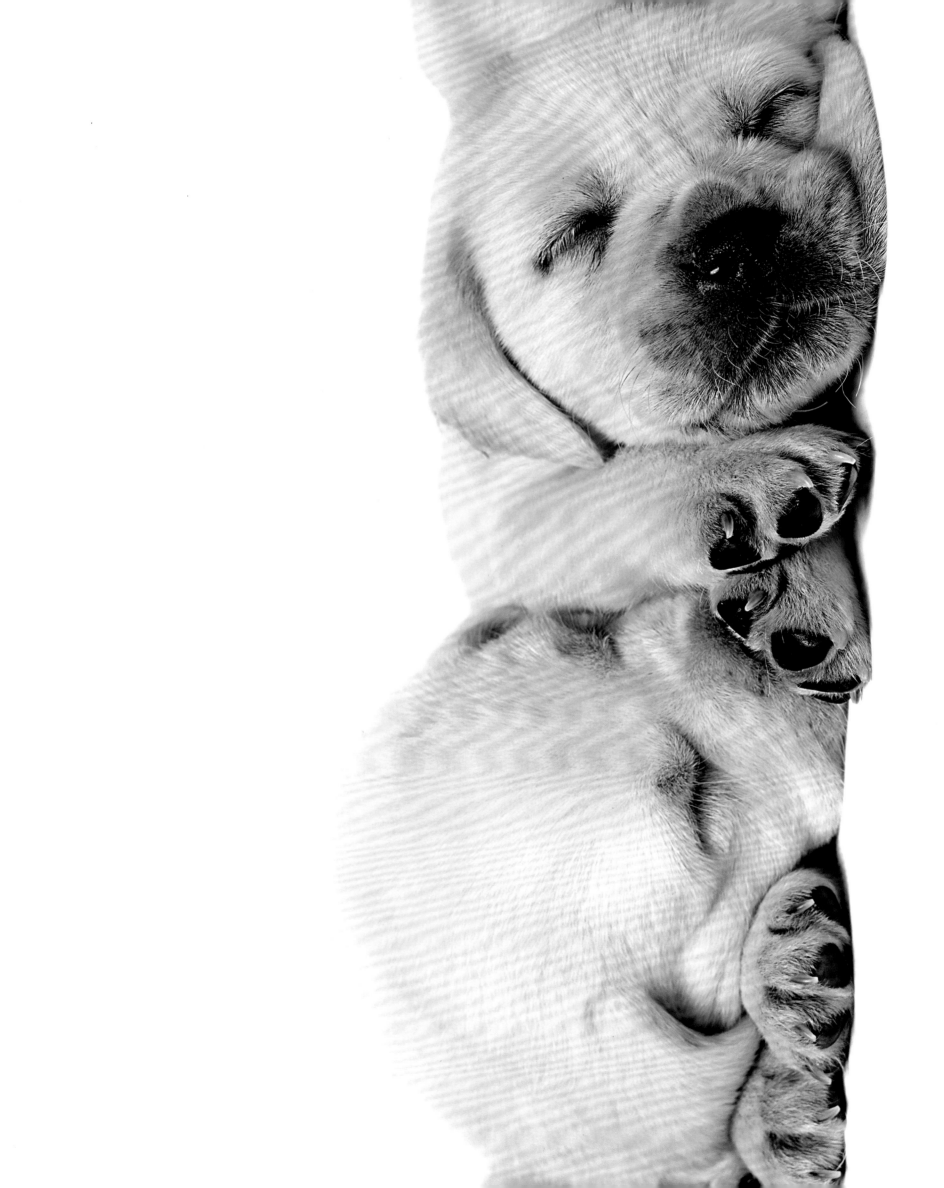

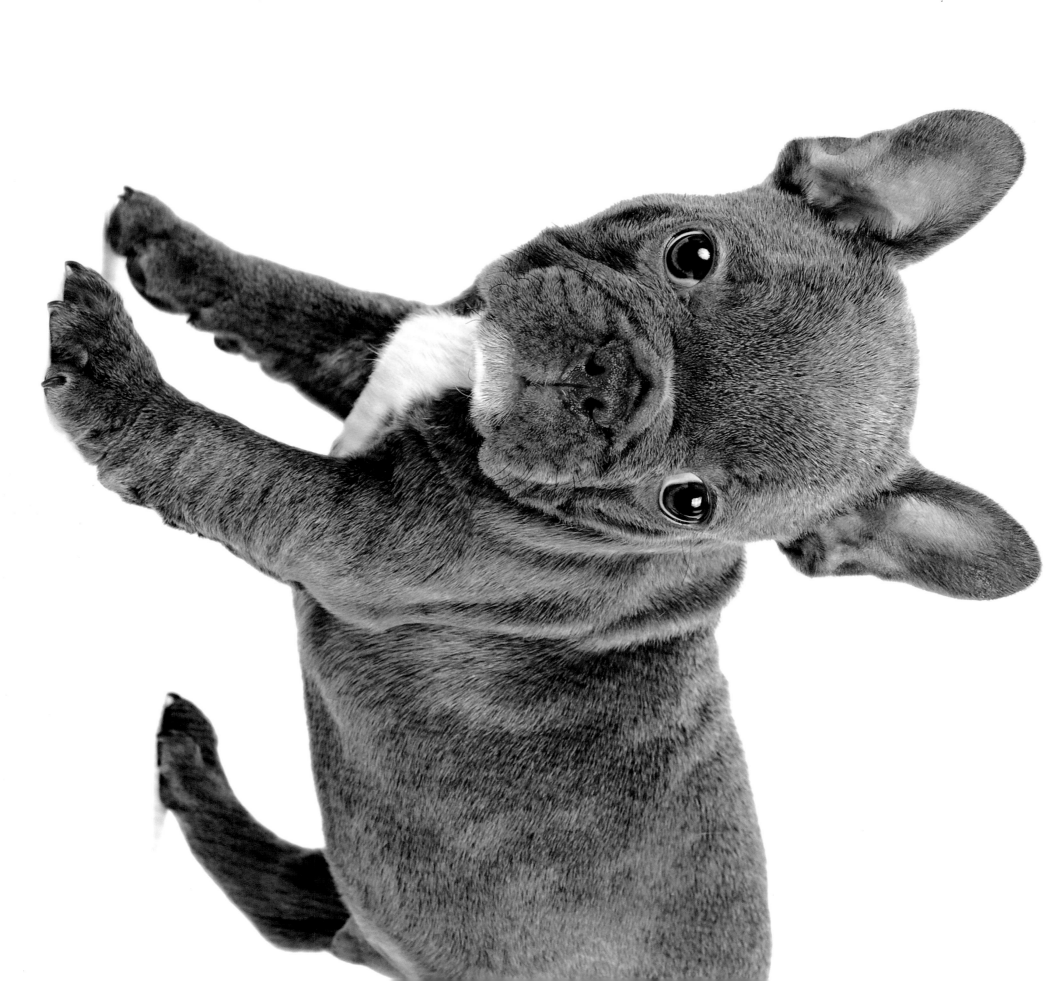

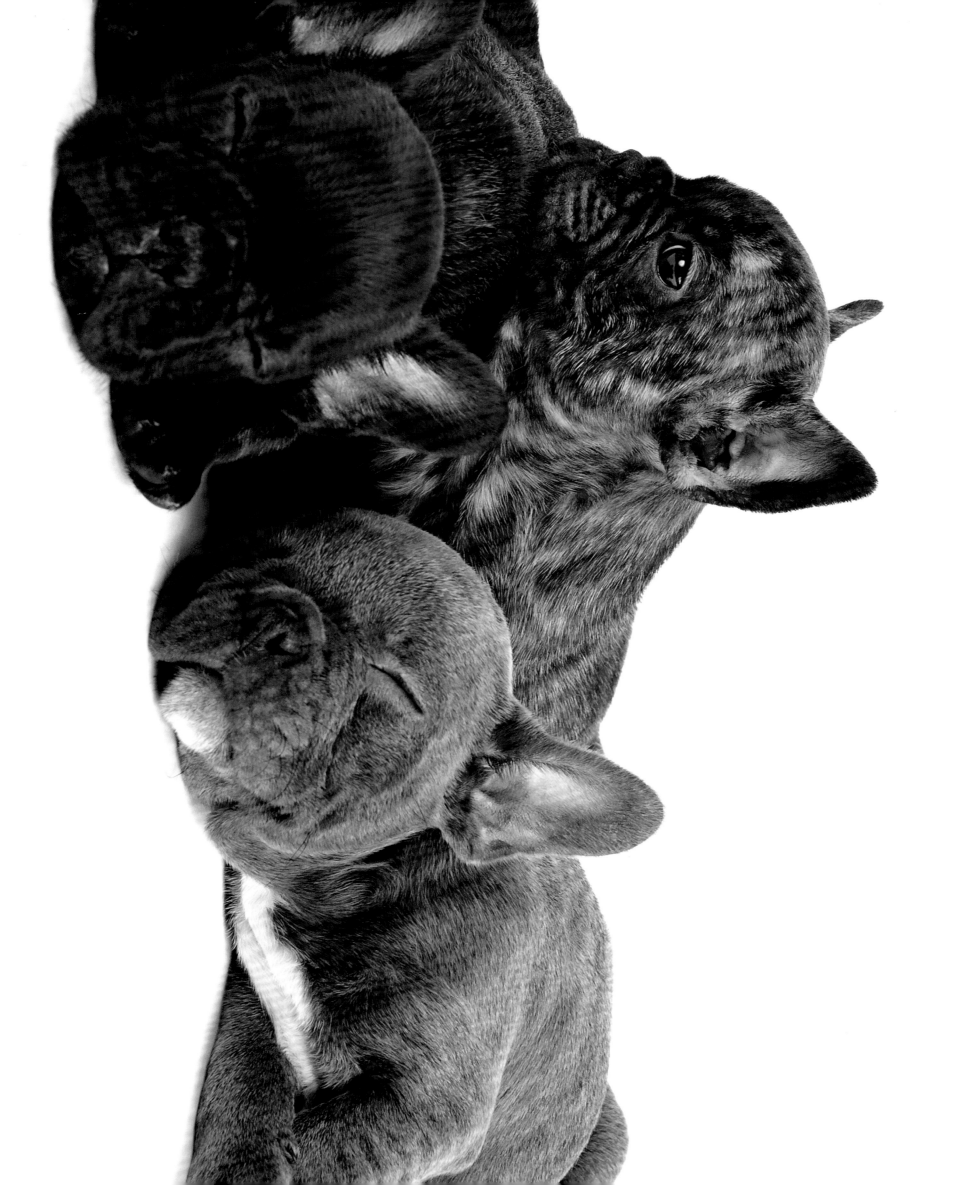

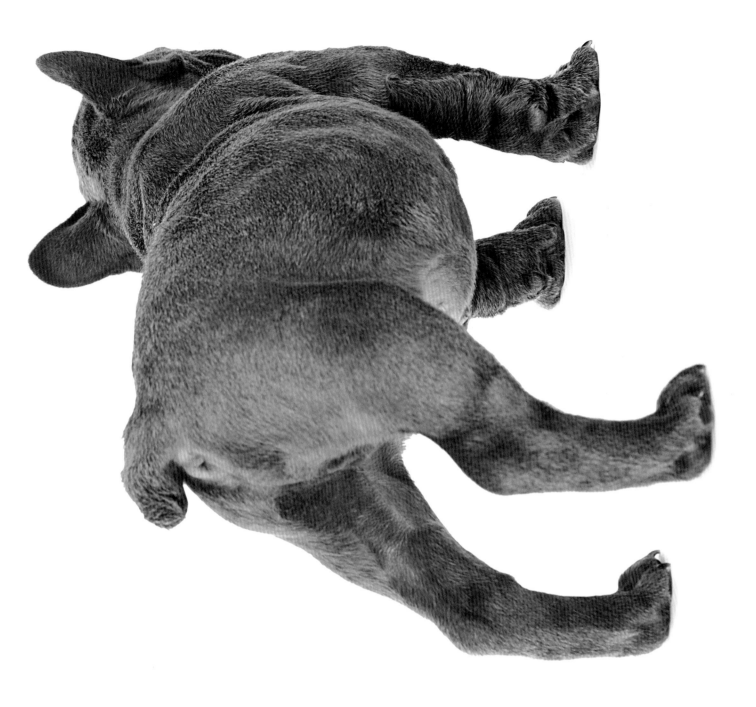
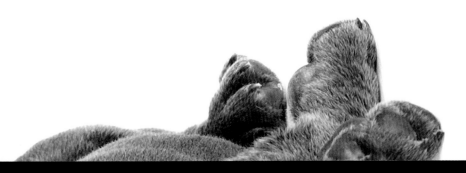

KENNETH

SHIH TZU / 2.5 LBS

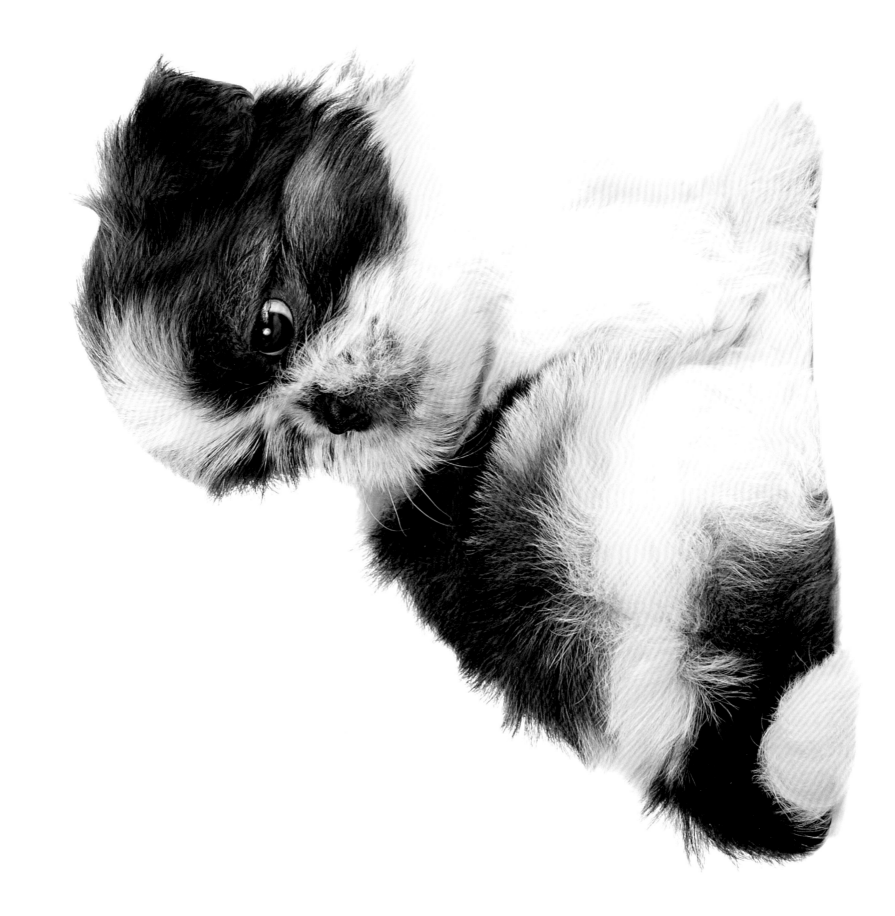

ABOVE: KEITH OPPOSITE: KEITH, KENNETH & KATIE

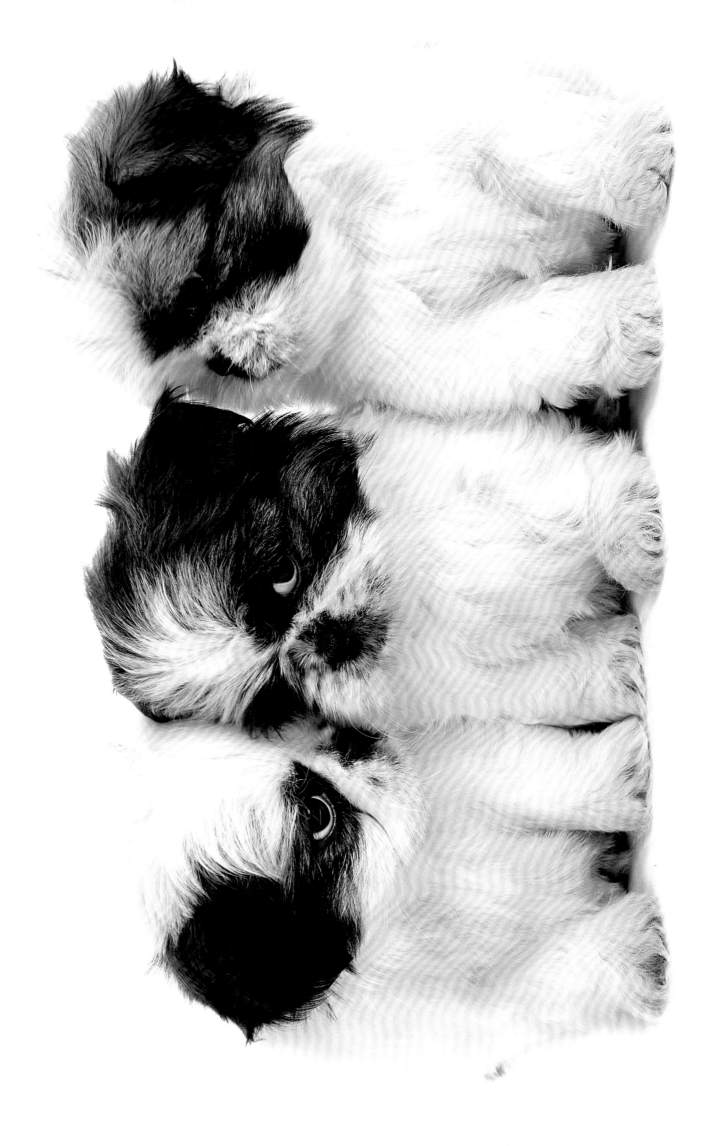

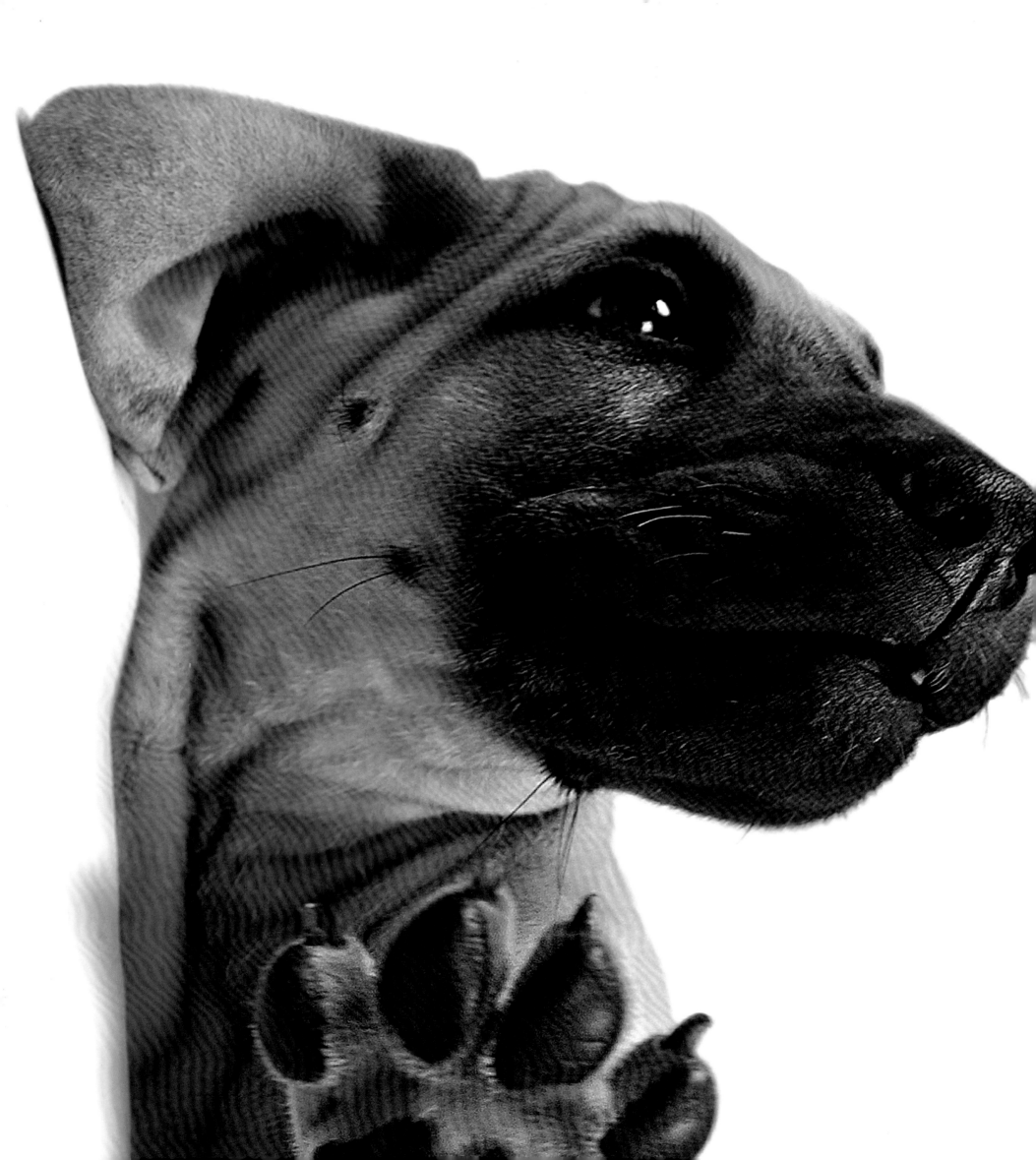

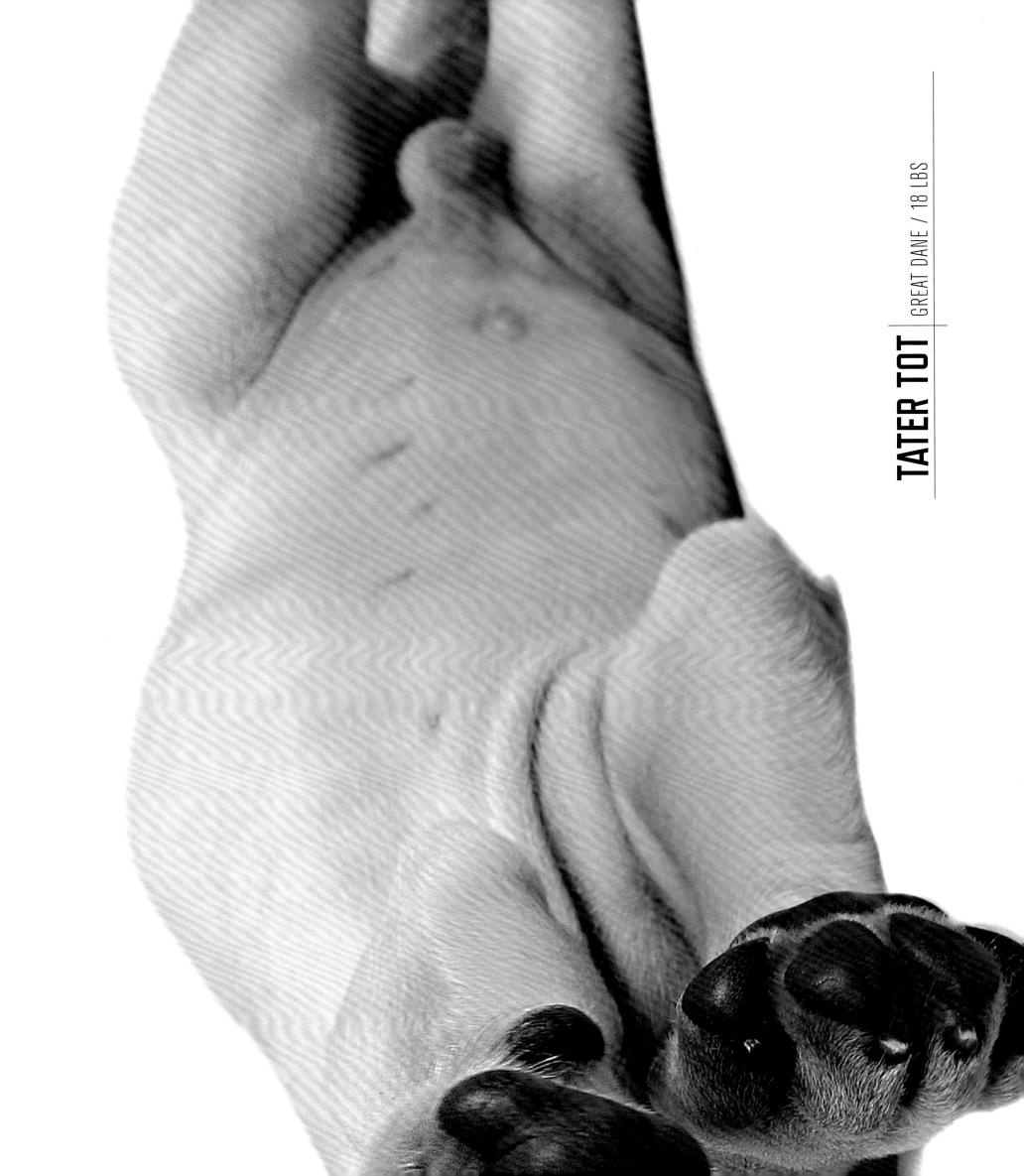

TATER TOT | GREAT DANE / 18 LBS

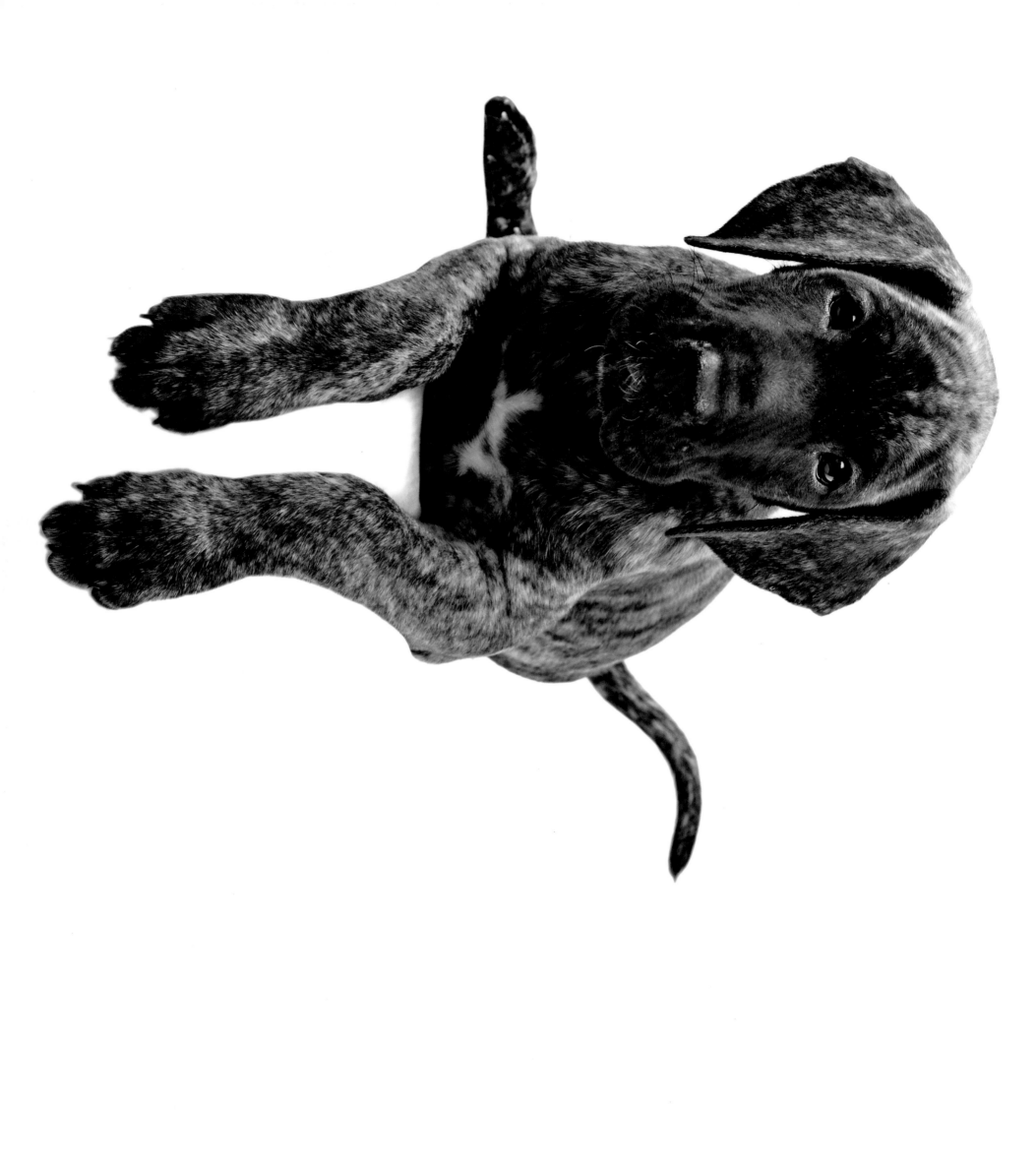

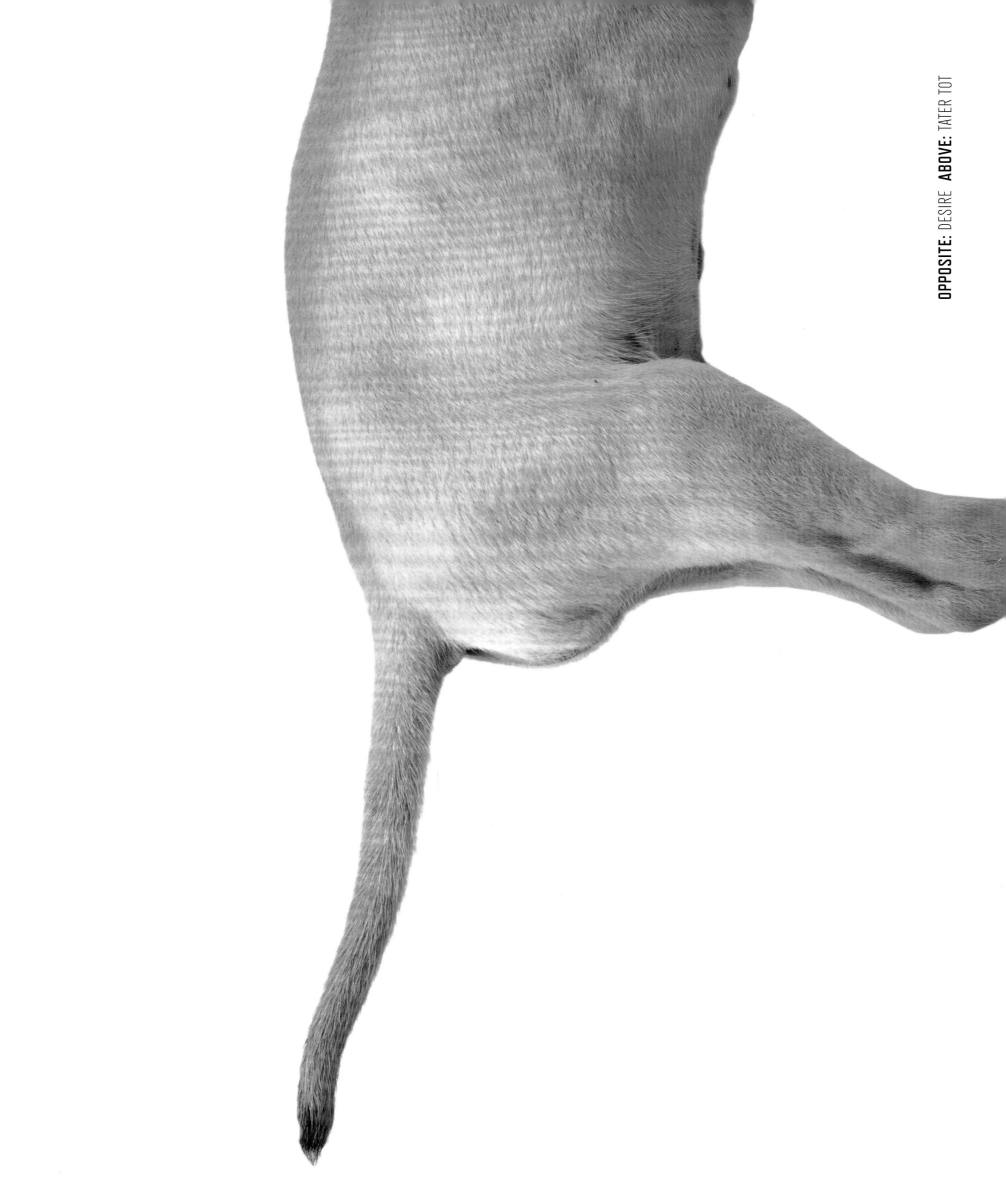

CAPTAIN

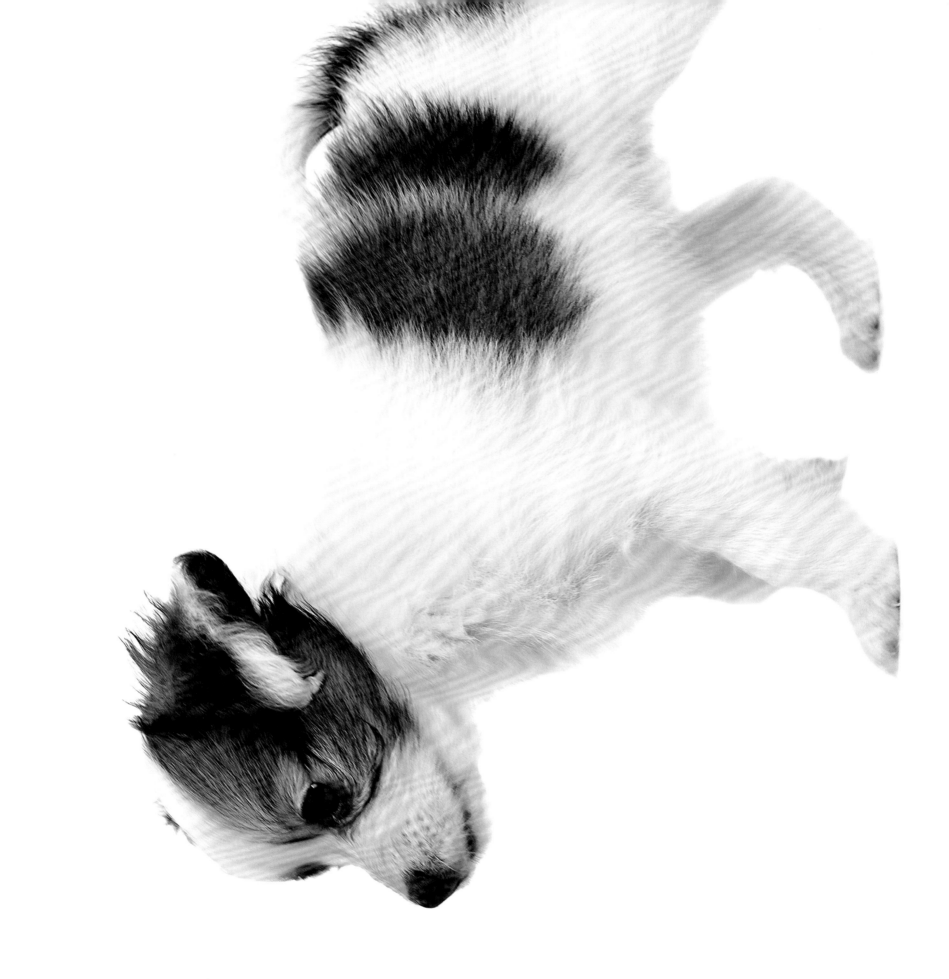

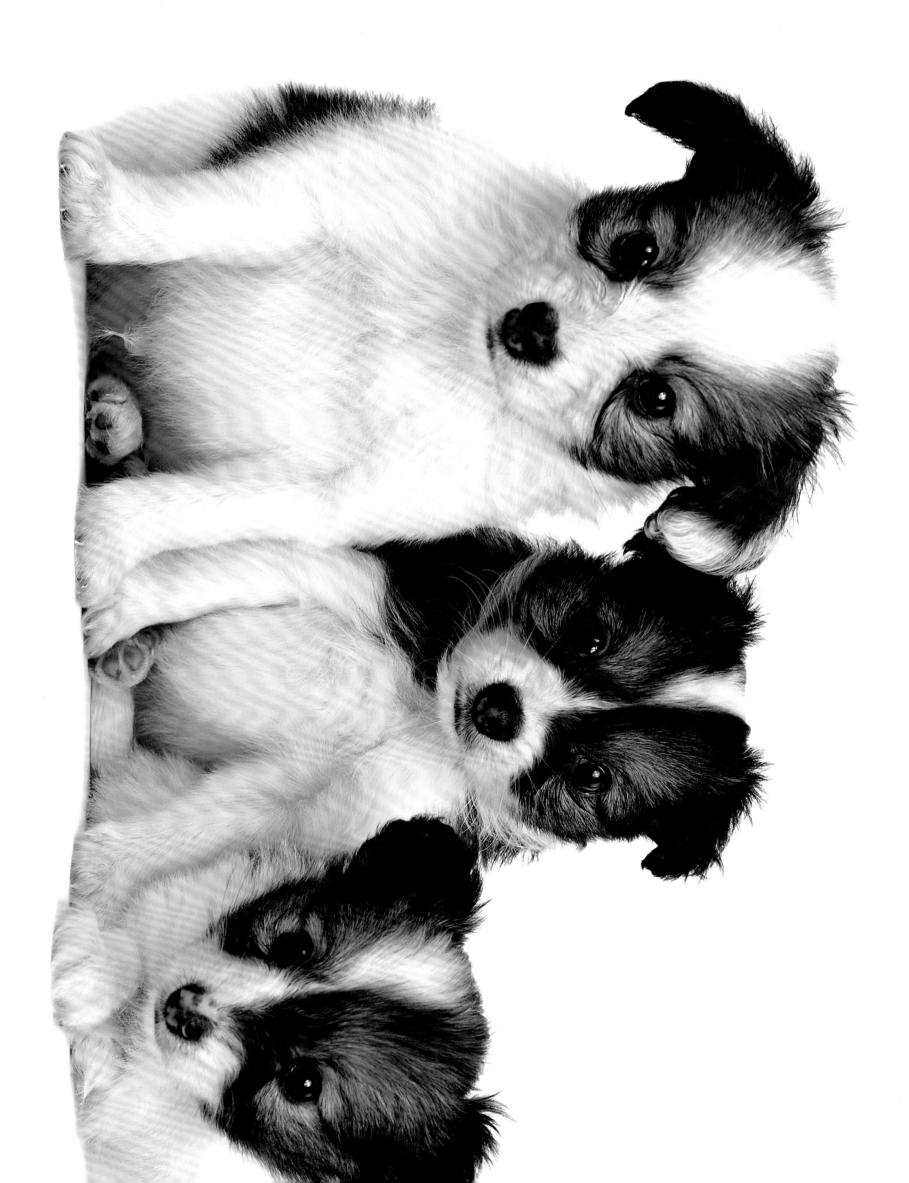

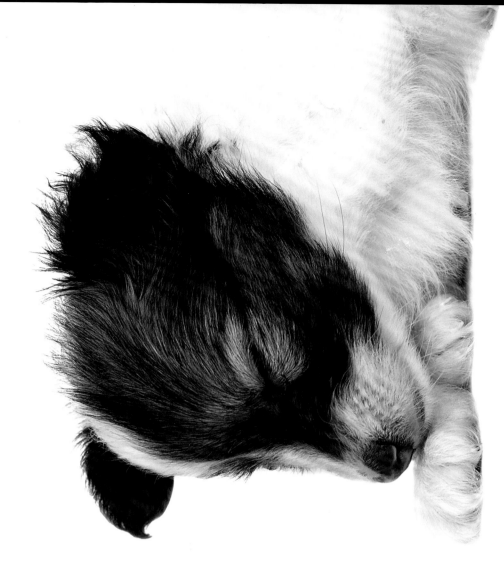

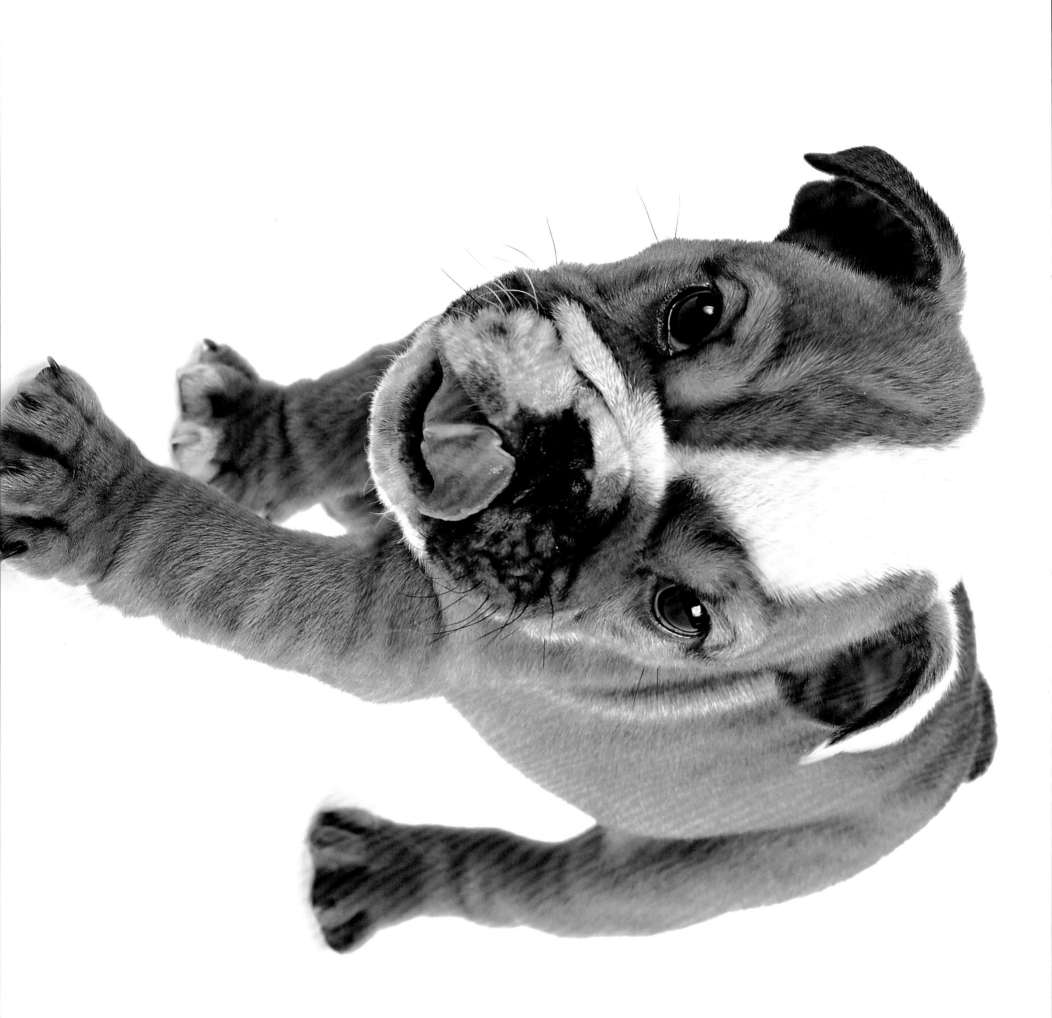

CHAD | ENGLISH BULLDOG / 5 LBS

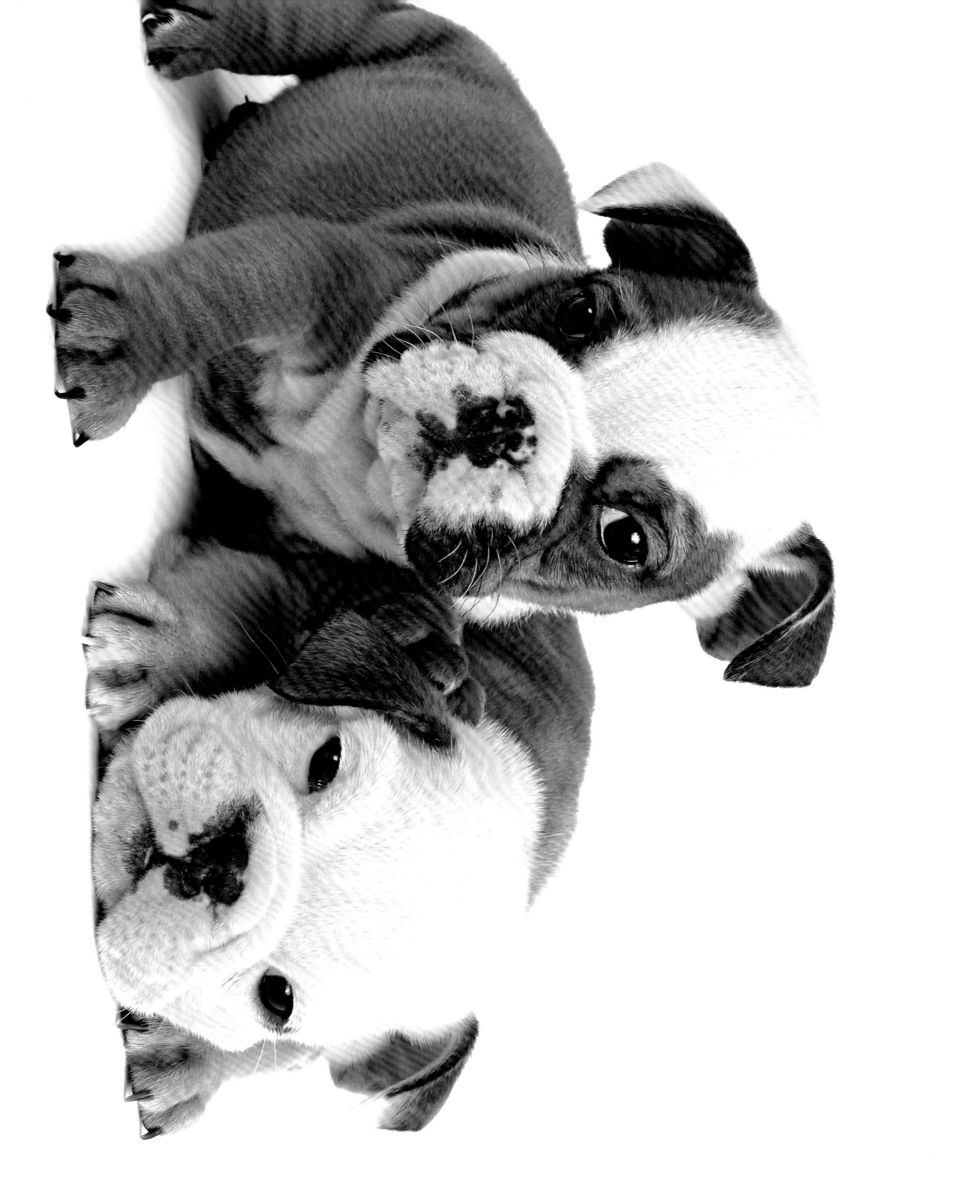

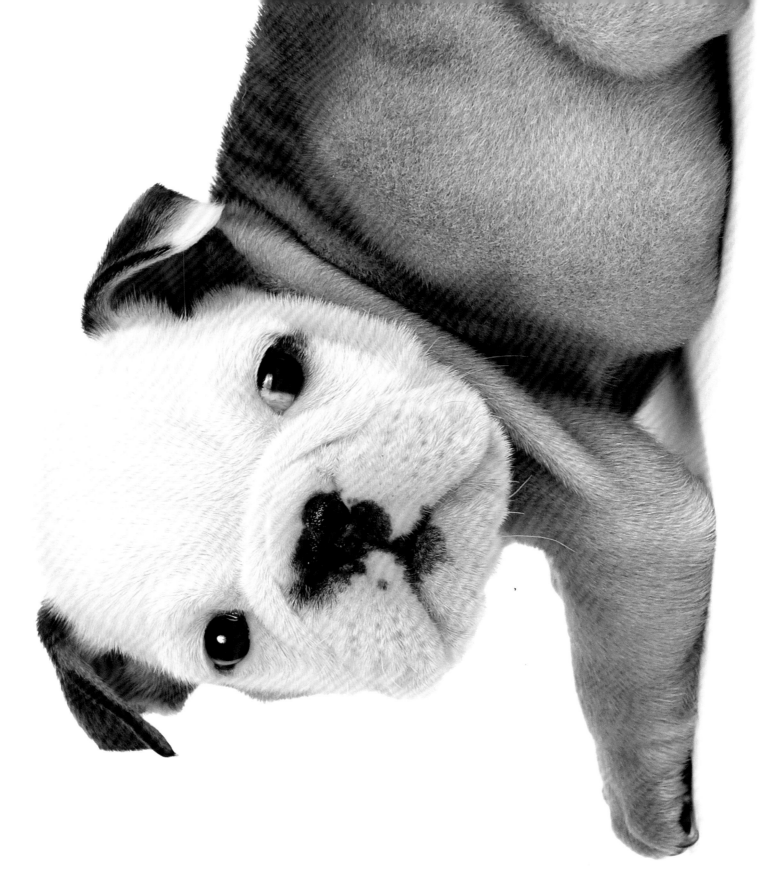

OPPOSITE: MISSY & CALVIN **ABOVE:** CALVIN

CLEO

GERMAN SHEPHERD / 9.5 LBS

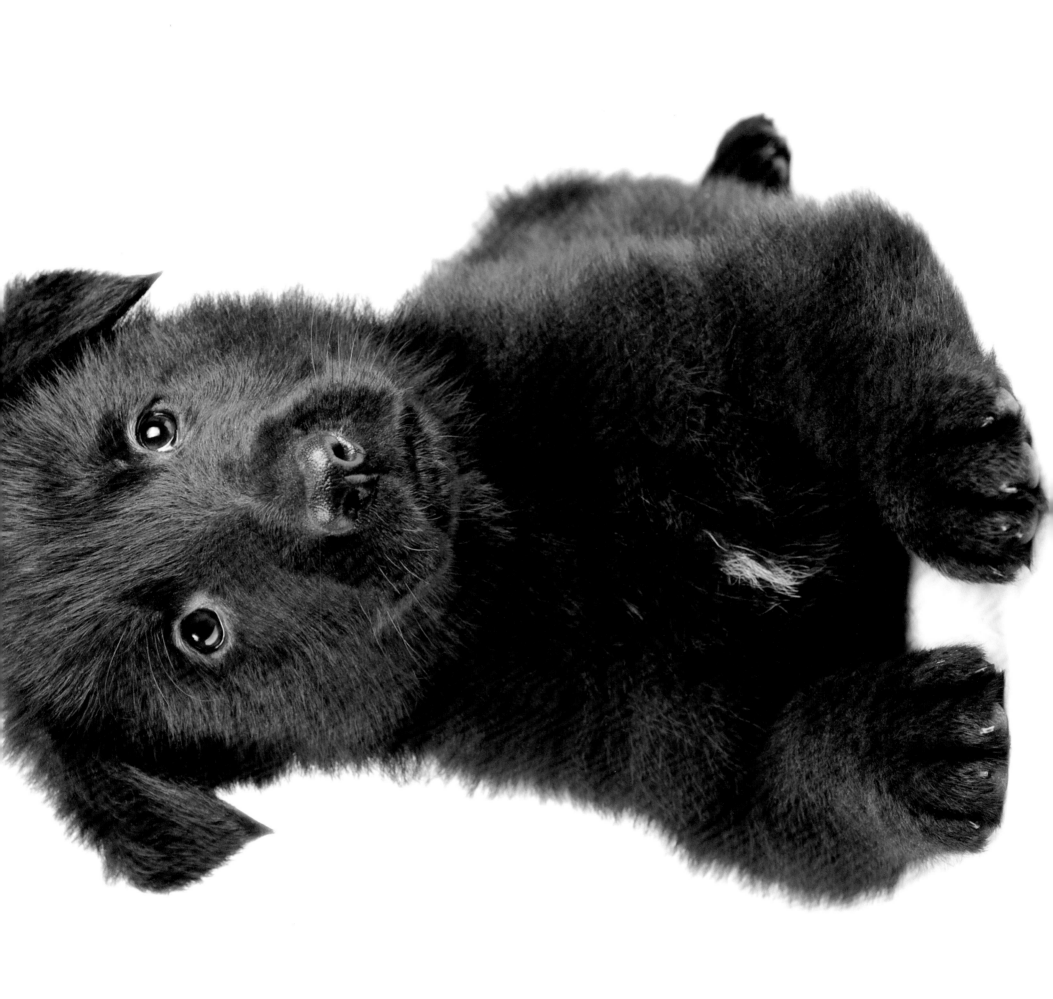

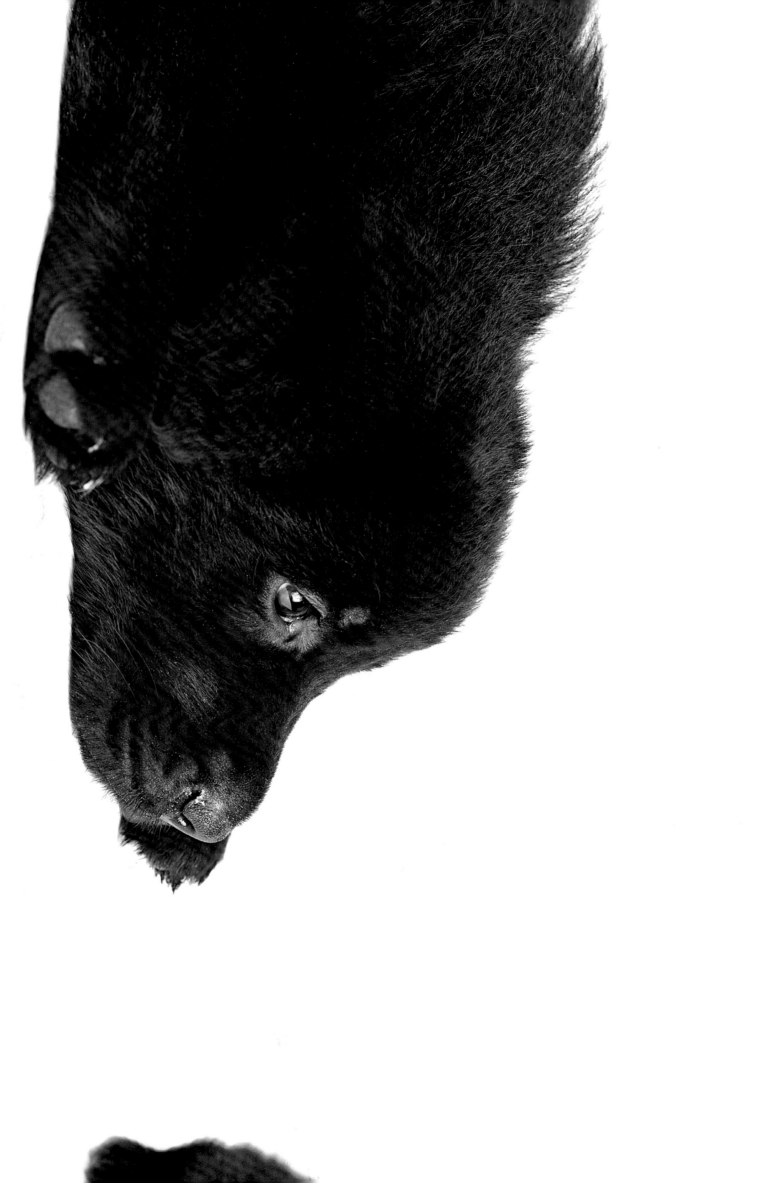

ABOVE: COLA OPPOSITE: COCO, COLT & CHUCK

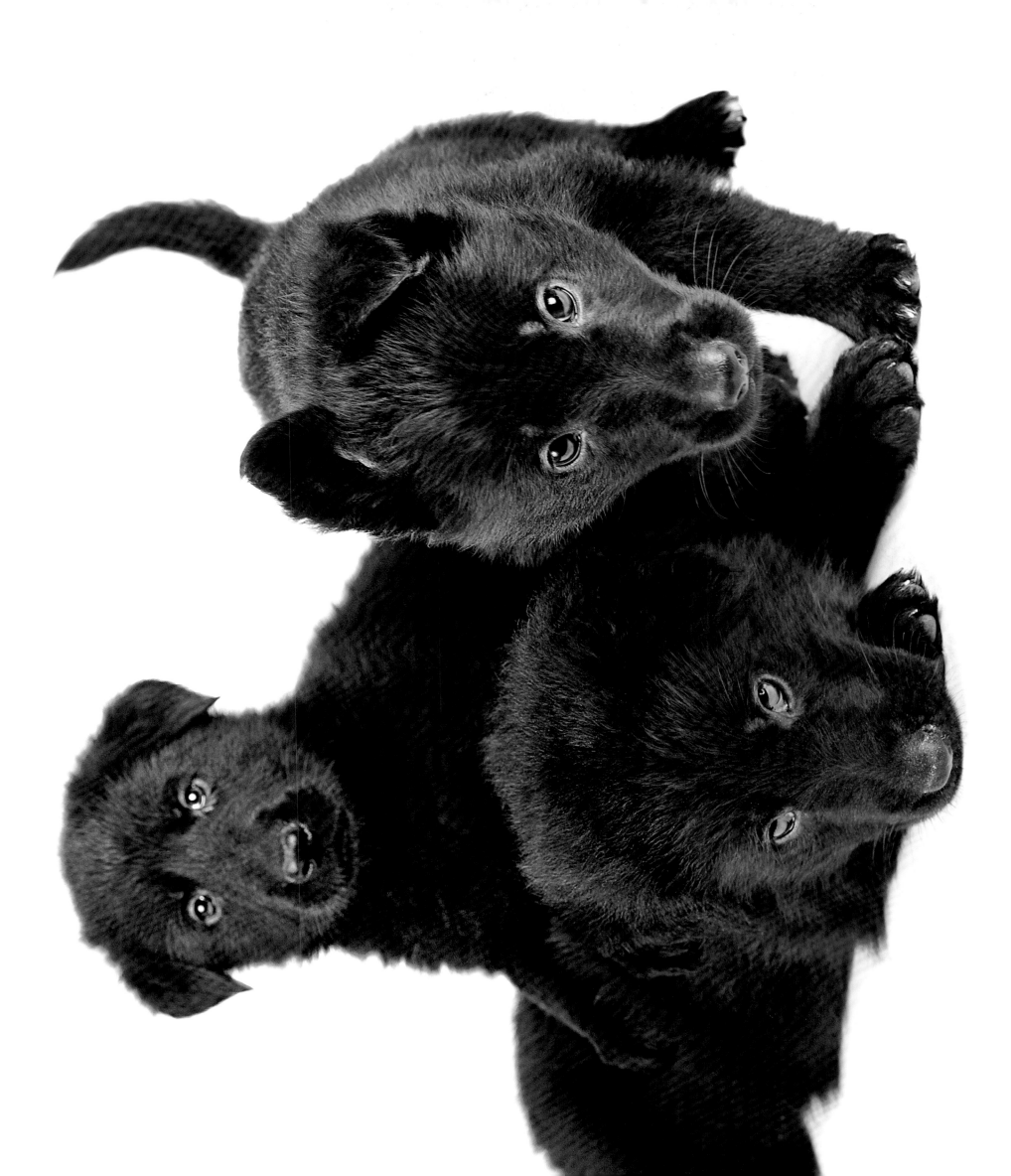

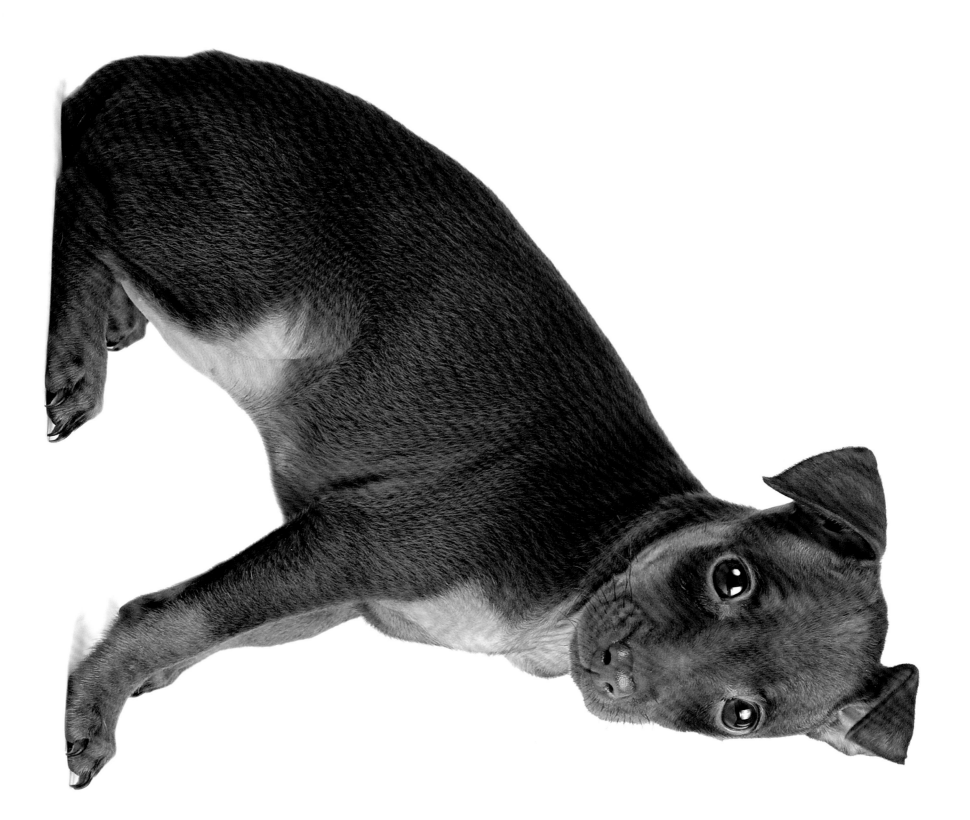

MAUDE | MINIATURE PINSCHER / 2.5 LBS

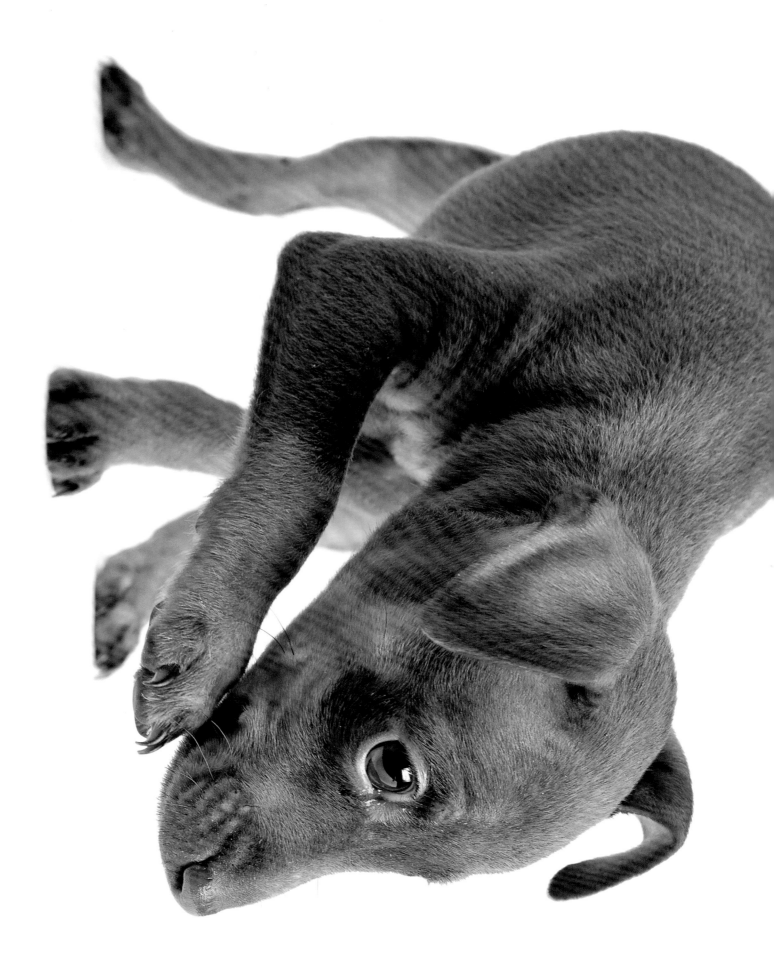

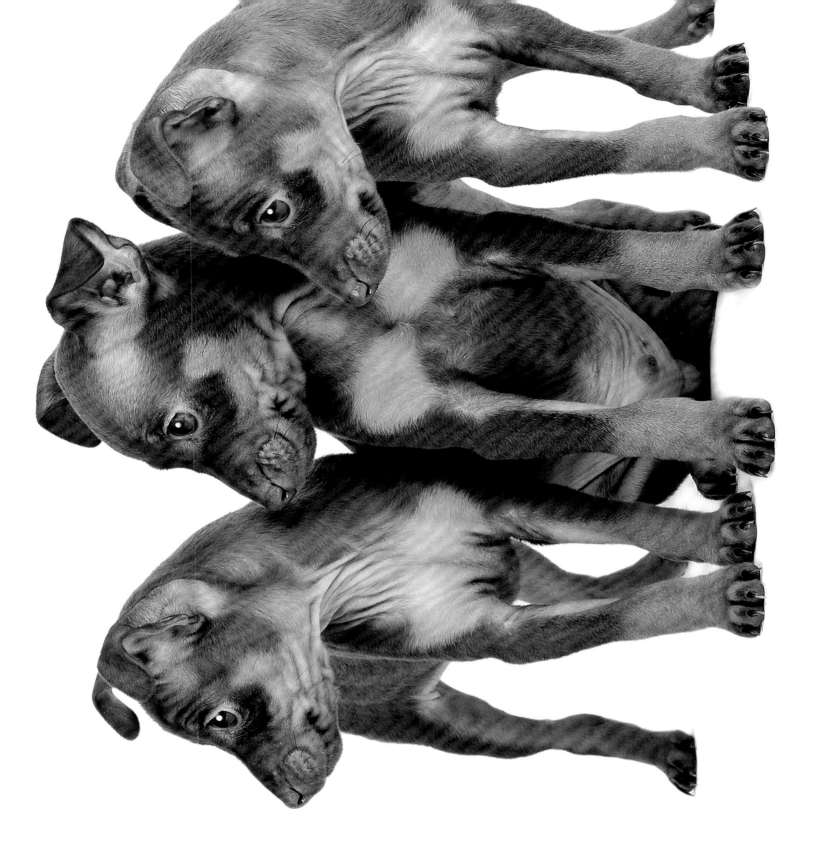

OPPOSITE: FRANK **ABOVE:** LEXIE, MAUDE & FRANK

GINGERSNAP

BASSET HOUND / 6.8 LBS

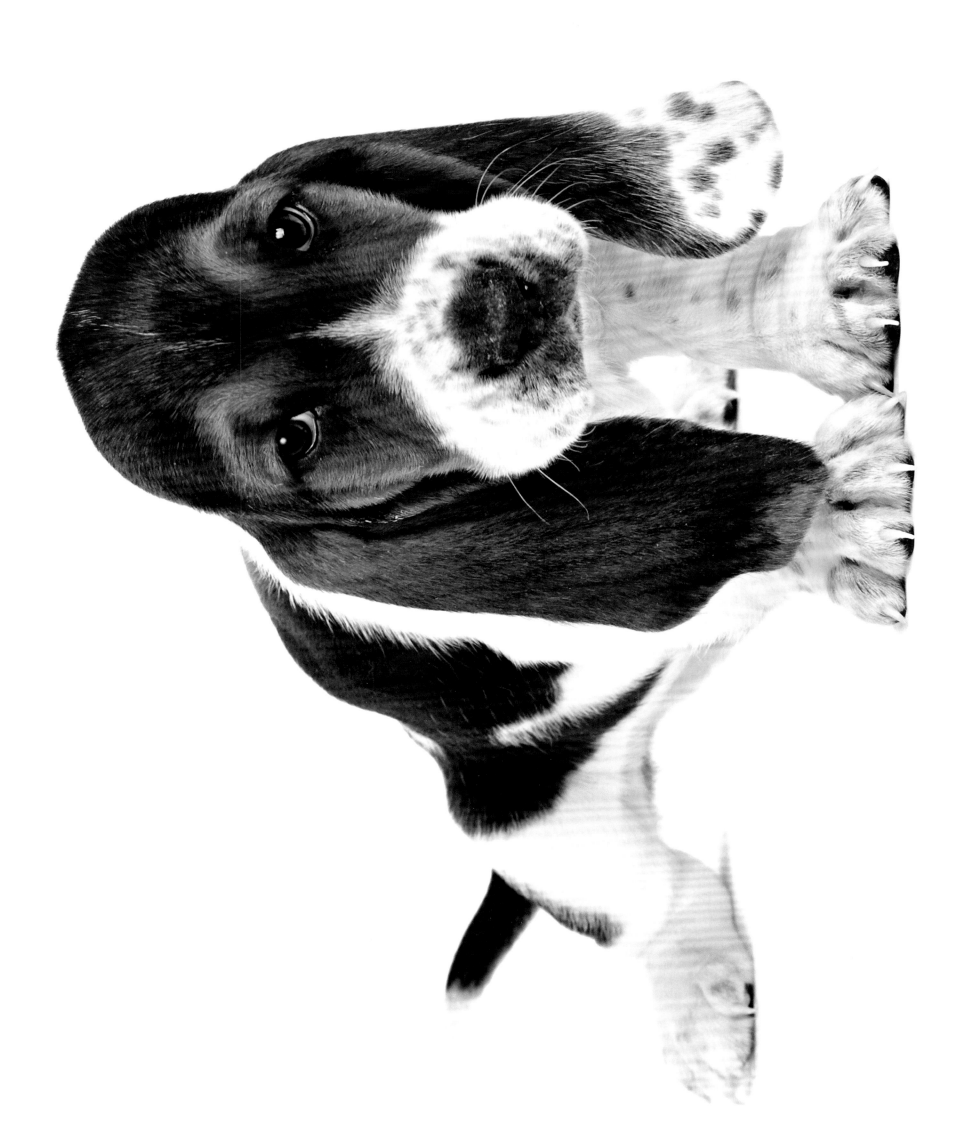

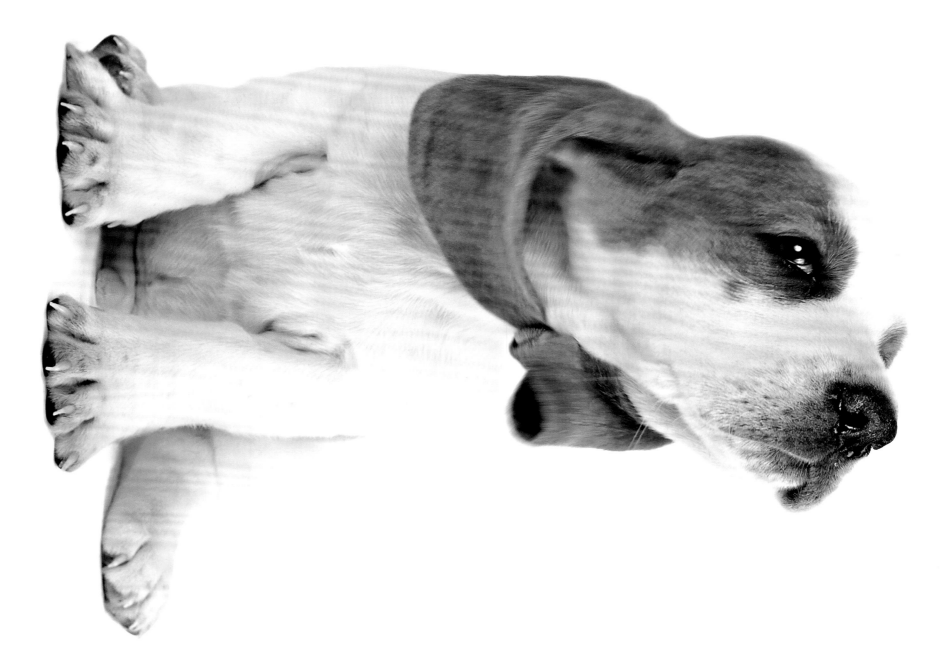

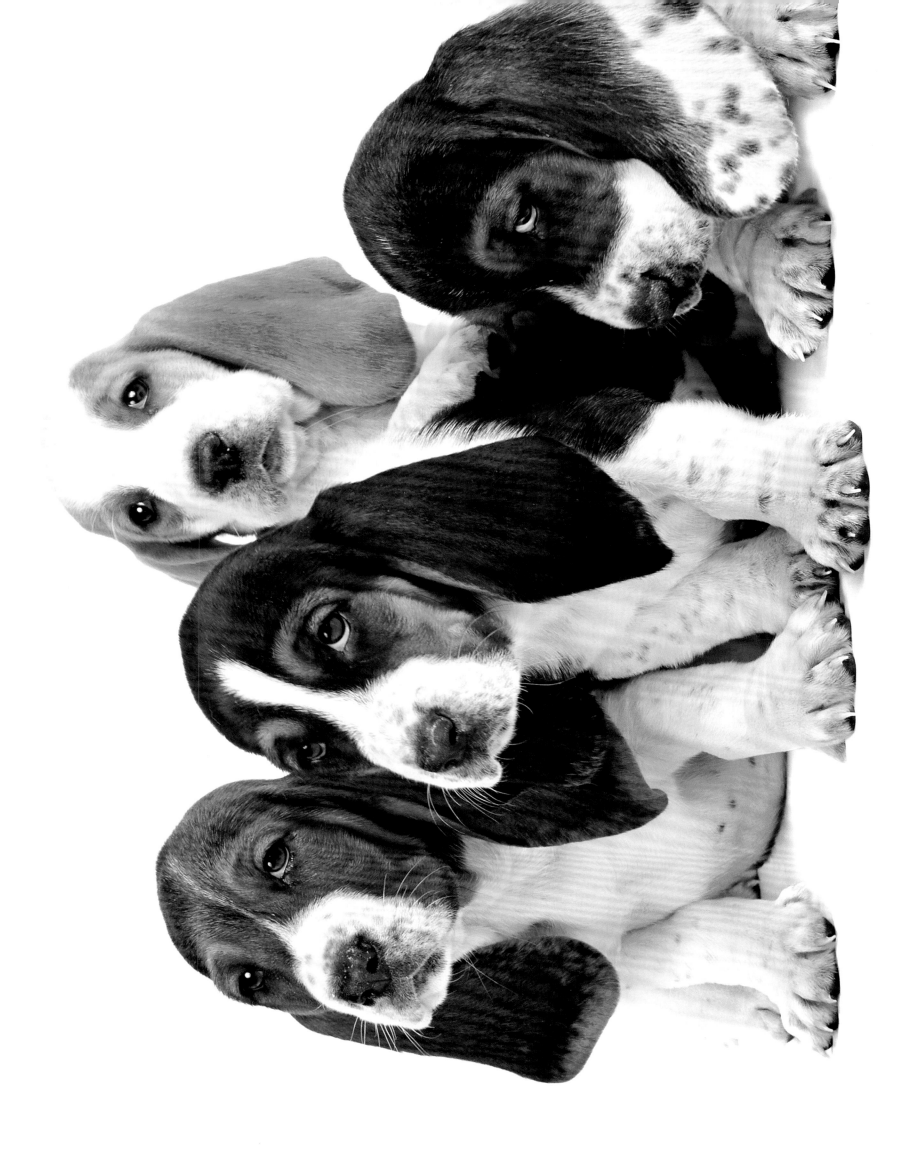

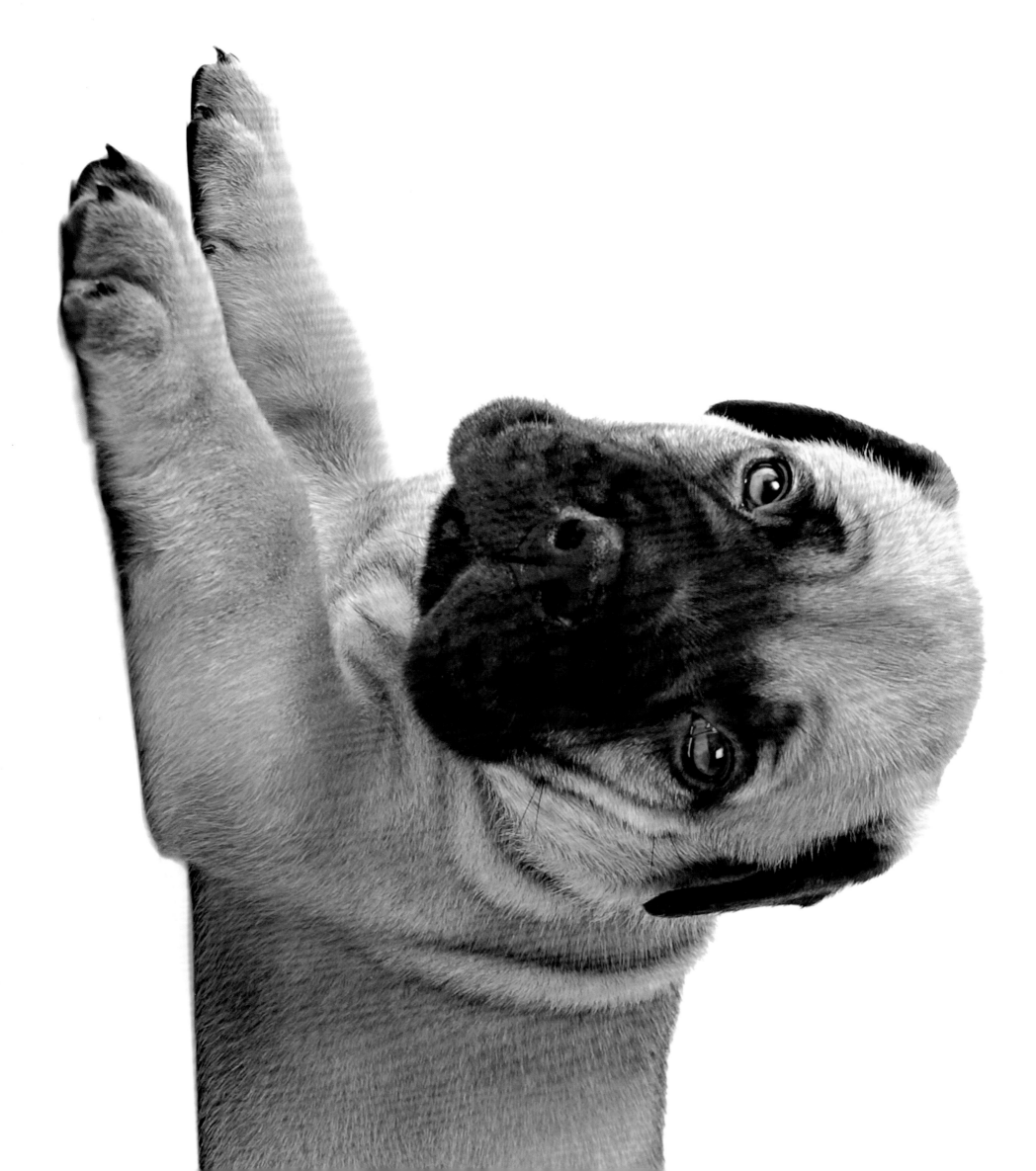

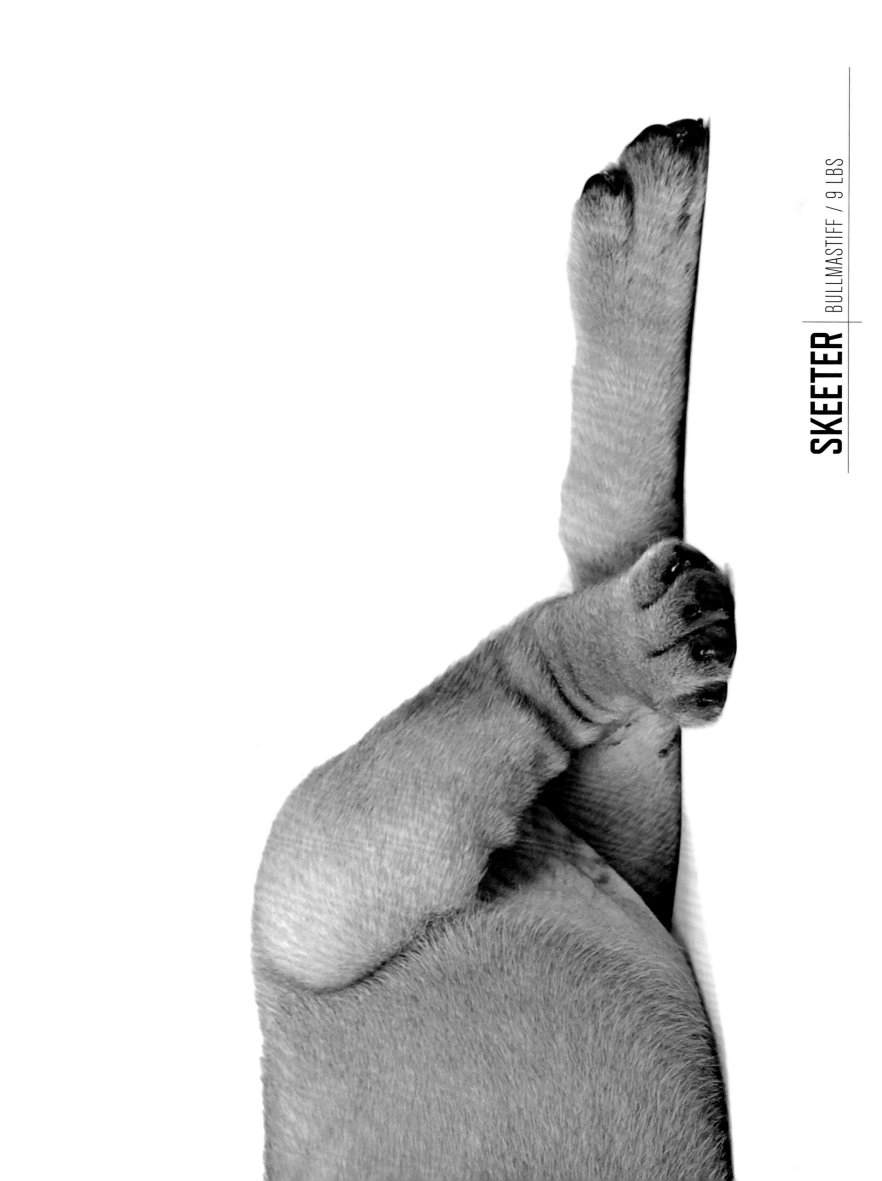

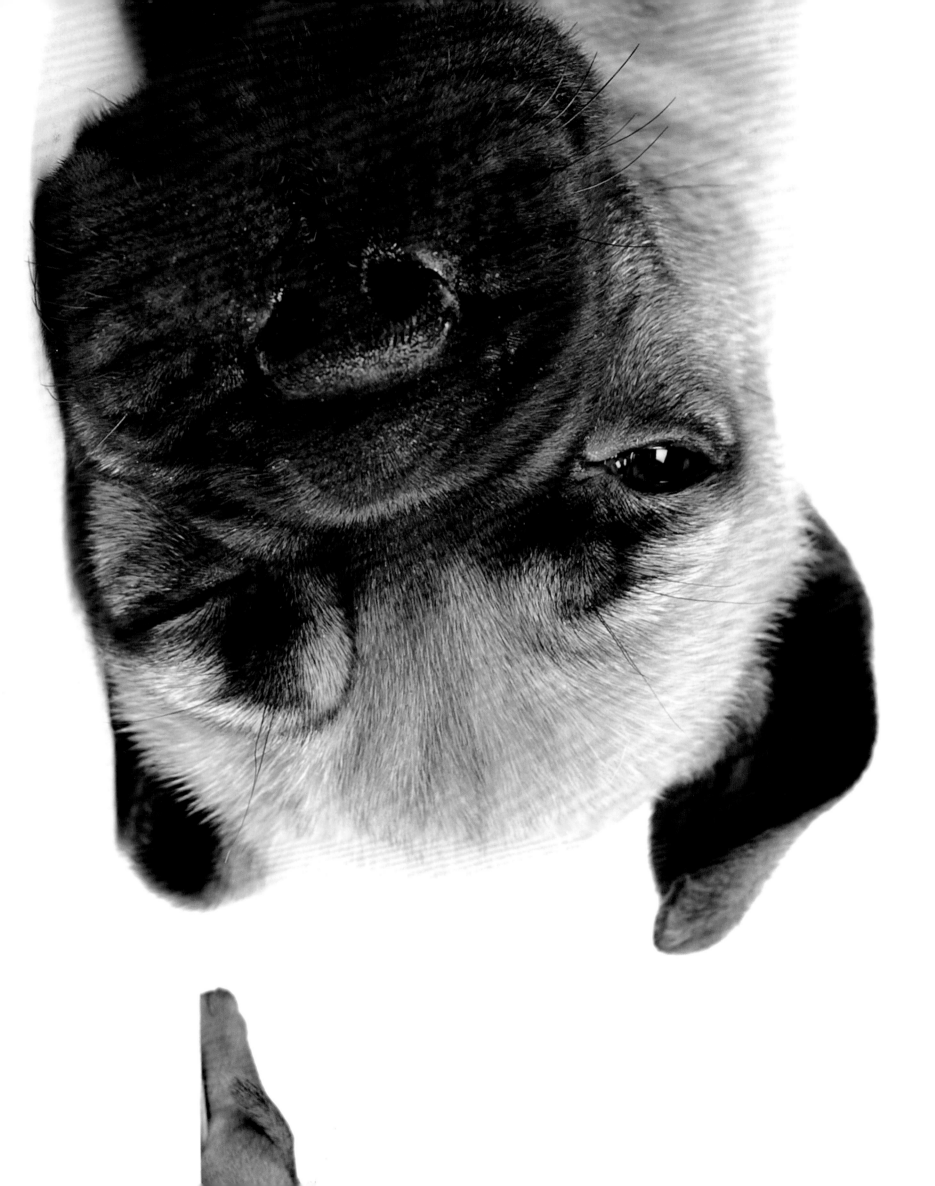

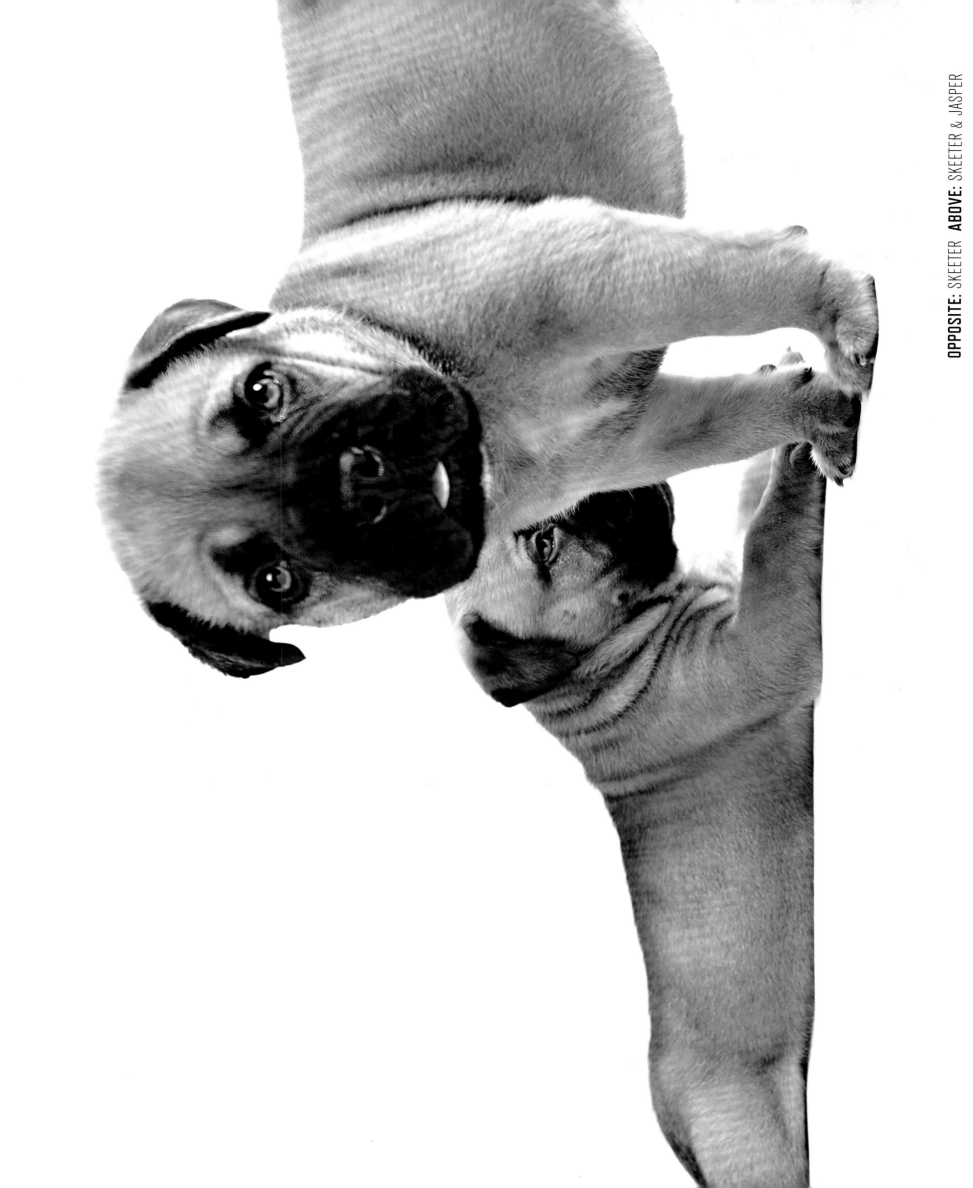

WENDY

CAVALIER KING CHARLES SPANIEL / 3 LBS

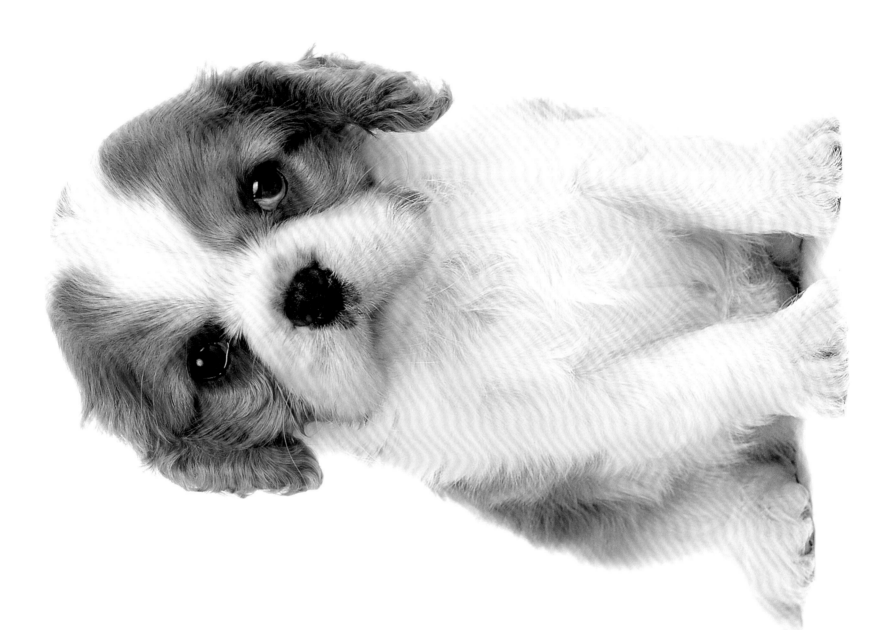

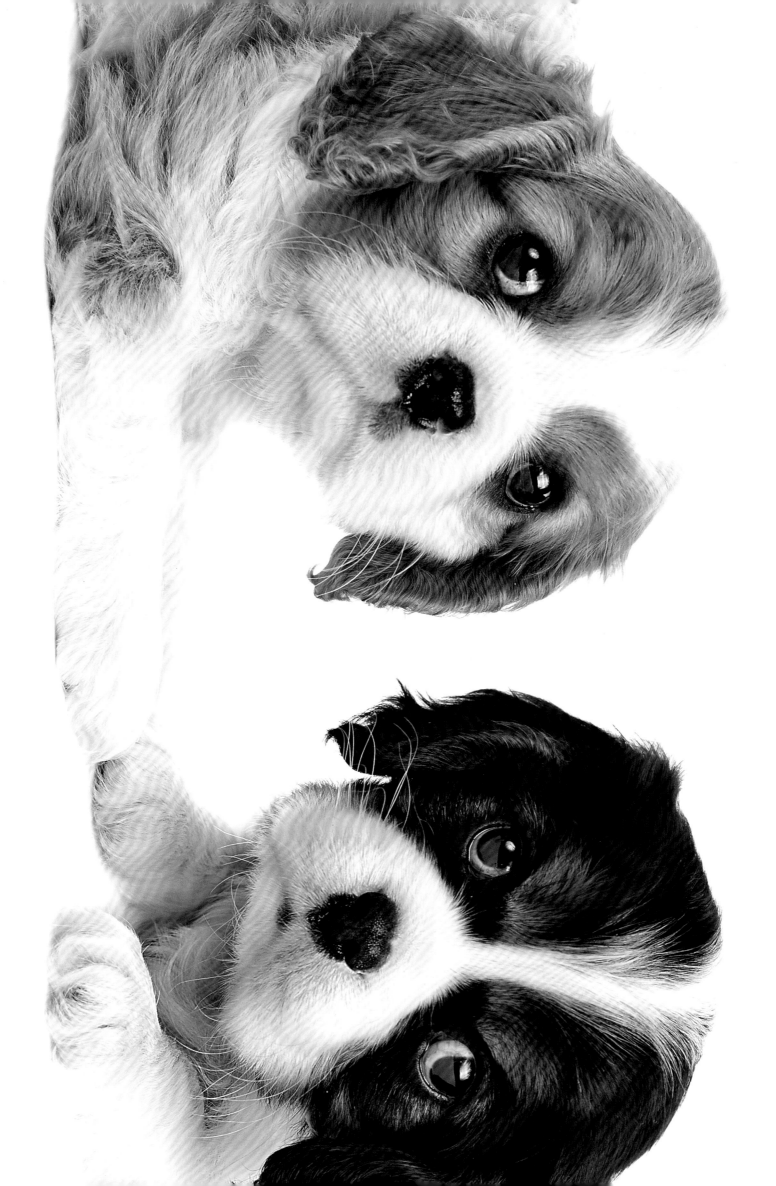

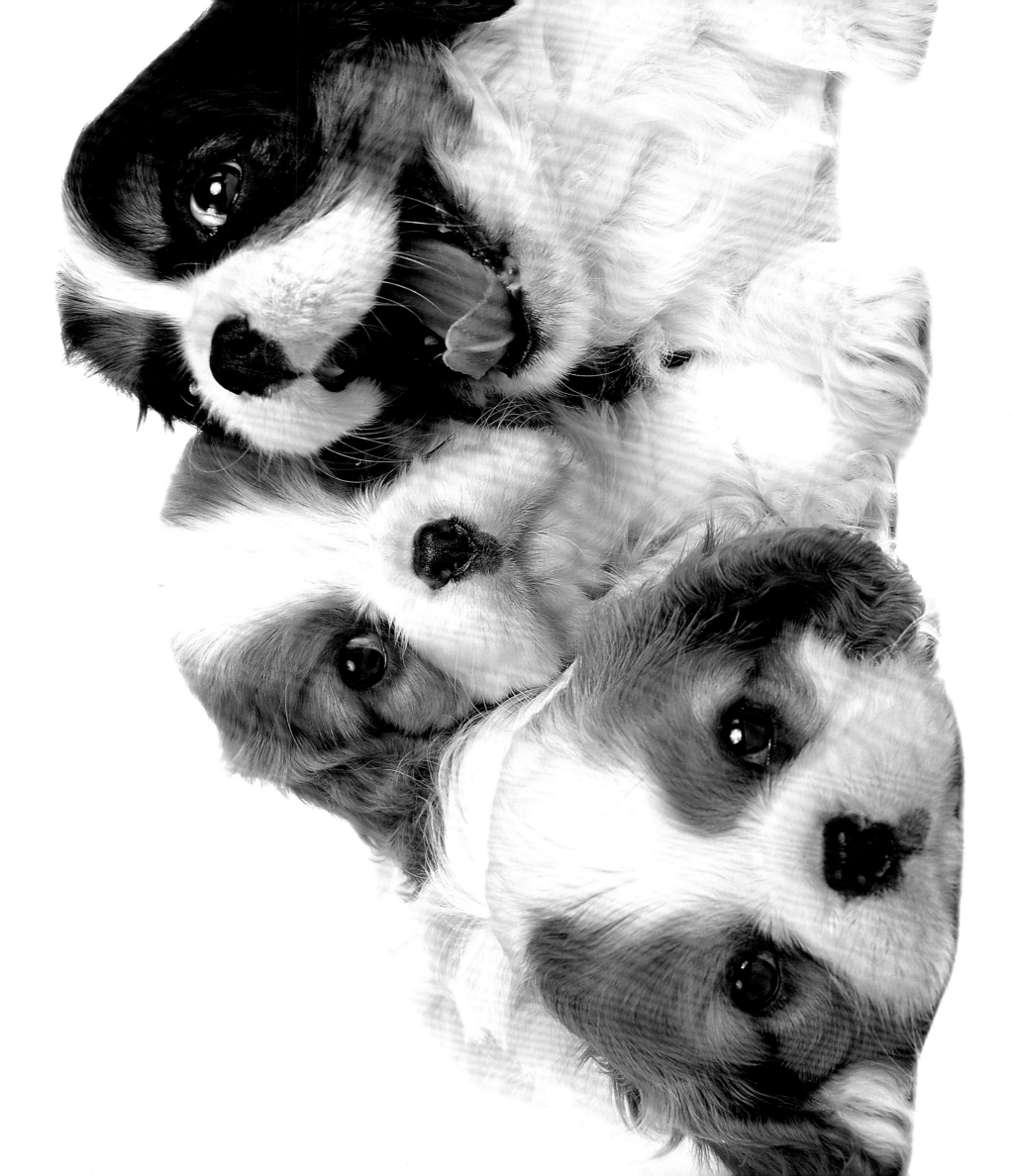

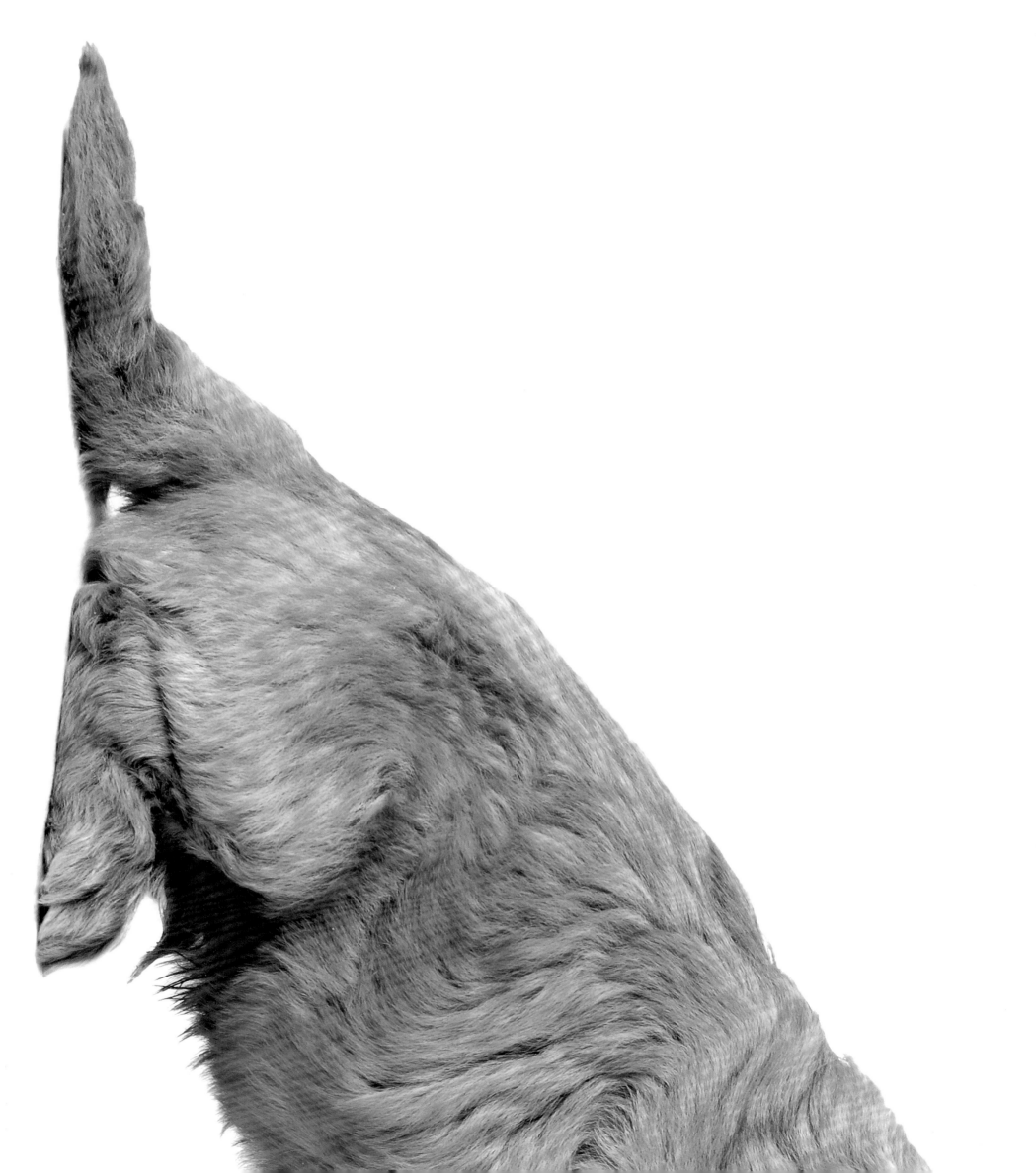

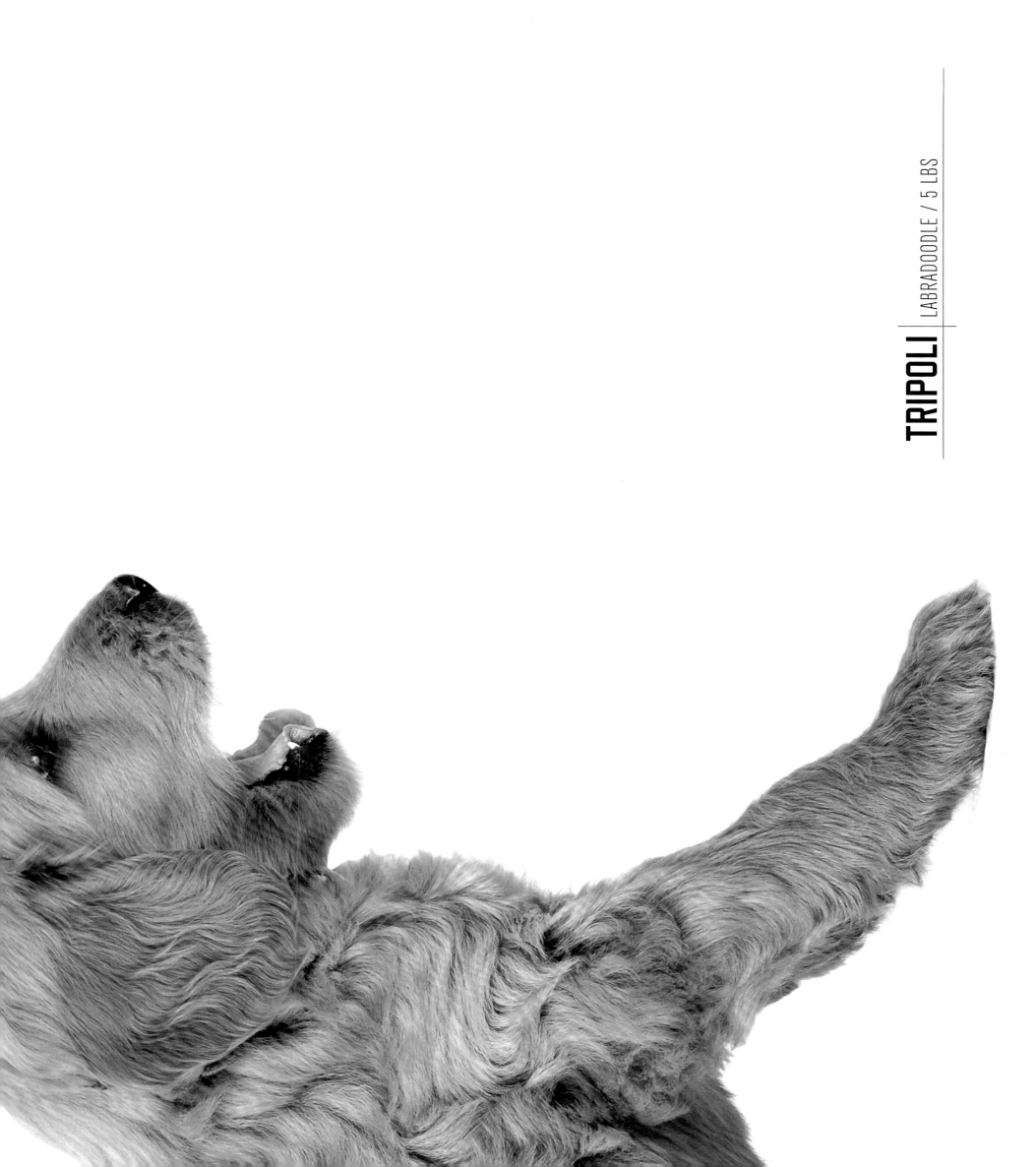

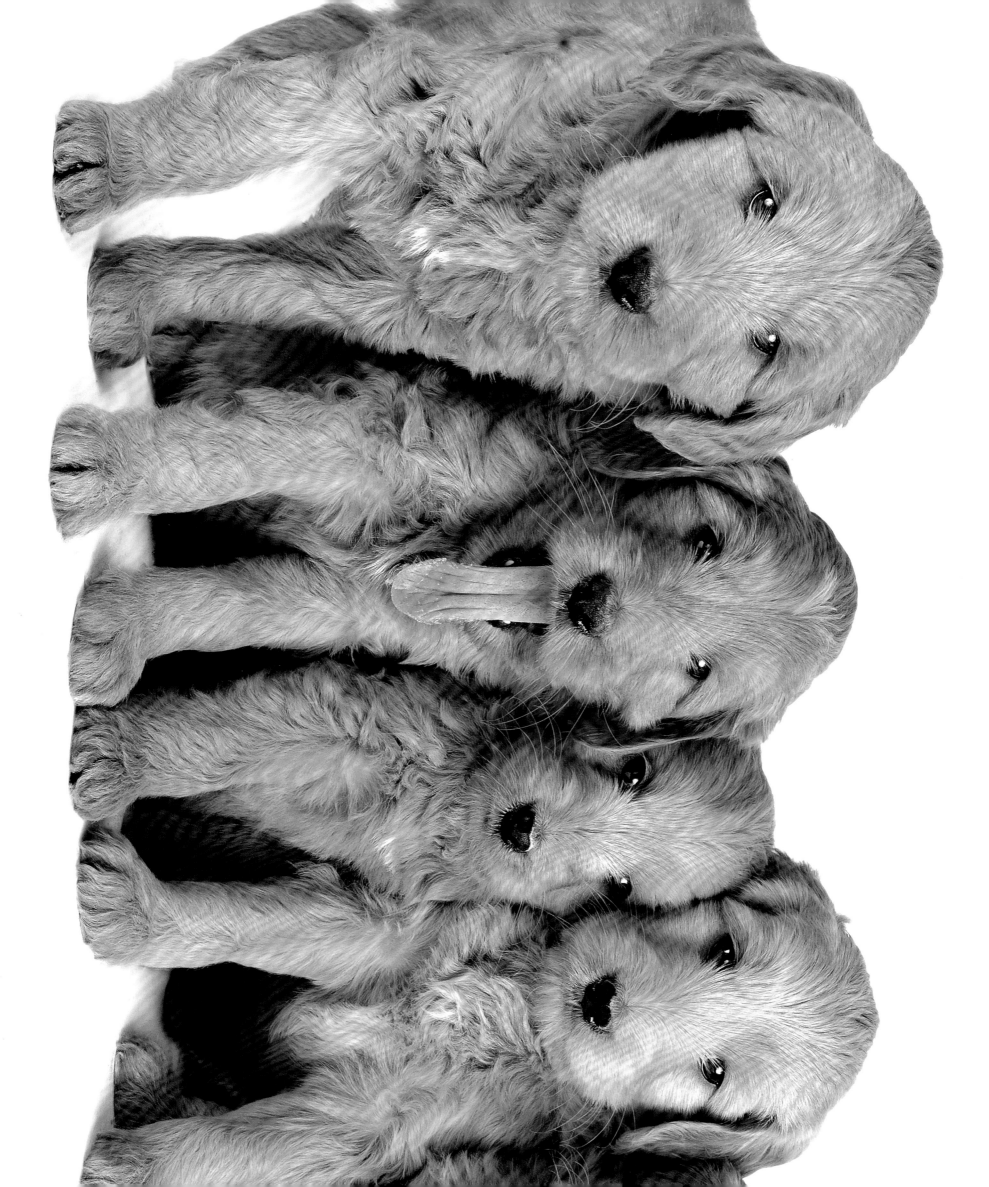

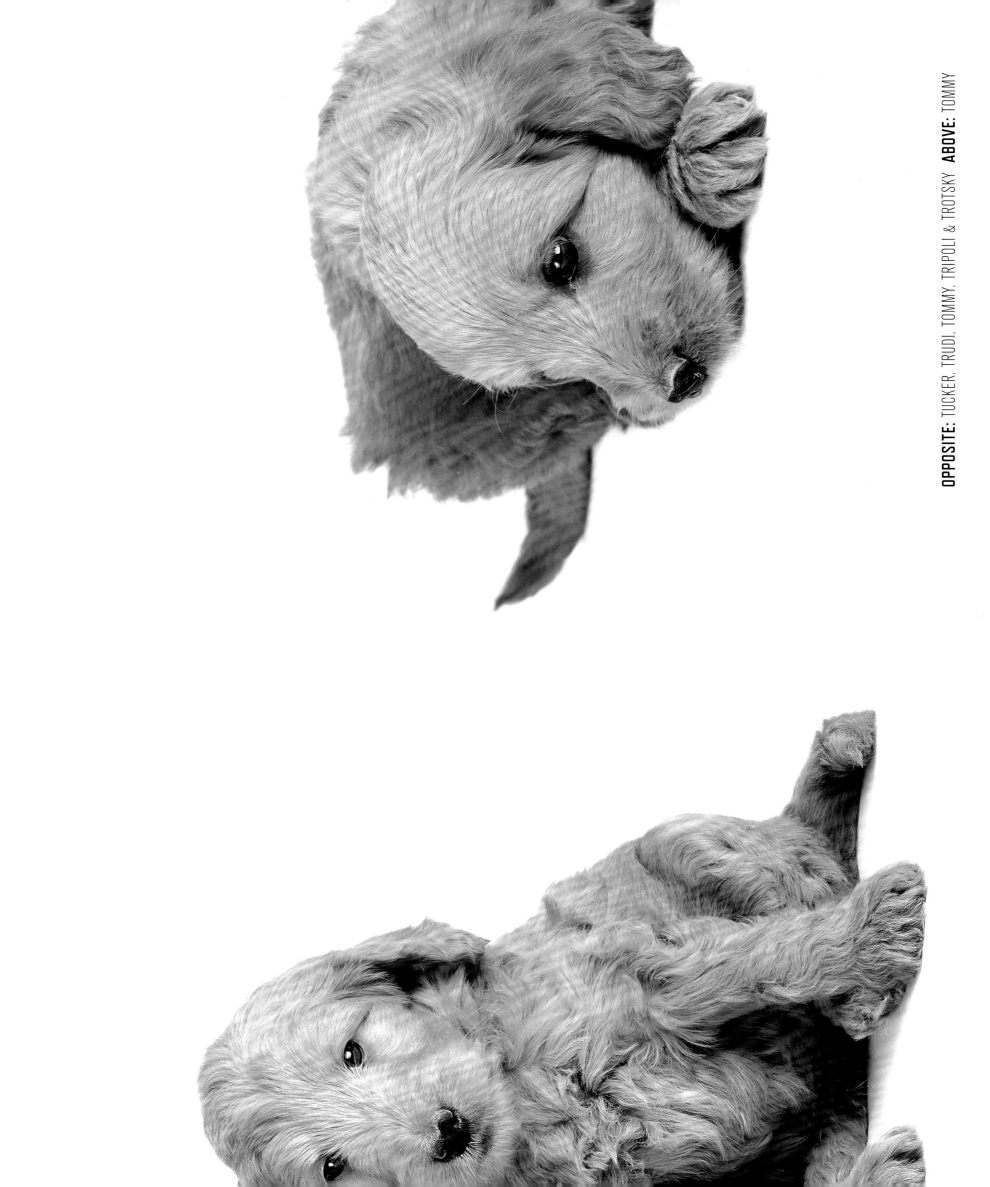

OPPOSITE: TUCKER, TRUDI, TOMMY, TOMMY, TRIPOLI, TRIPOLI & TROTSKY **ABOVE:** TOMMY

BAILY

LHASA APSO / 3 LBS

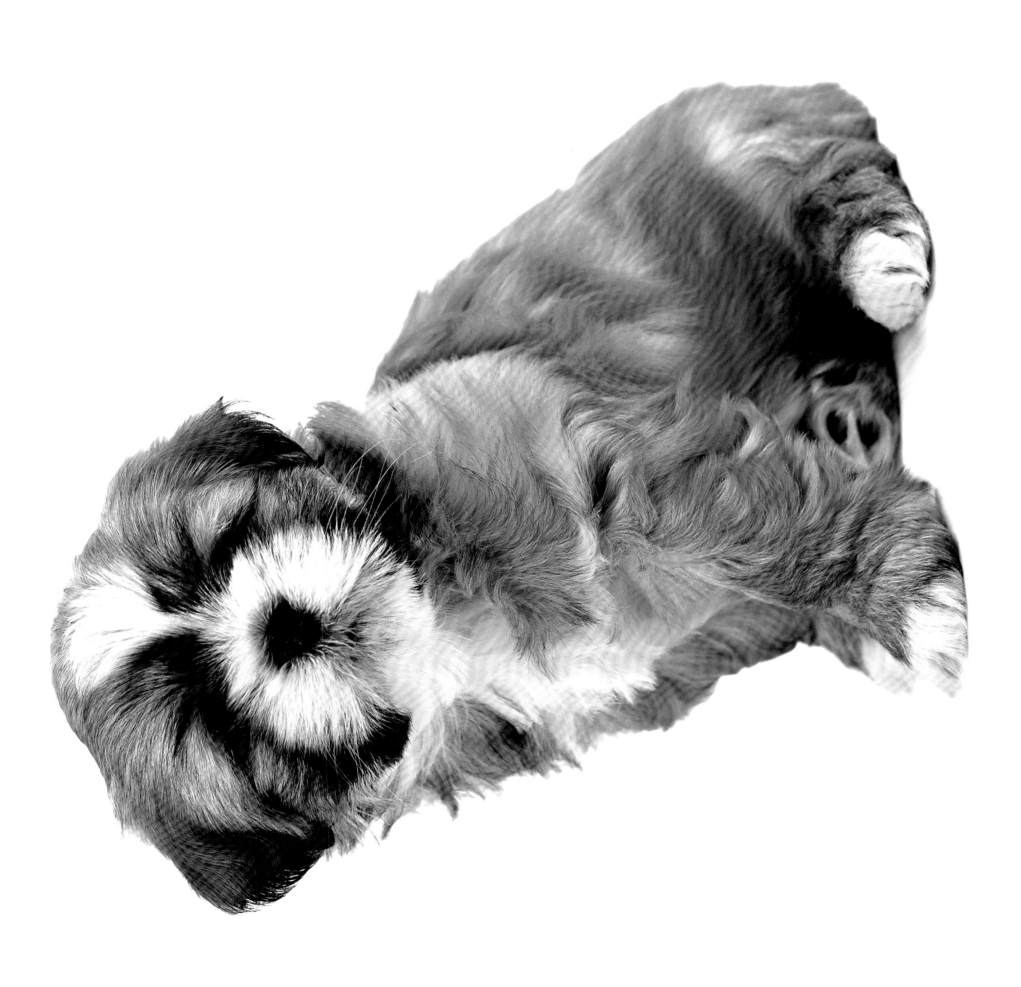

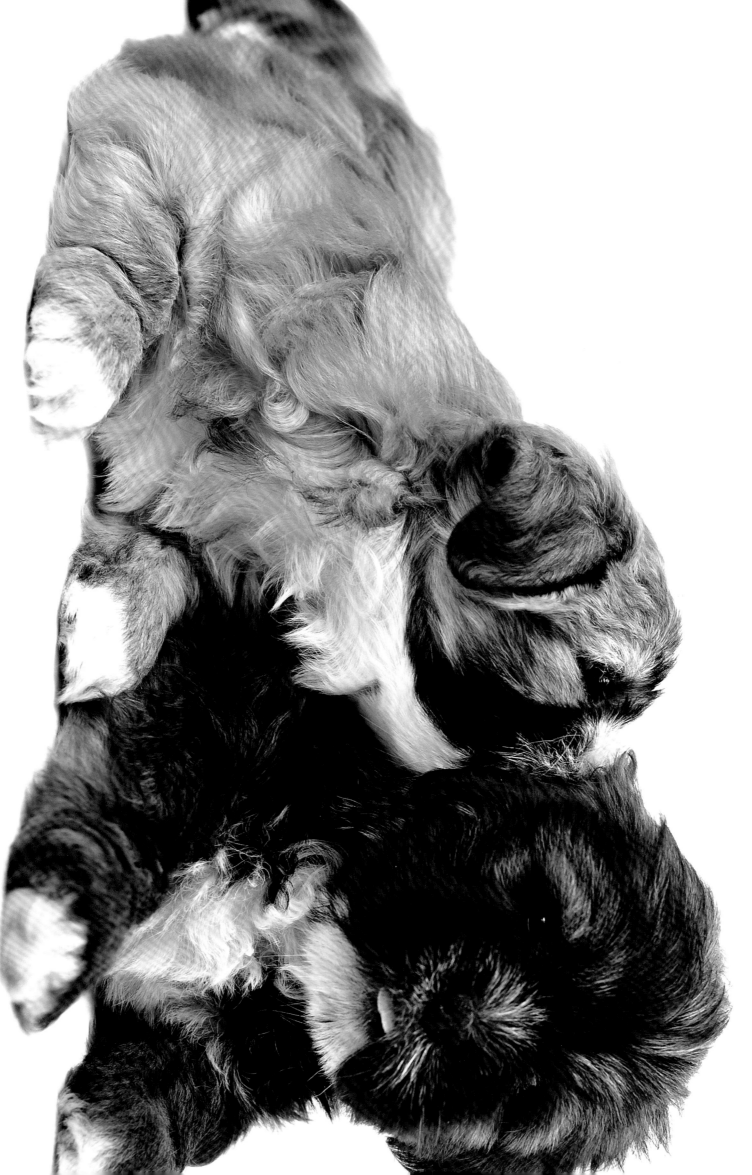

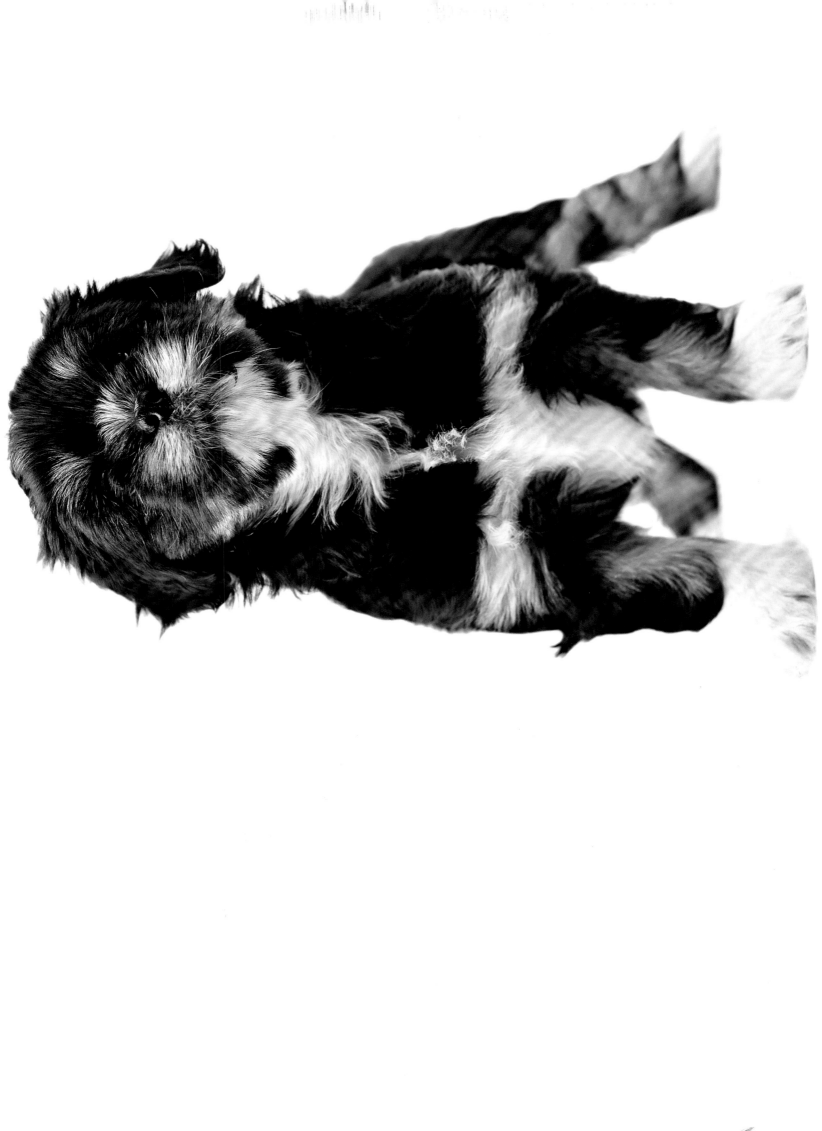

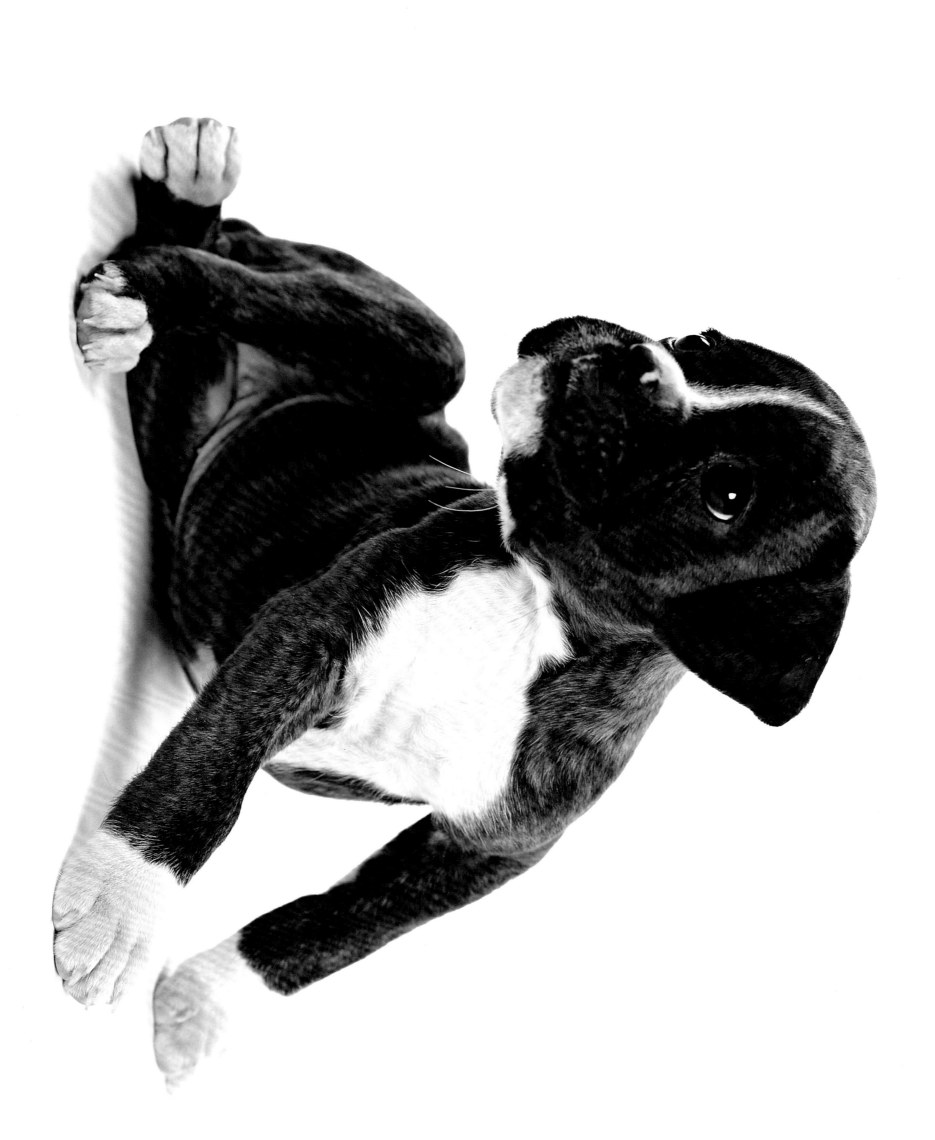

KORAL
BOXER / 5.6 LBS

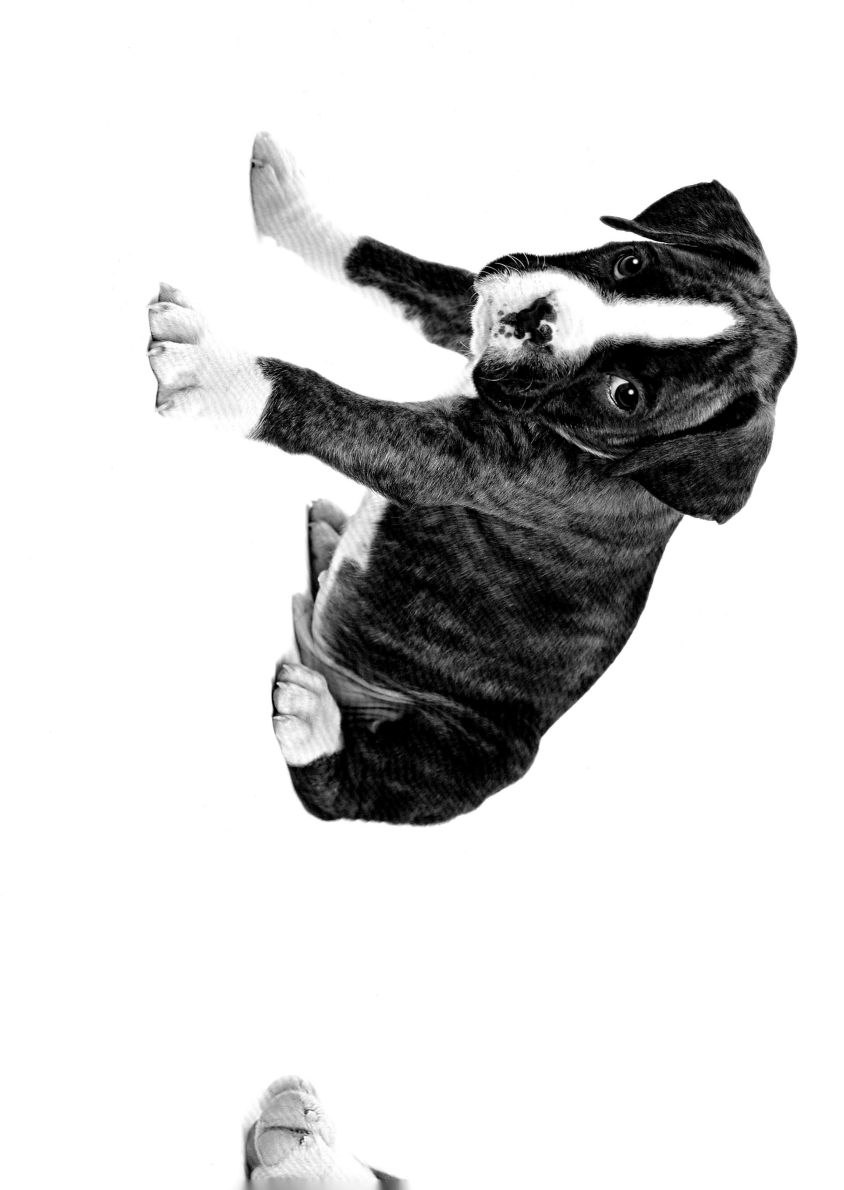

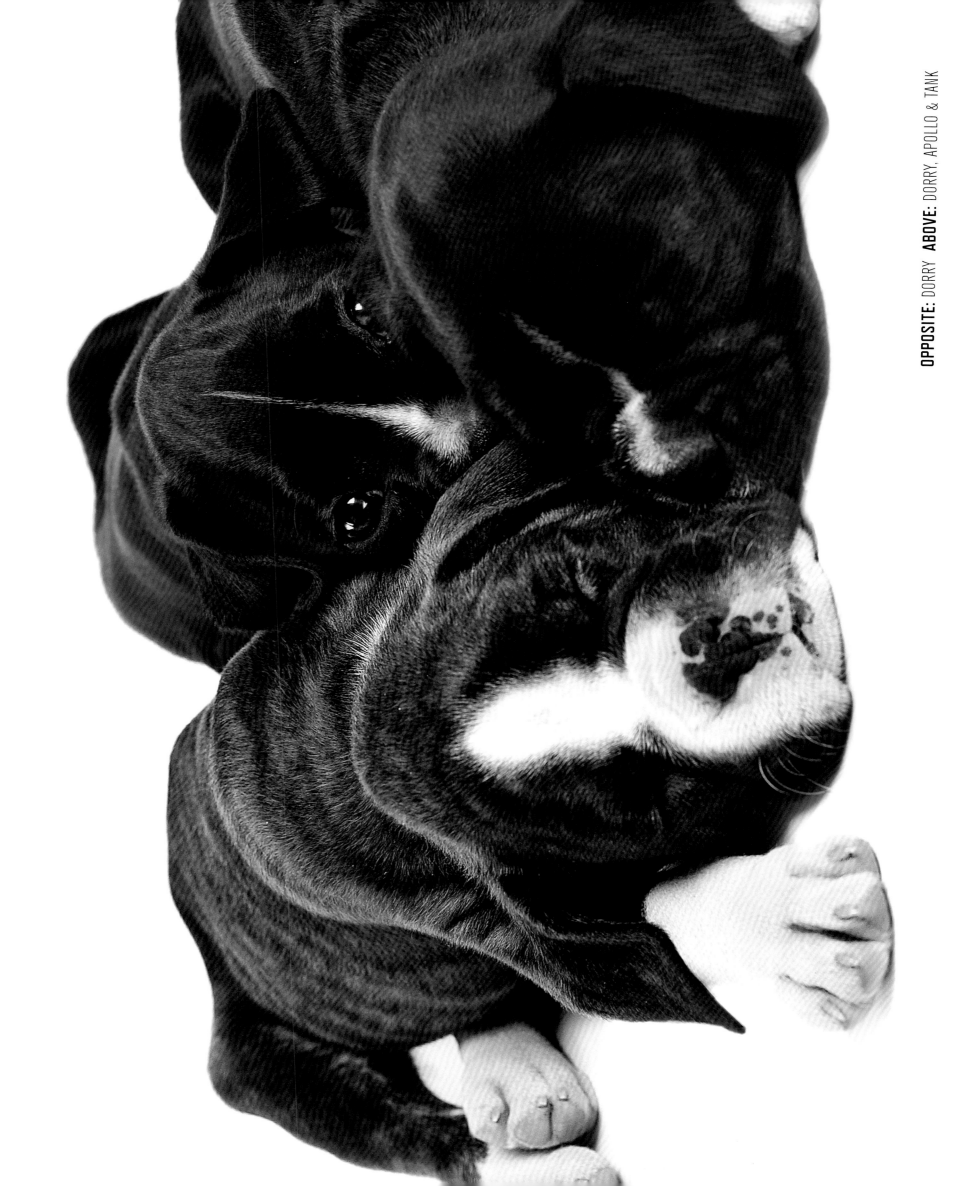

ARCHIE

DACHSHUND / 3.5 LBS

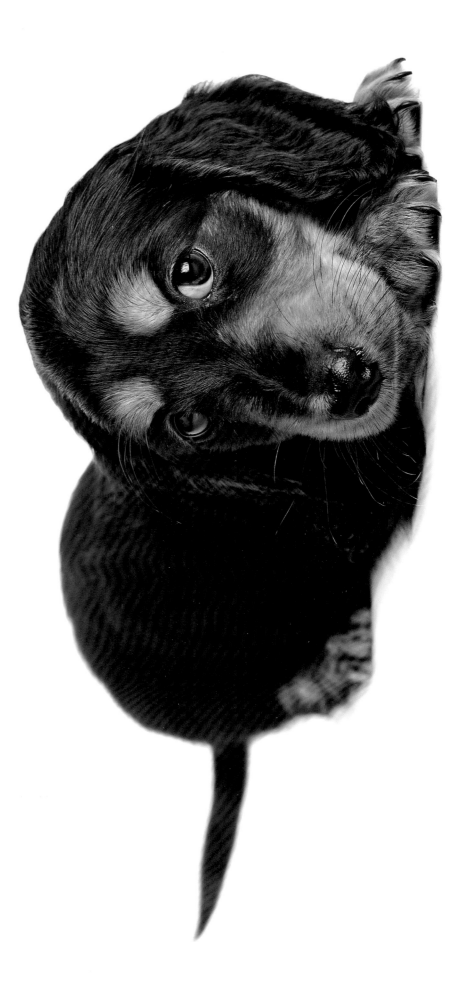

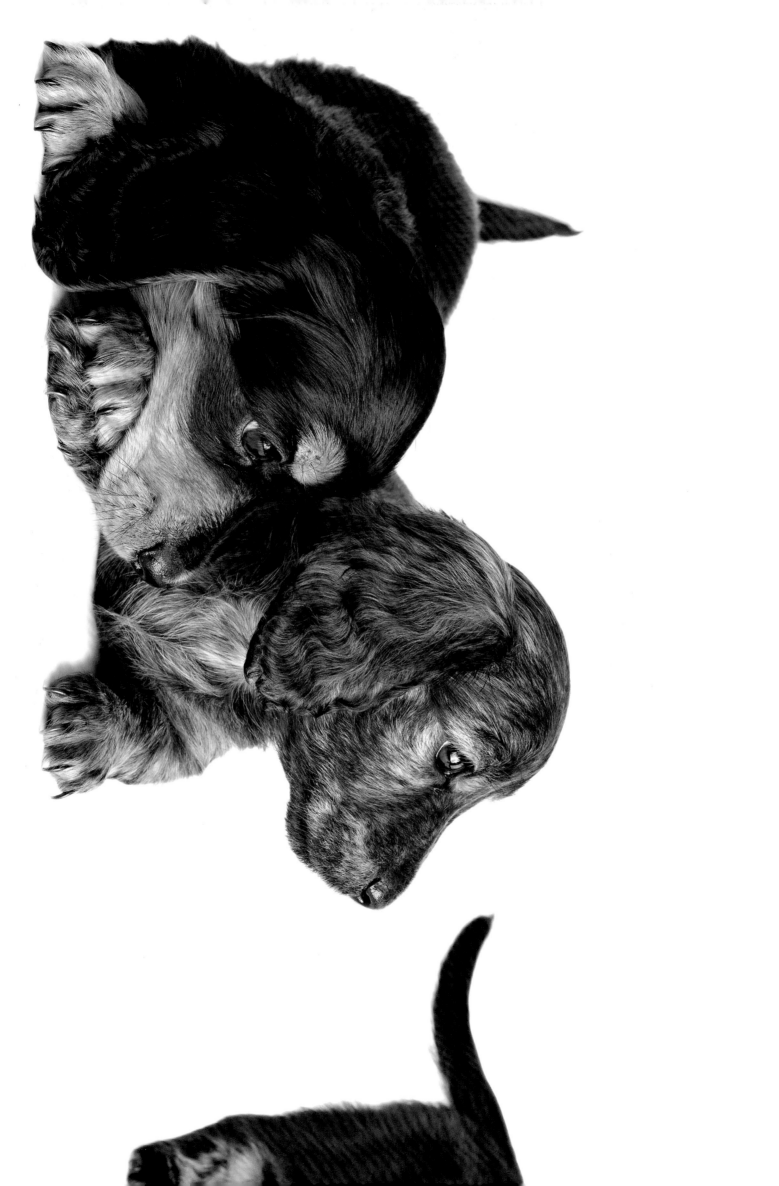

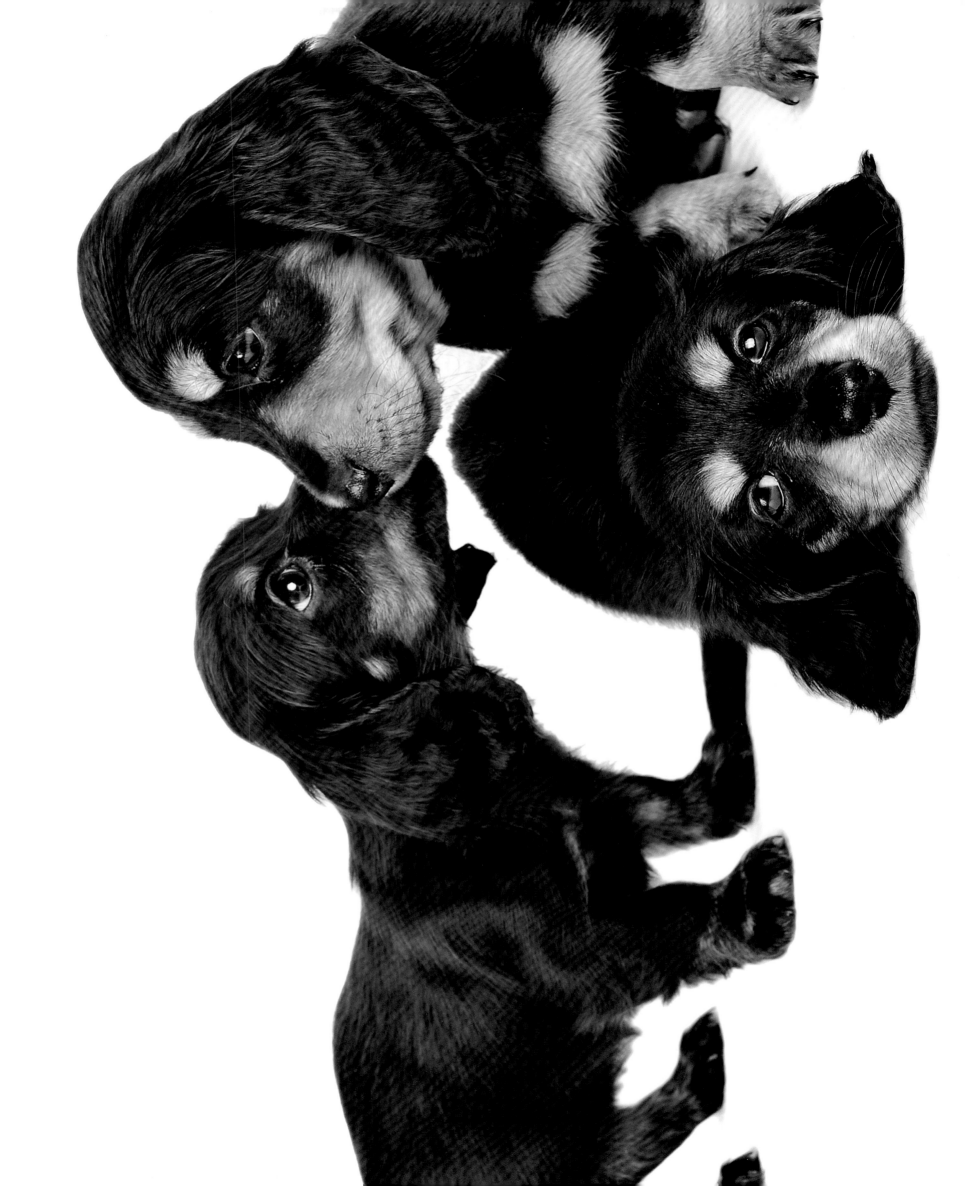

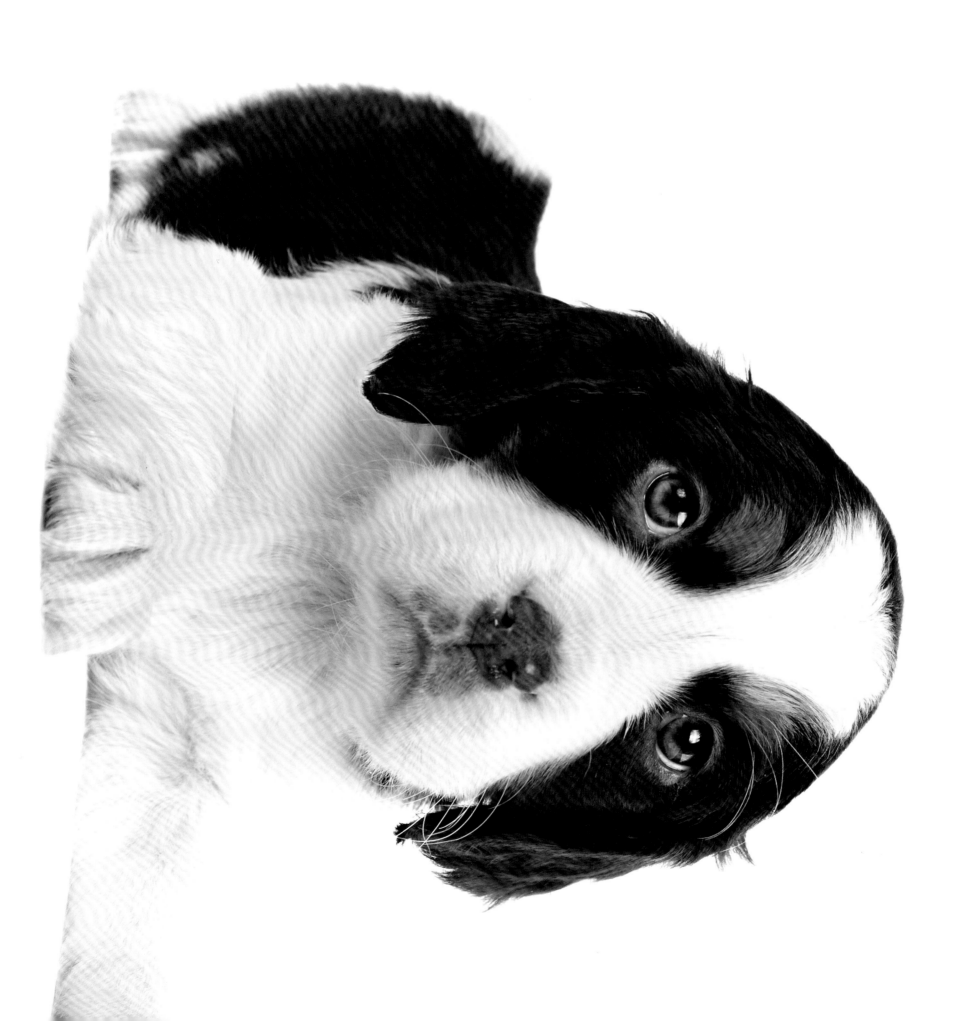

DAISY | ENGLISH SPRINGER SPANIEL / 3.4 LBS

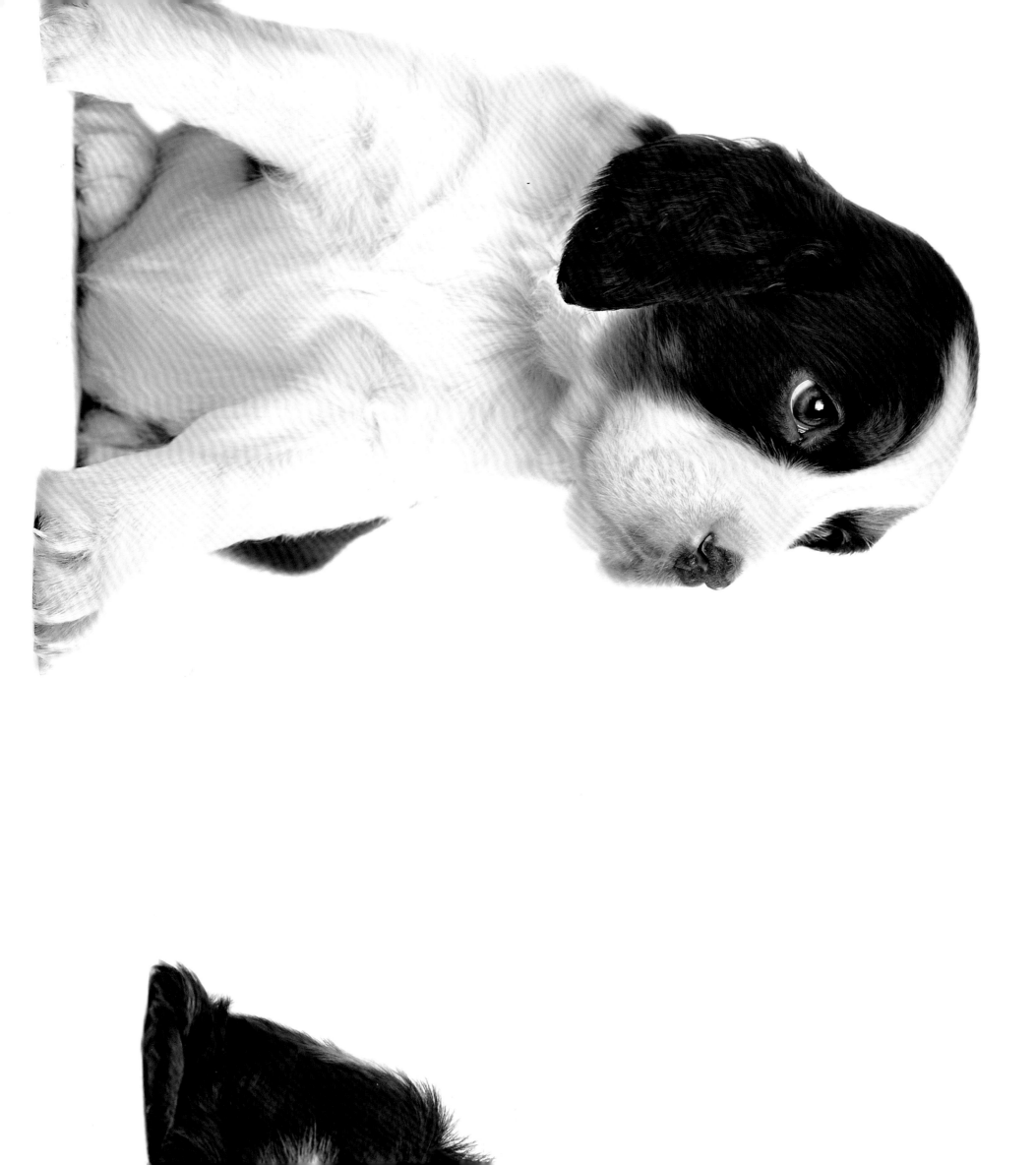

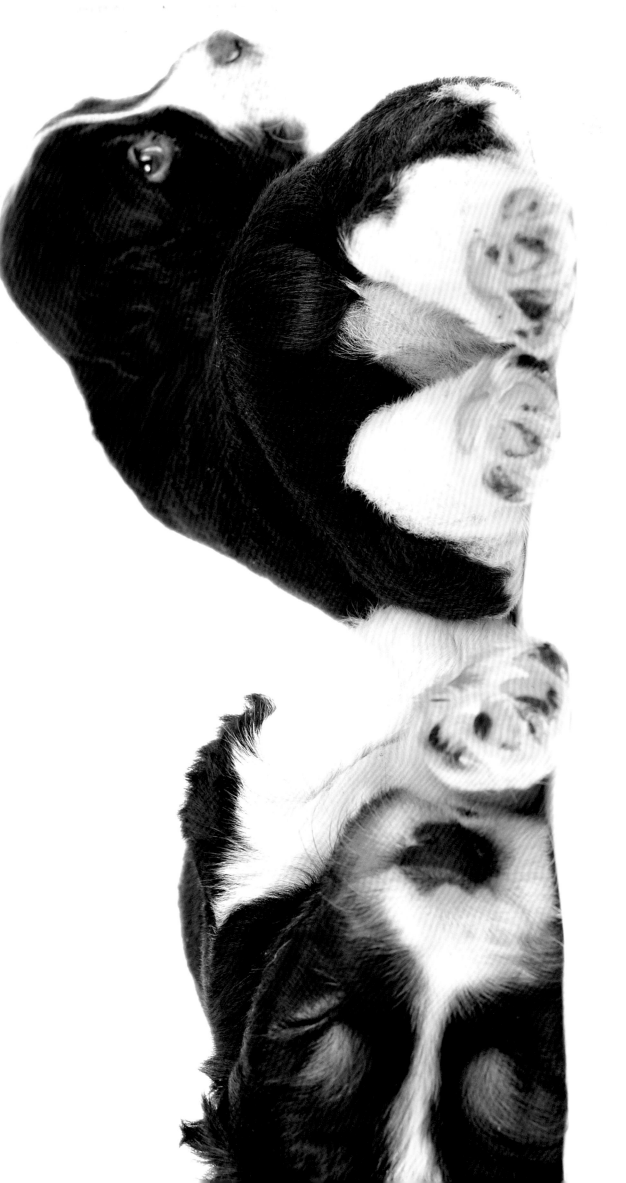

STELLA

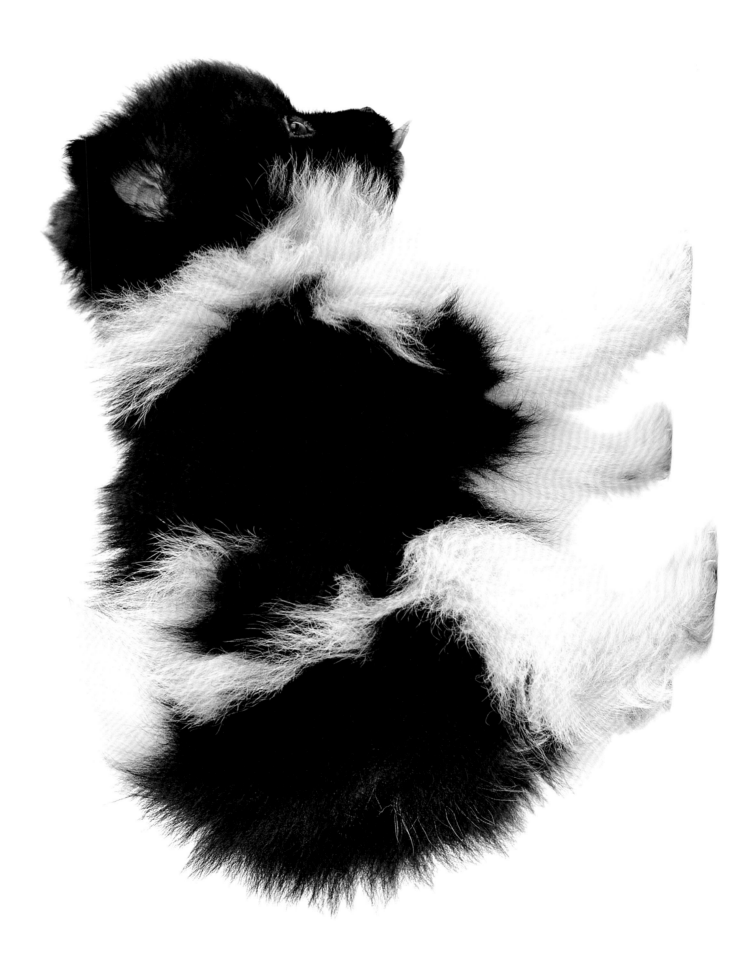

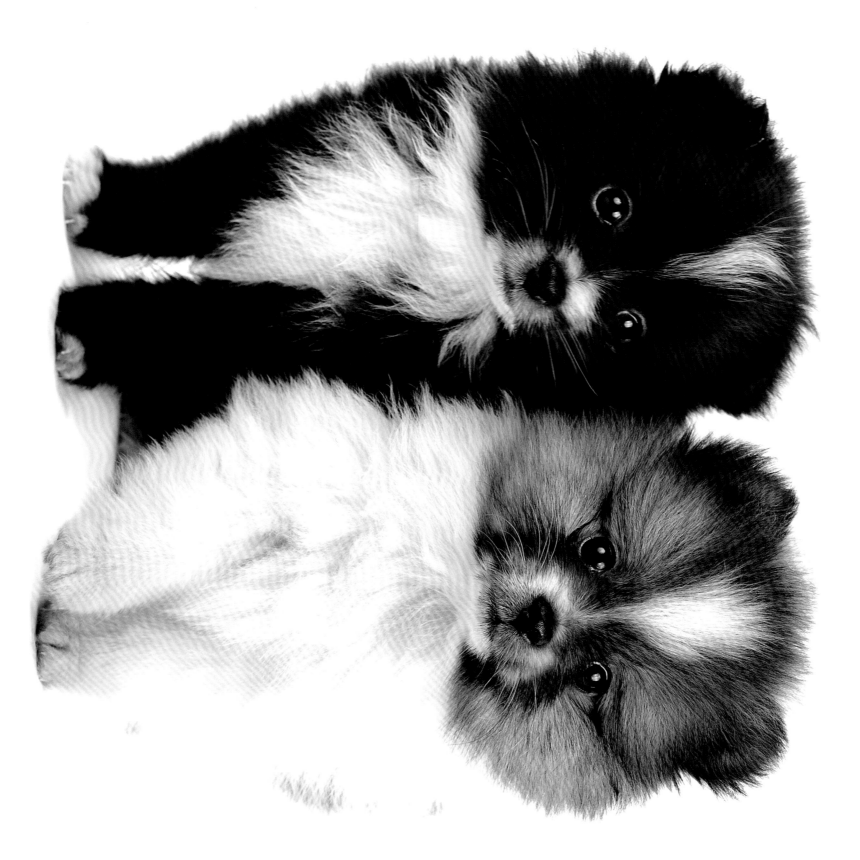

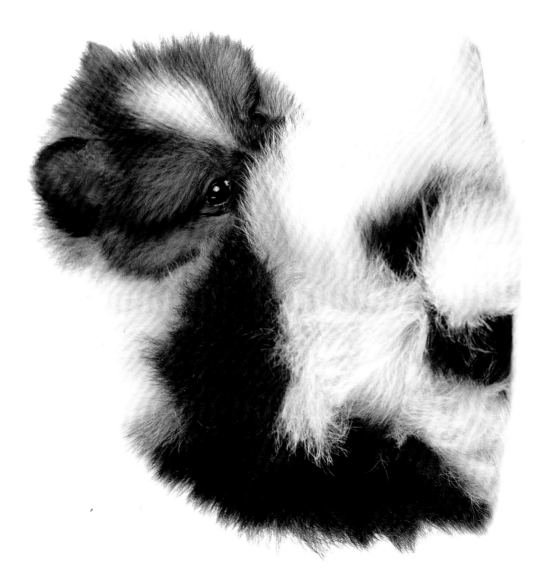

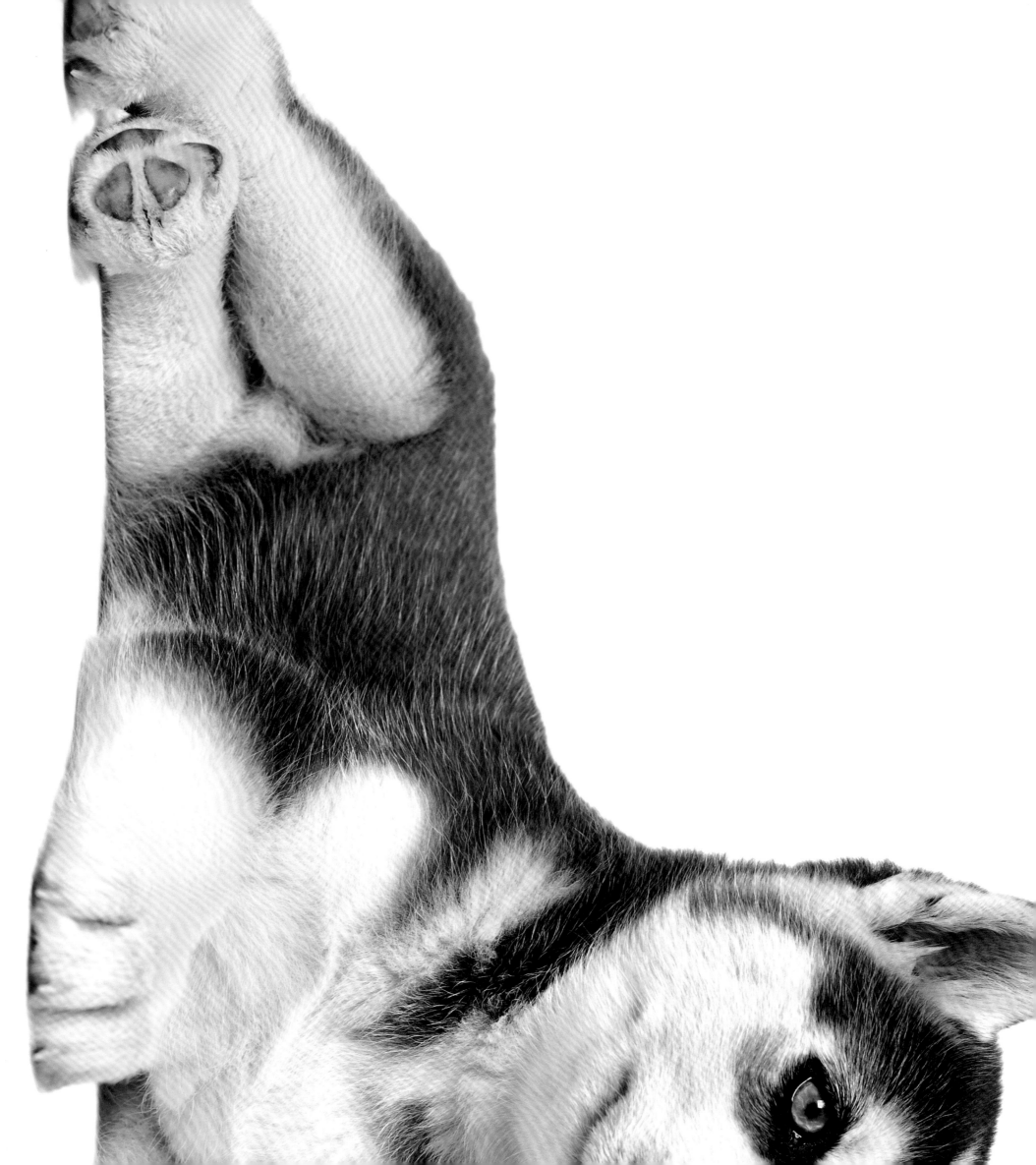

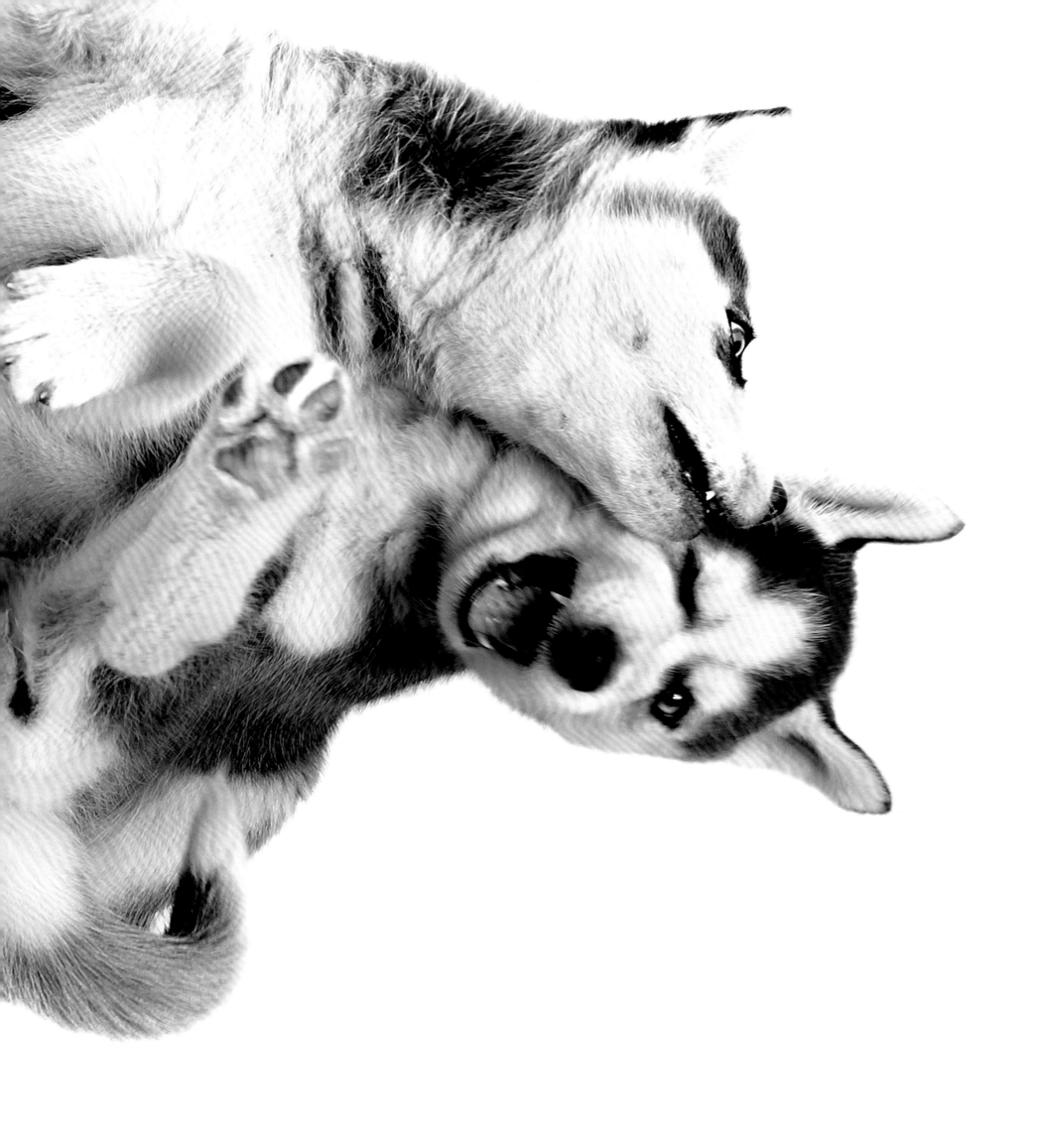

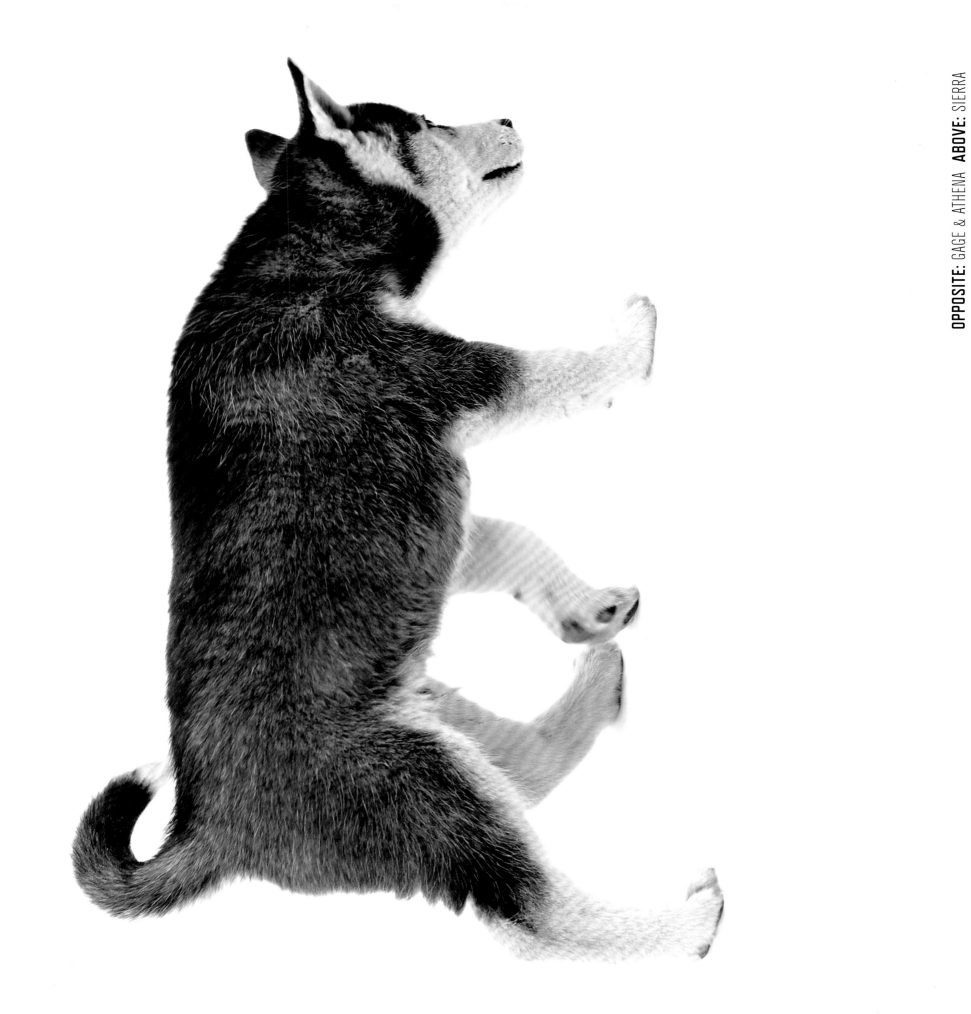

BONITA

YORKSHIRE TERRIER / 2.6 LBS

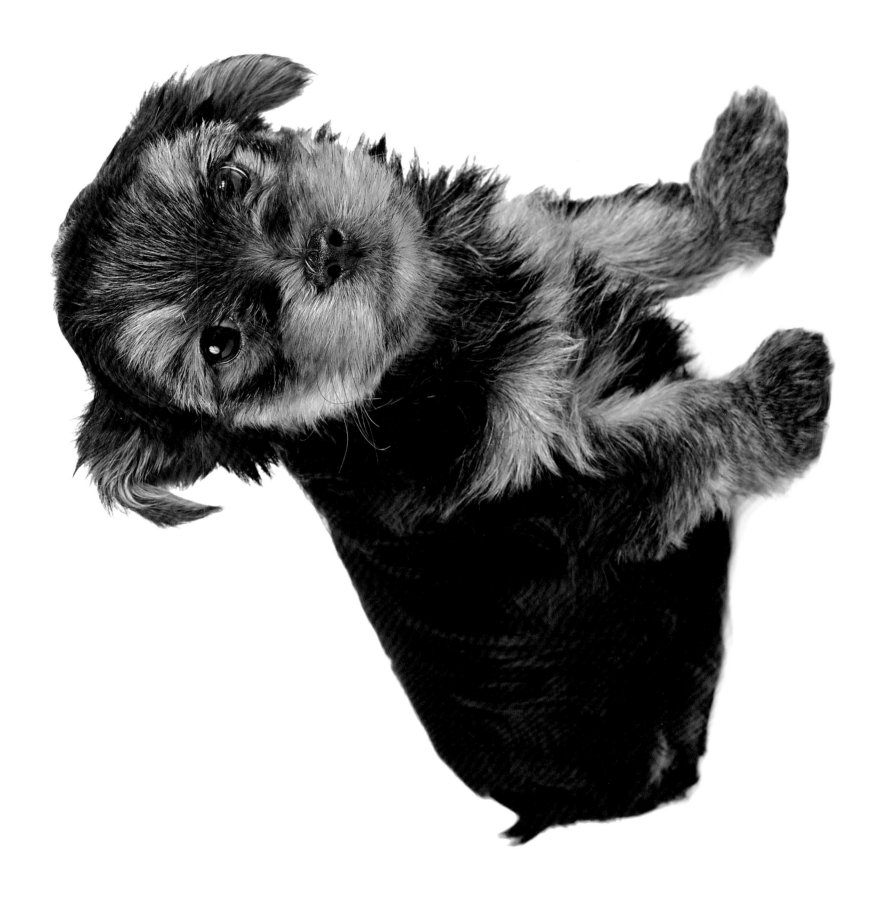

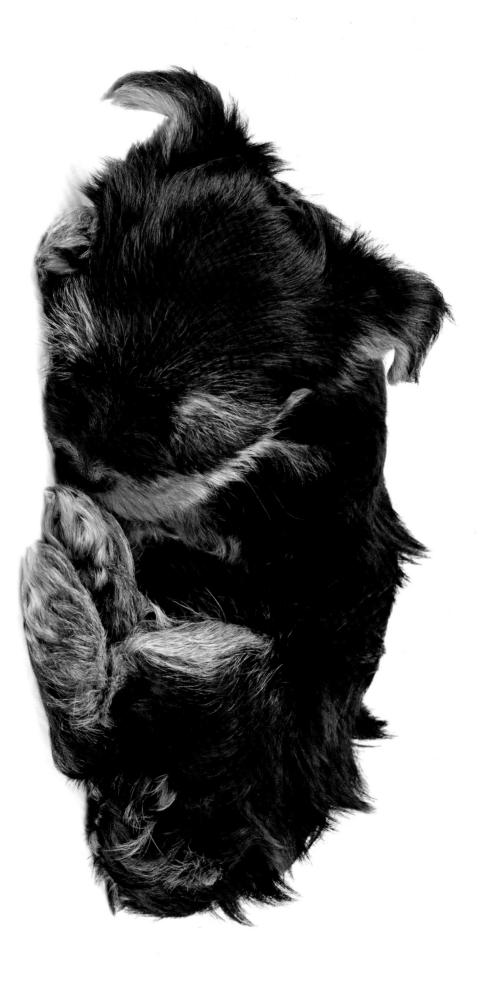

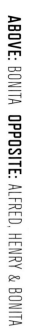

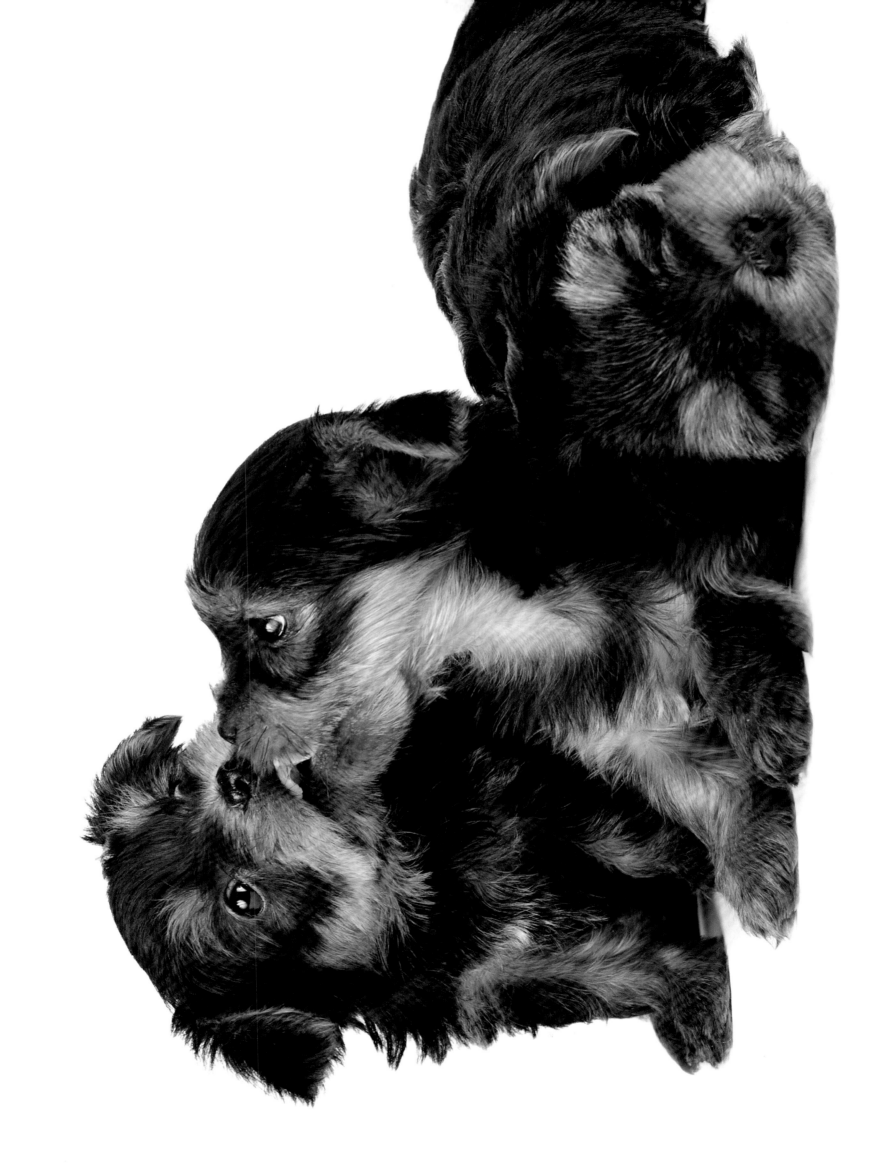

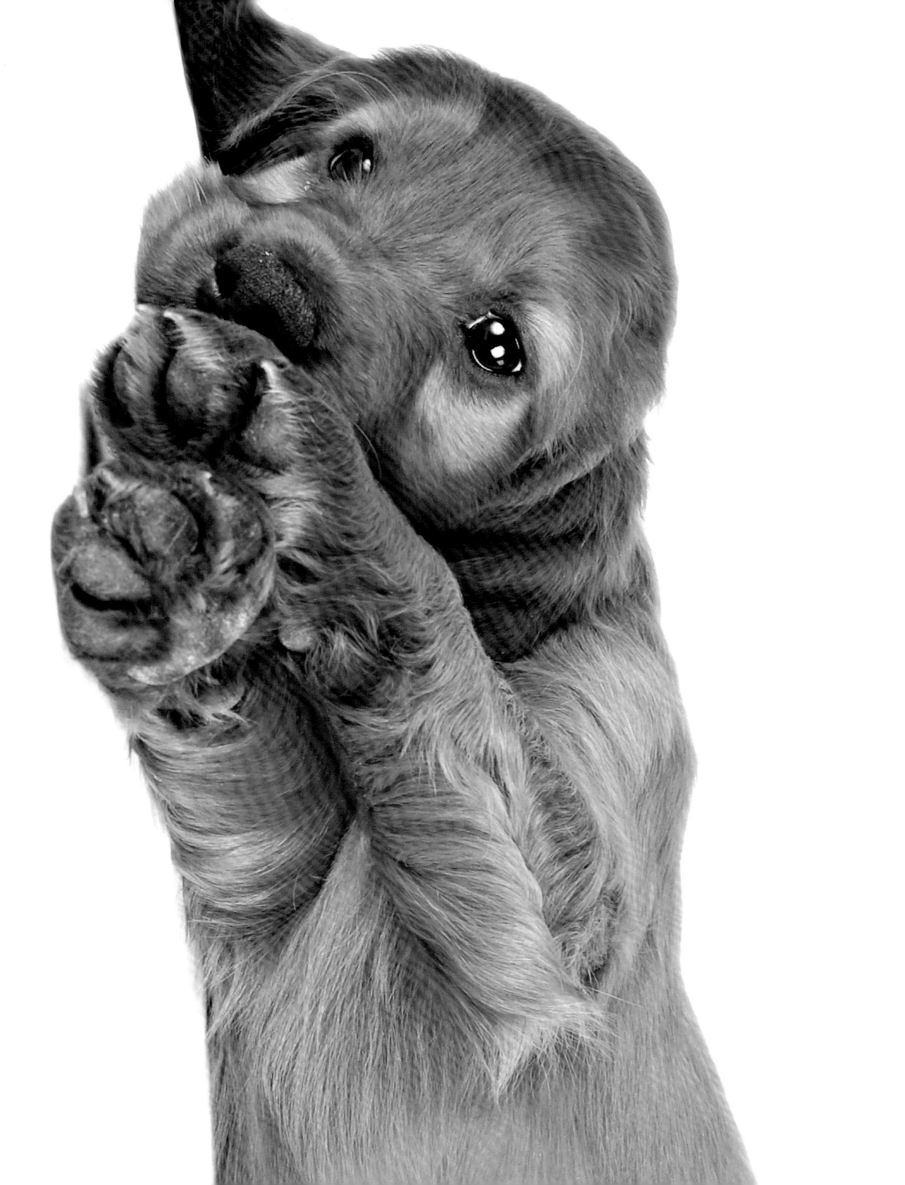

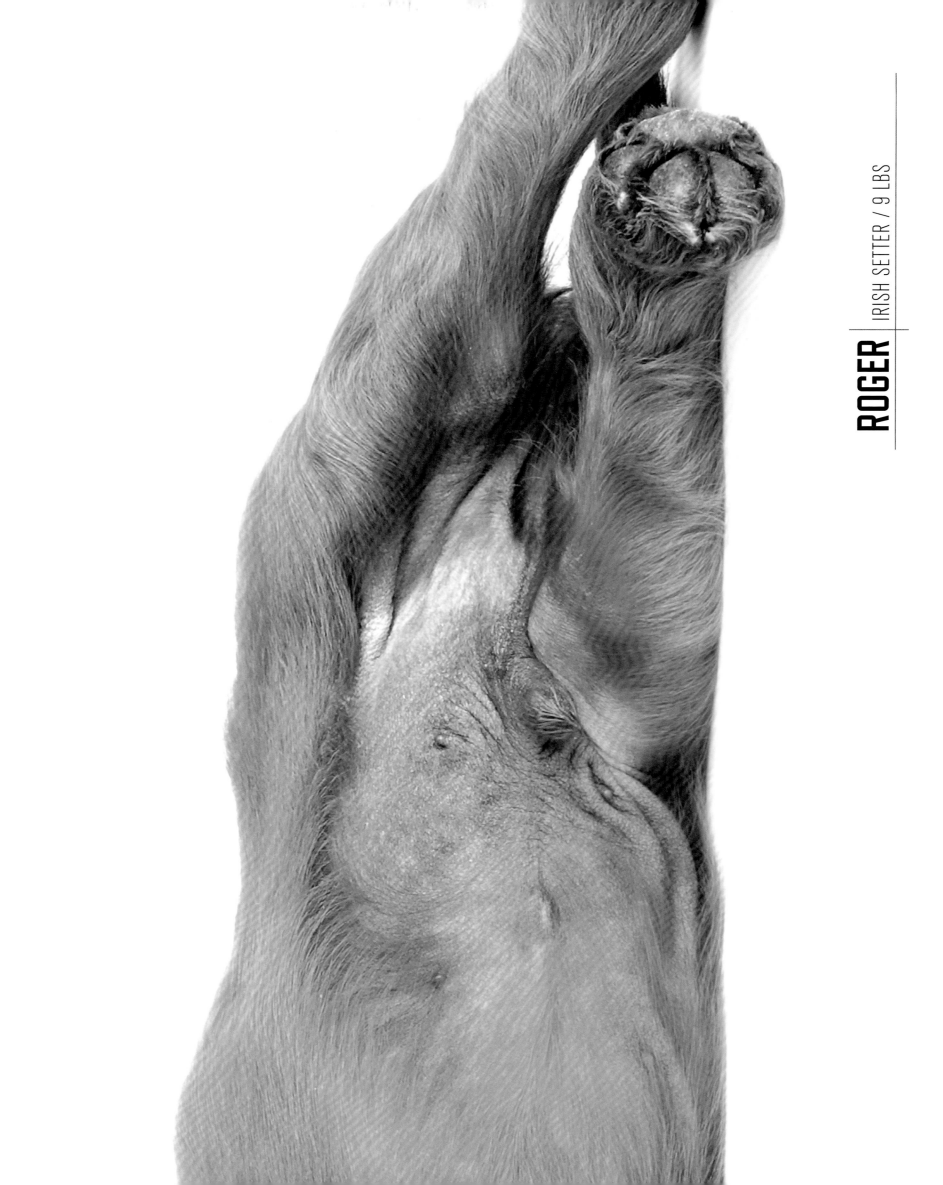

ROGER | IRISH SETTER / 9 LBS

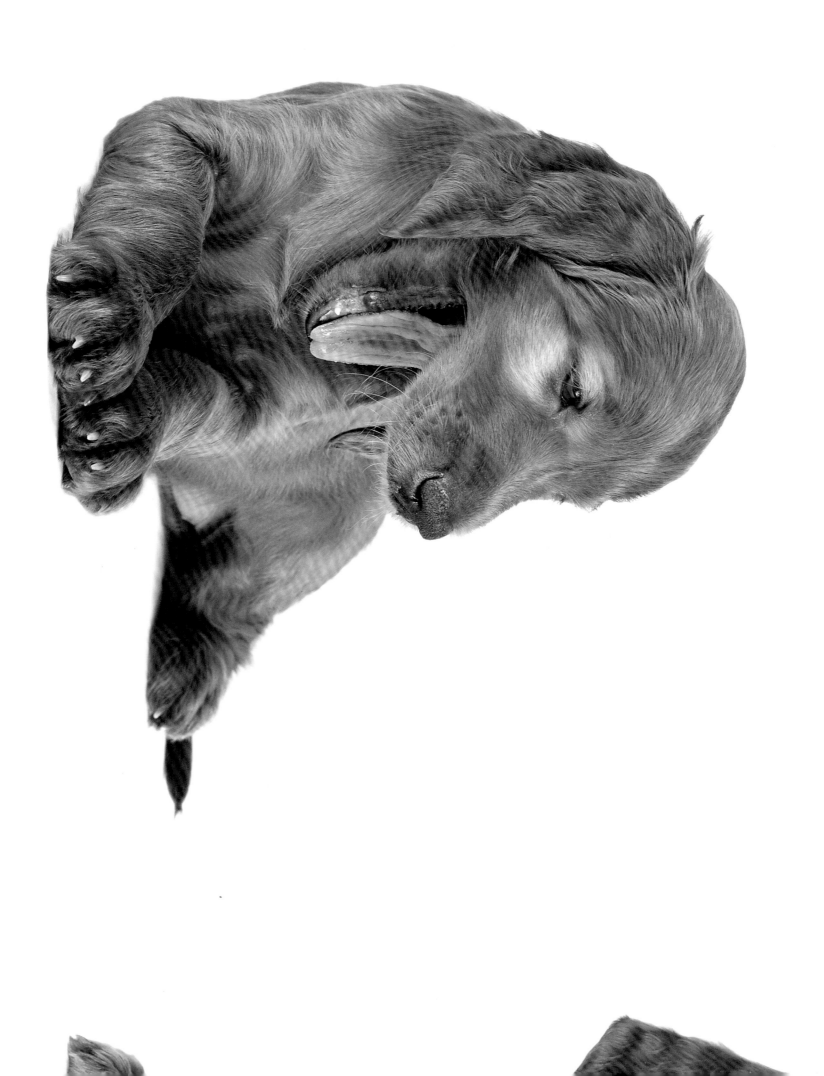

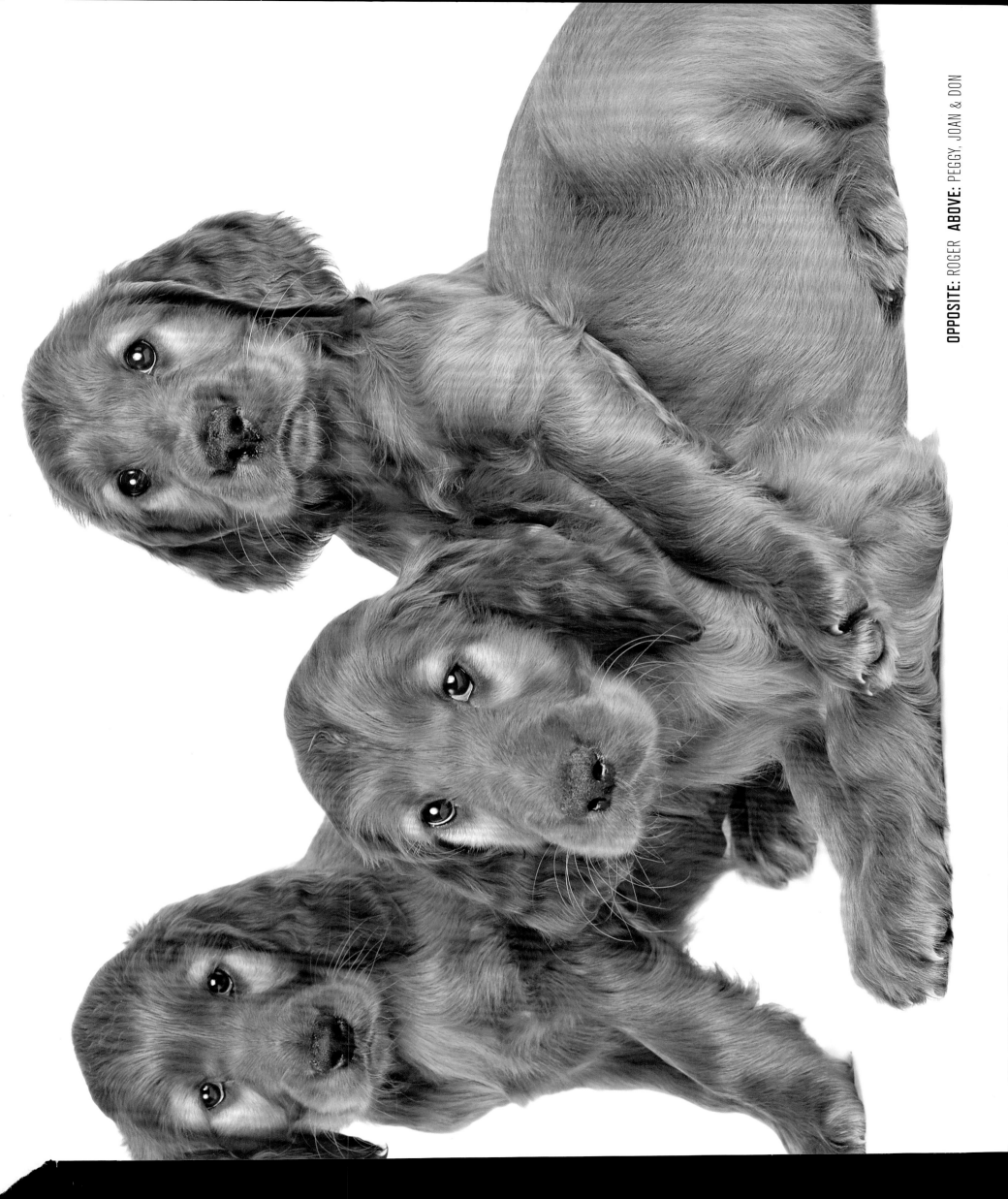

OPPOSITE: ROGER **ABOVE:** PEGGY, JOAN & DON

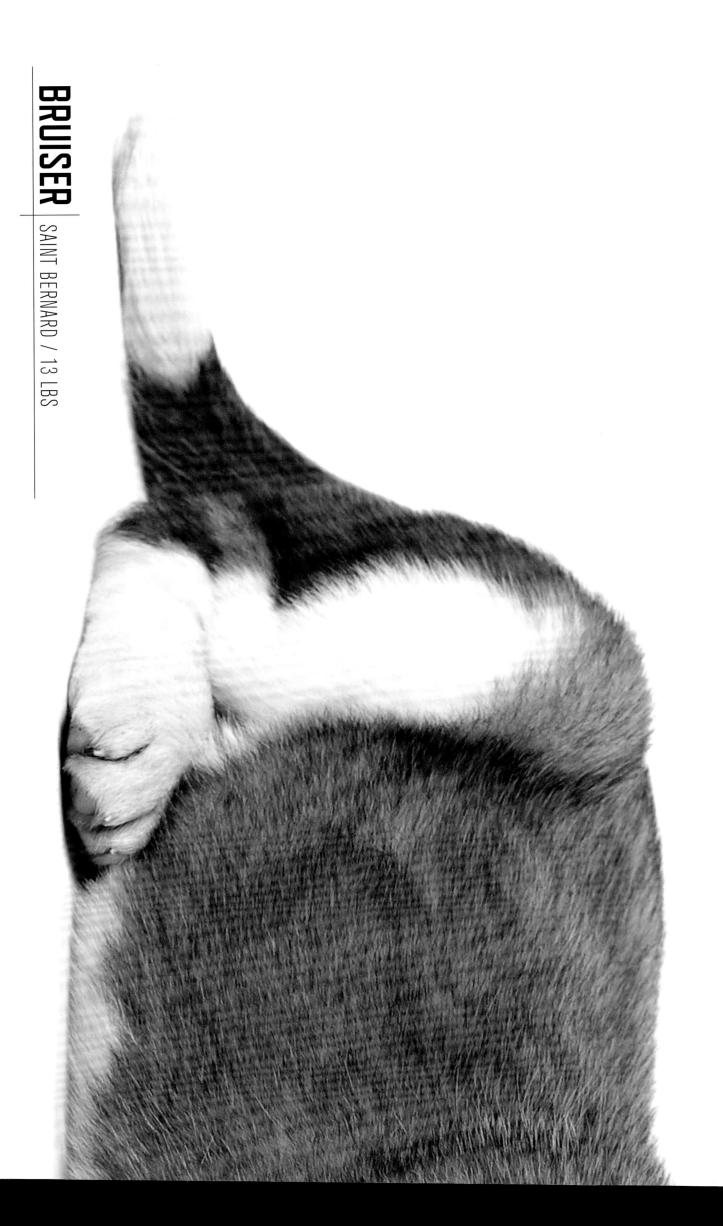

BRUISER

SAINT BERNARD / 13 LBS

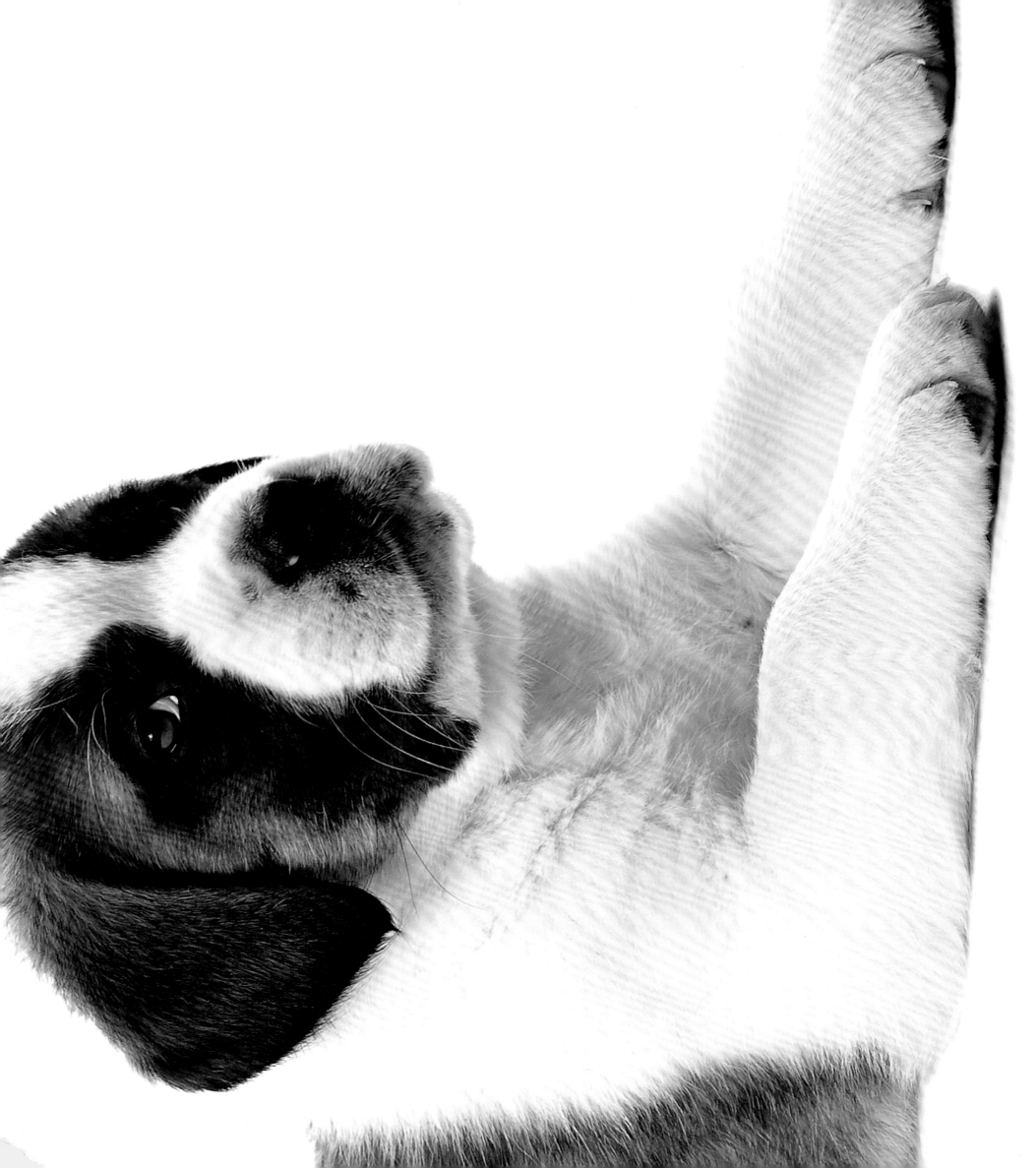

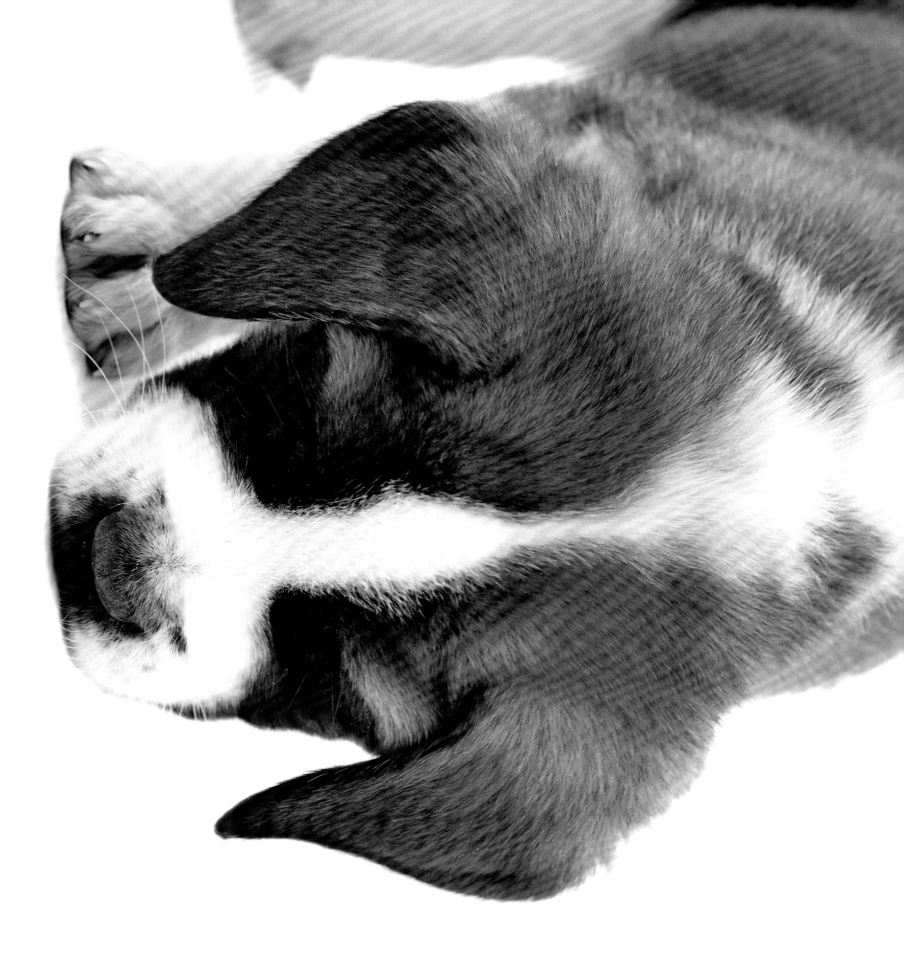

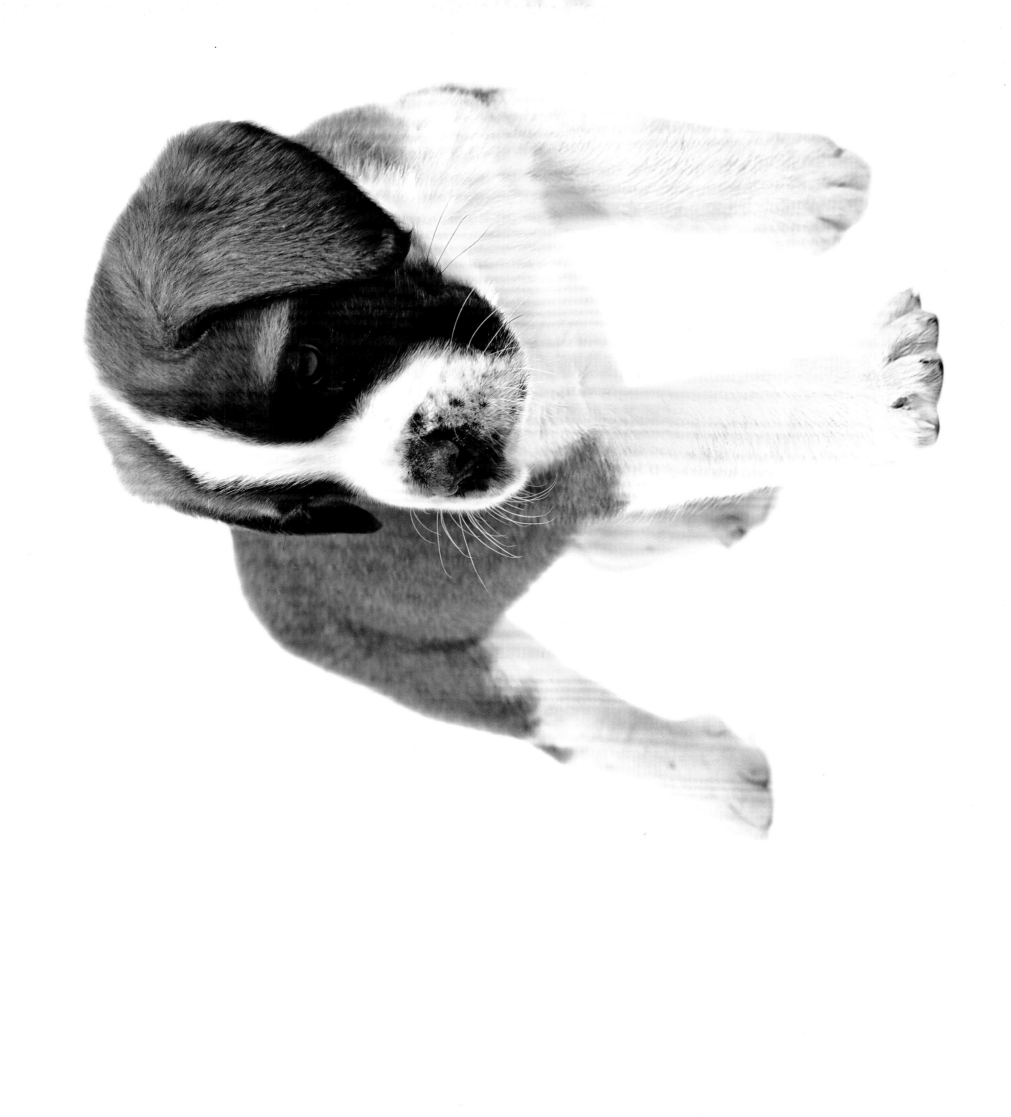

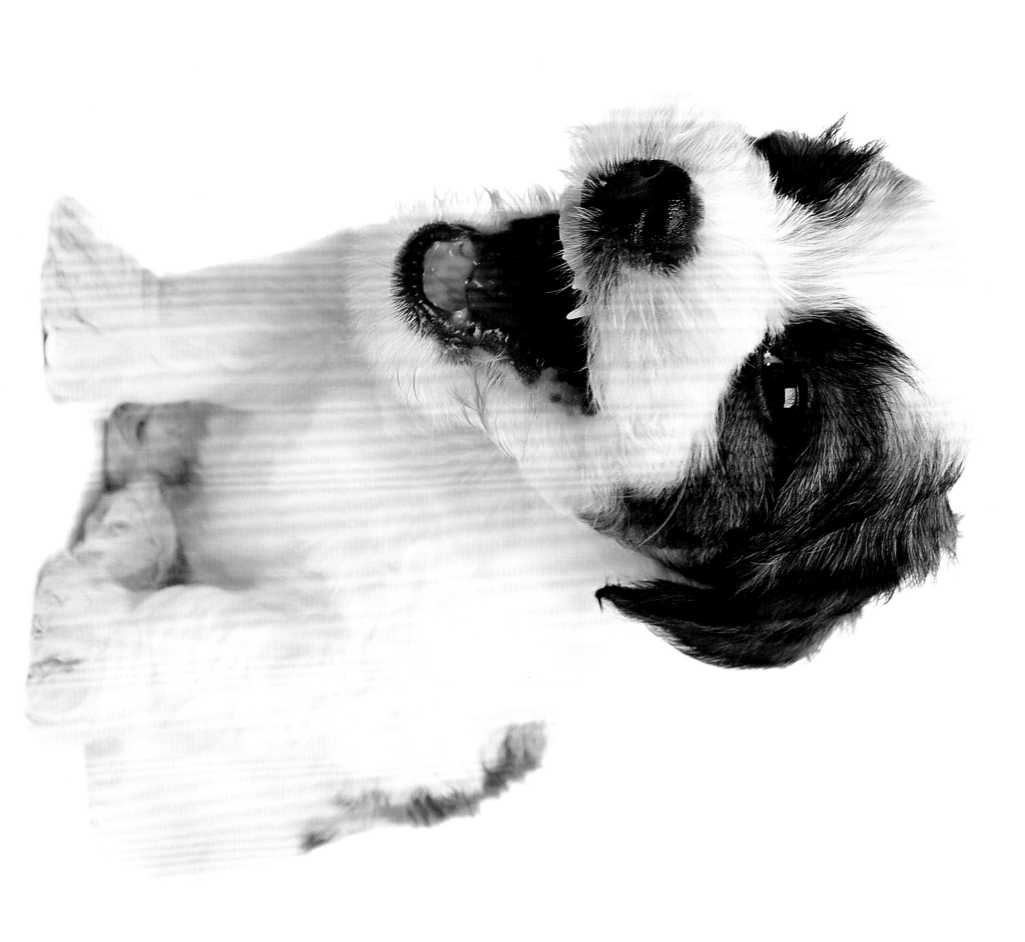

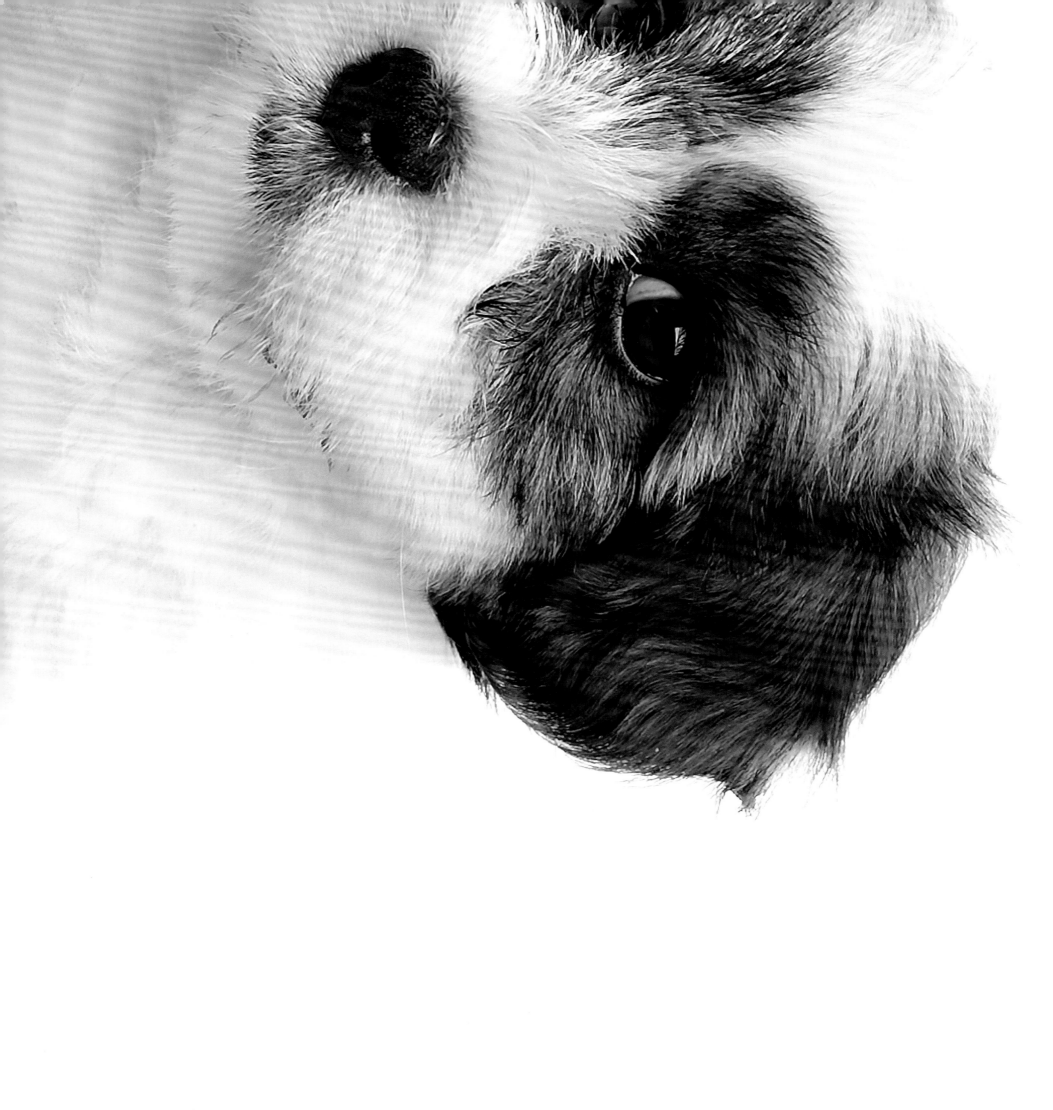

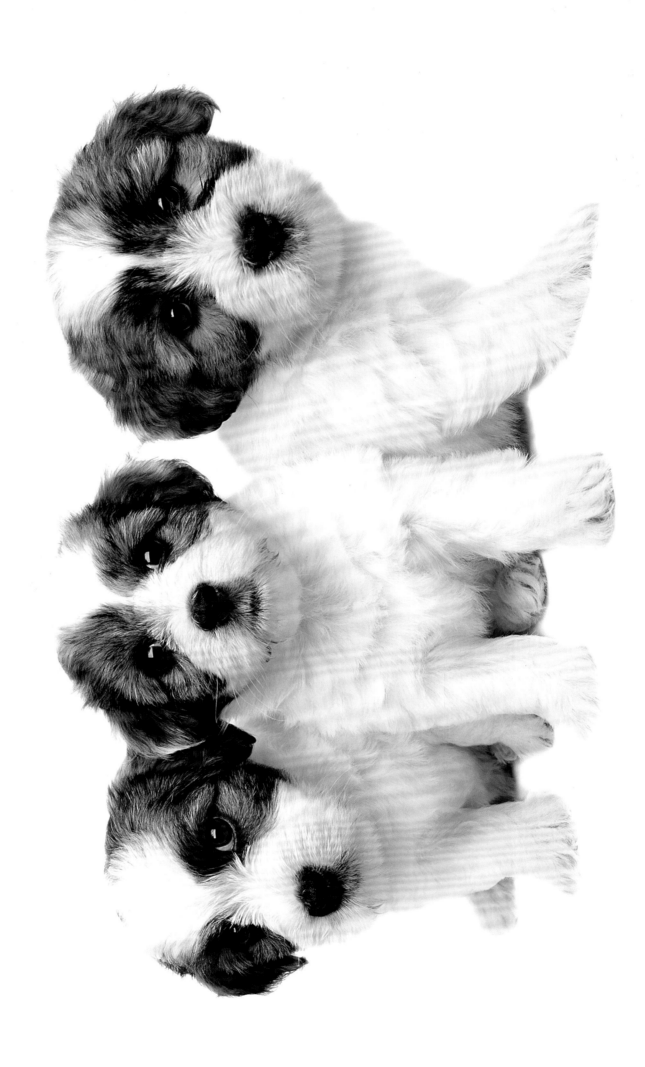

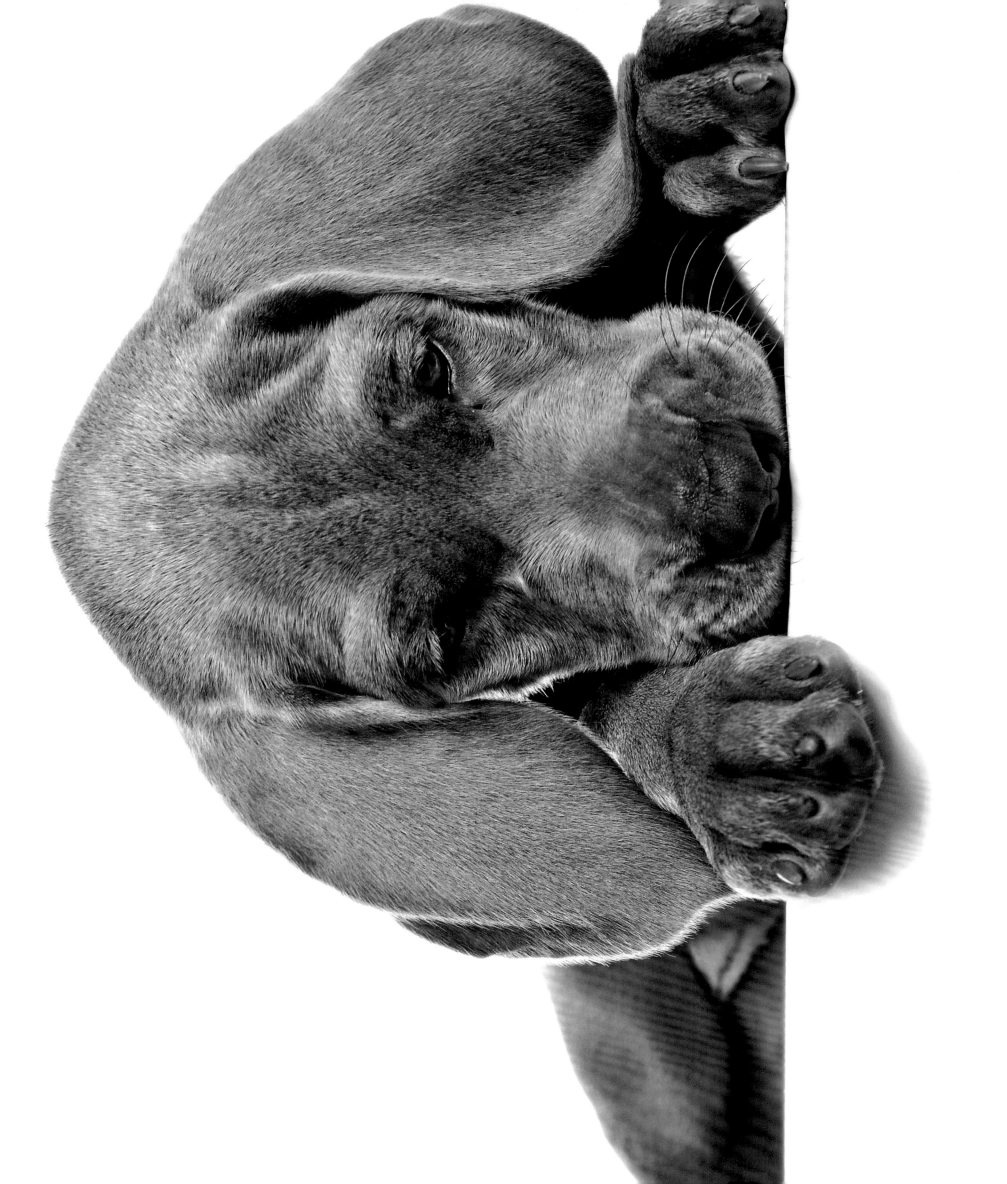

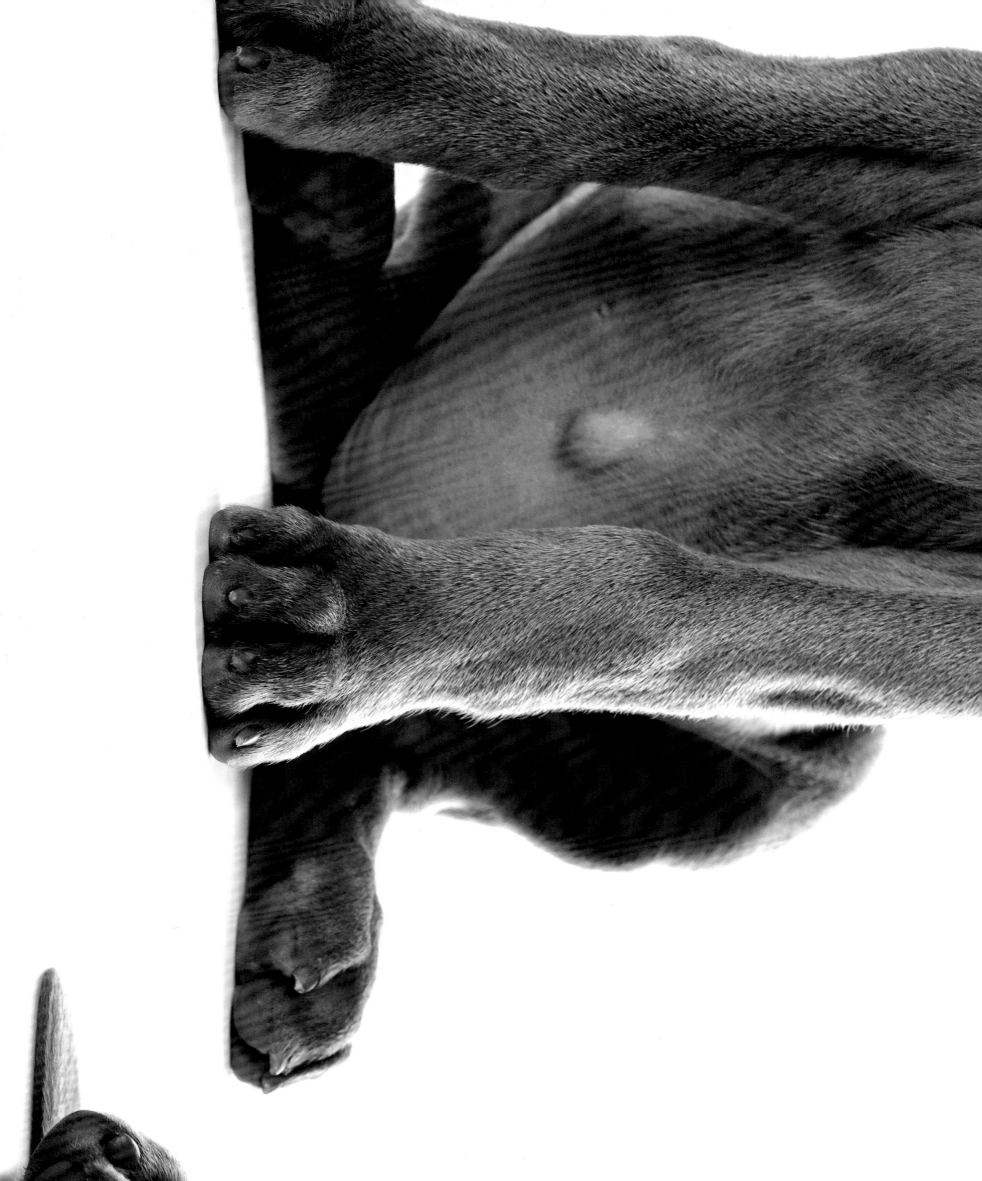

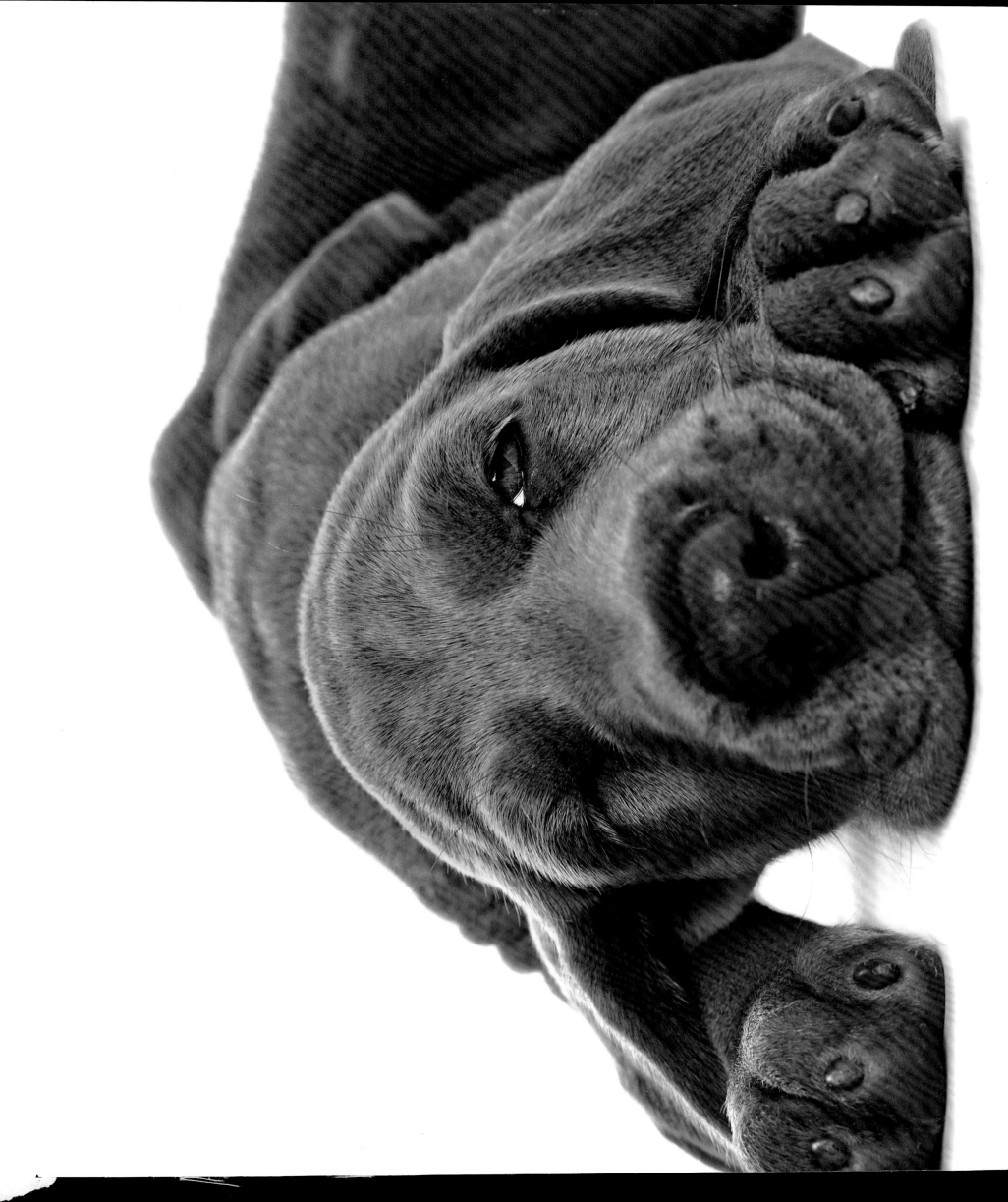

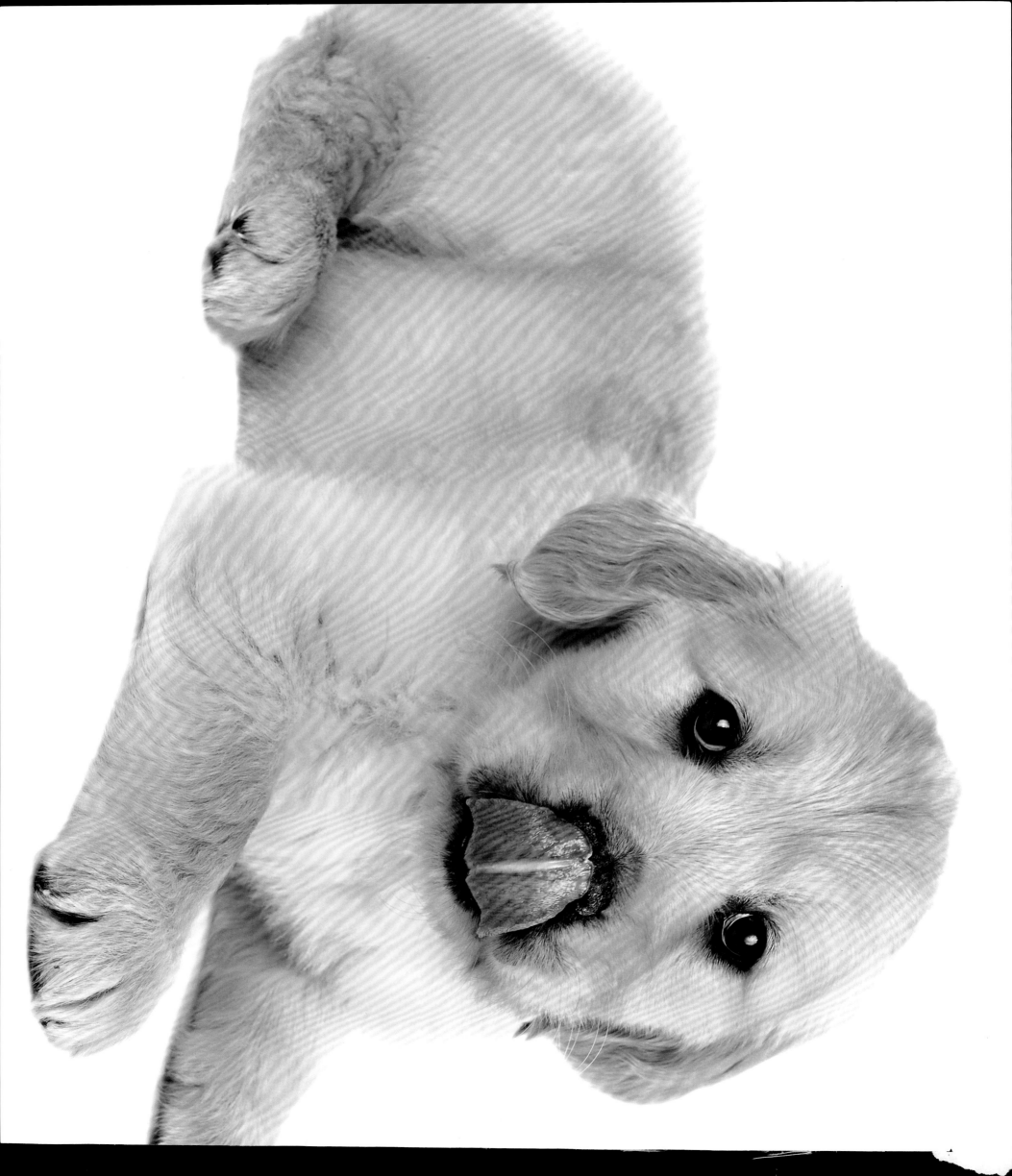

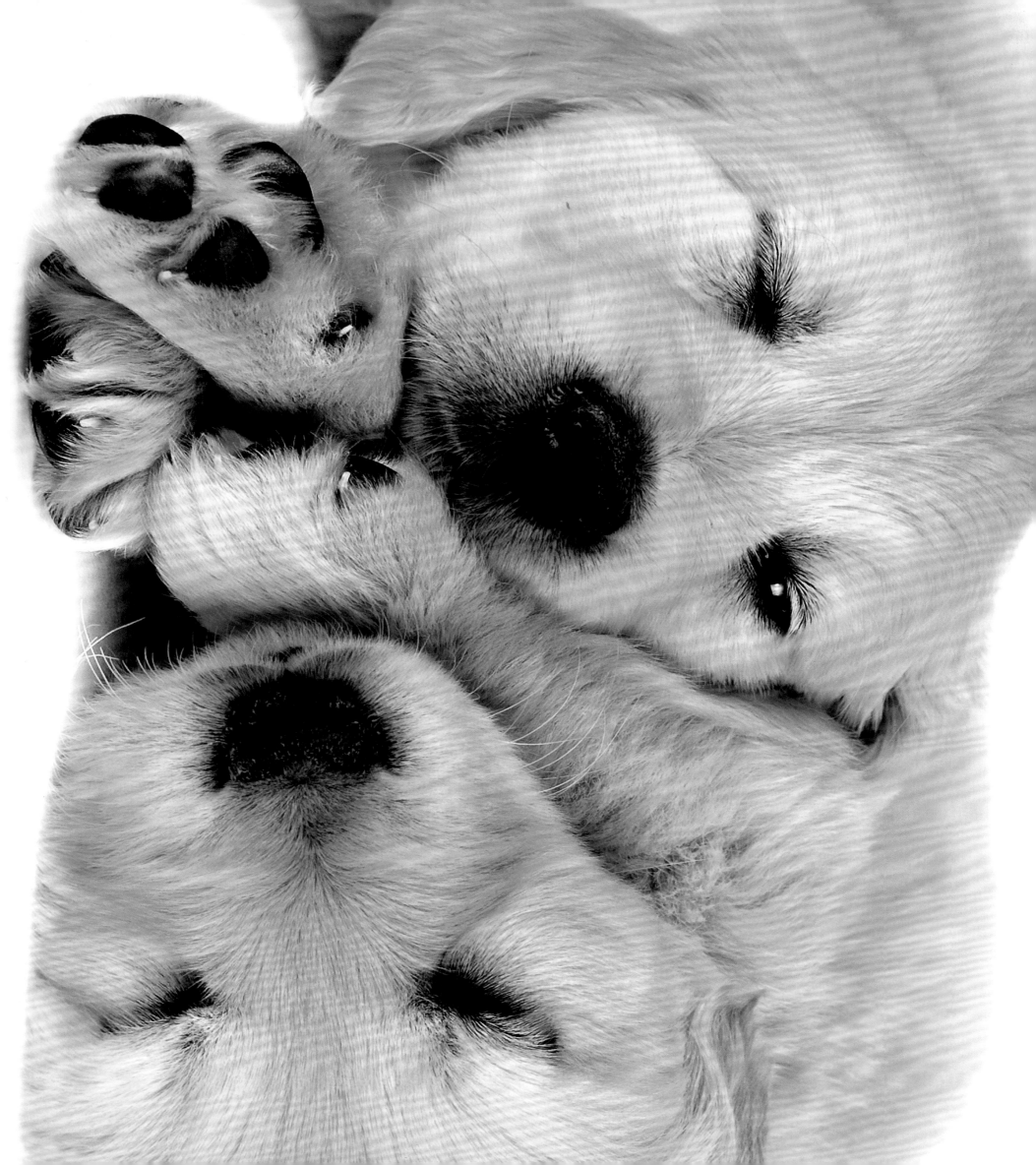

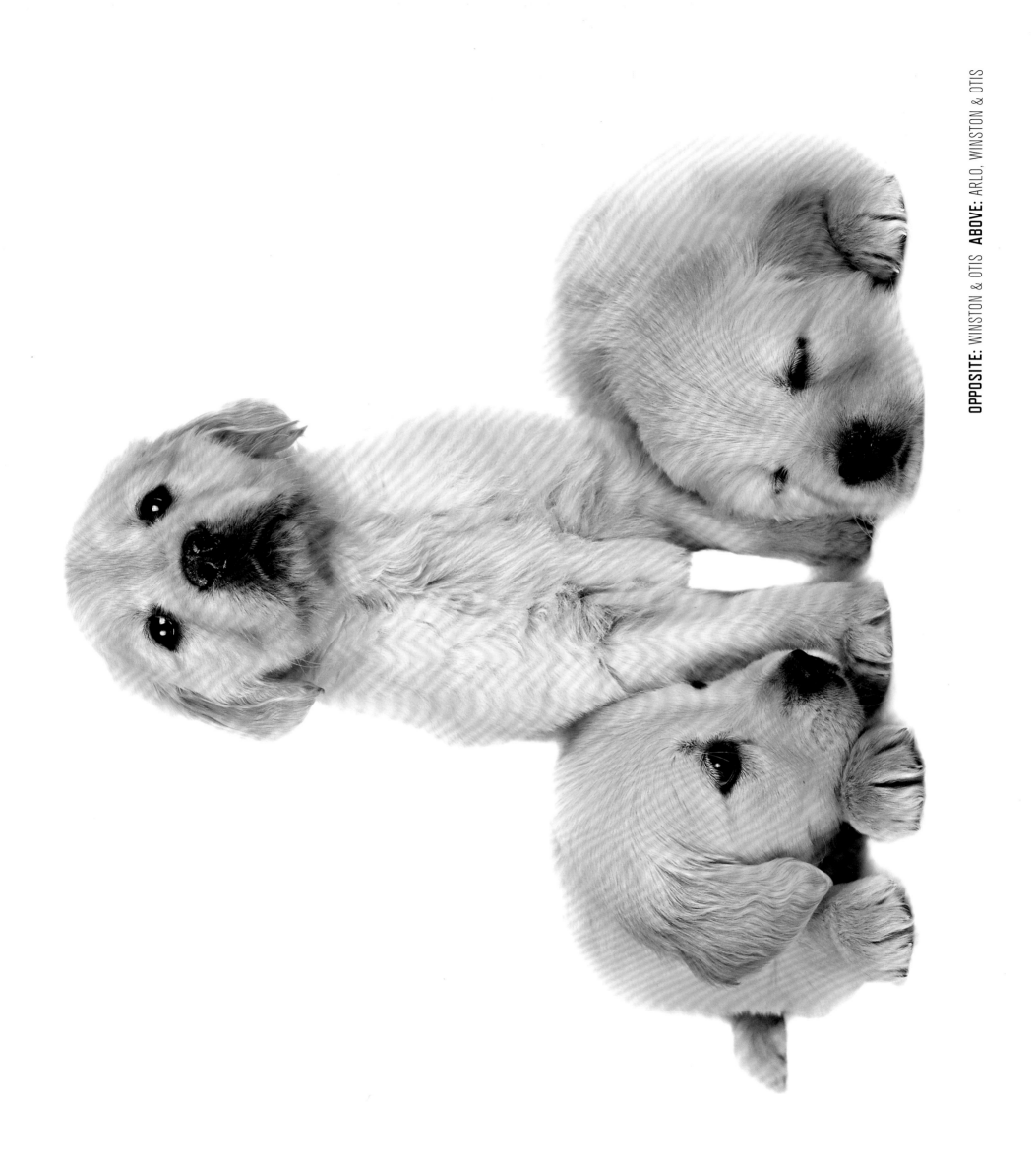

MOE

YORKIPOO / 2.5 LBS

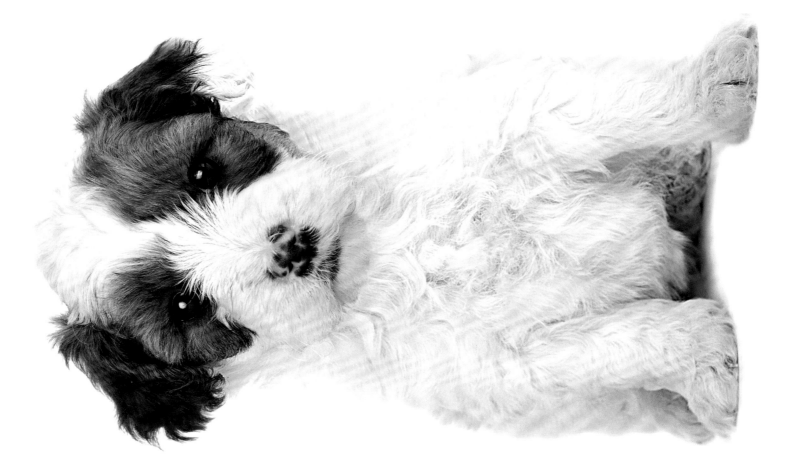

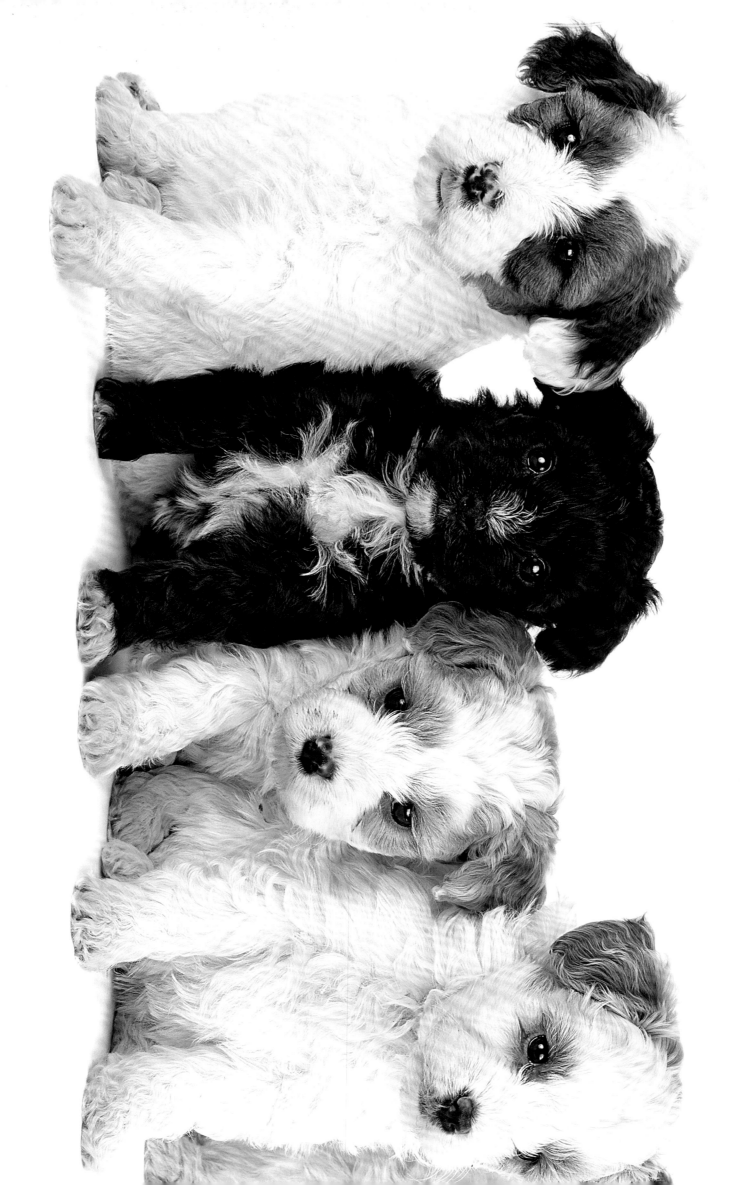

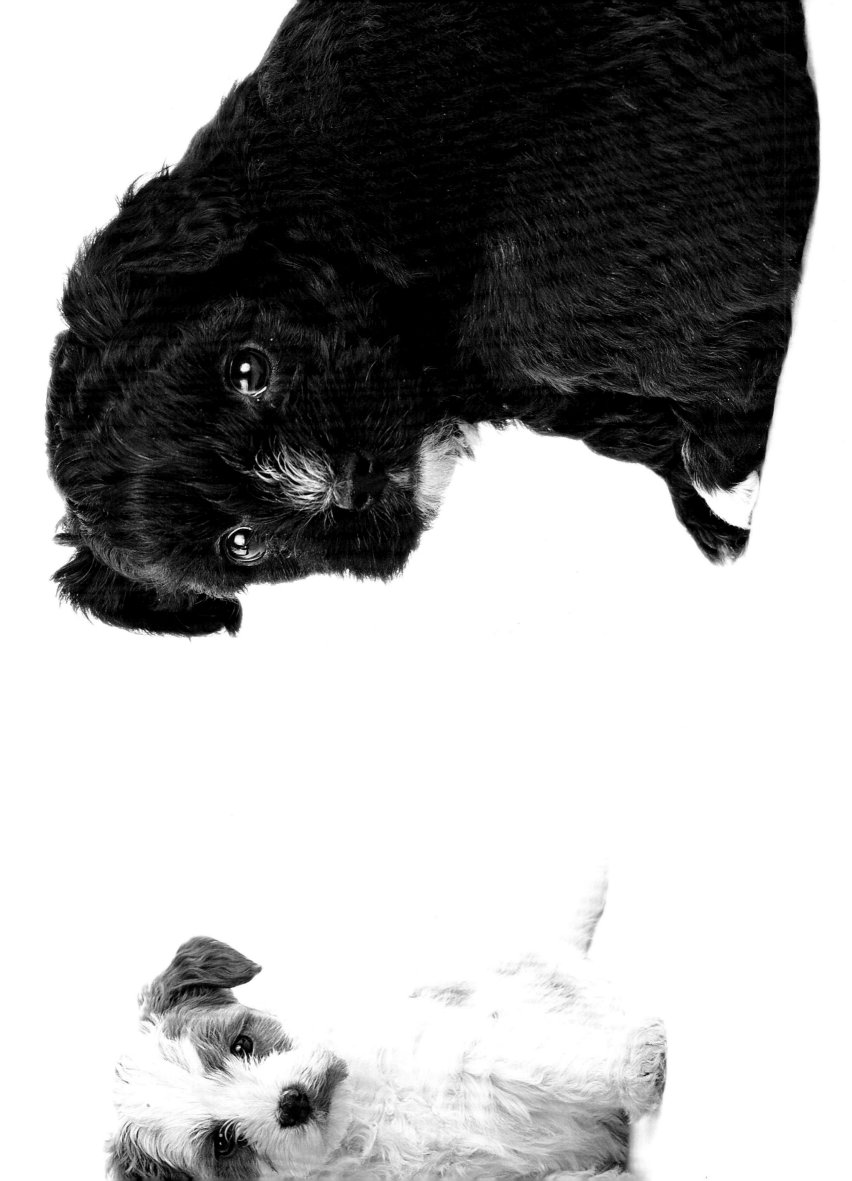

THE PROCESS

The puppies in this book were all photographed at six weeks of age.

Because the portraits of these pups were to appear at life size, we wanted all the puppies to be the same age. This way, the drastic differences in size from breed to breed are emphasized. As you flip through the pages of this book, the impact of this concept is dramatic: it's incredible just how different one puppy can be from another—despite being exactly the same age.

Although I knew how unique this project would be conceptually, when I received the assignment to photograph dozens of six-week-old puppies, I immediately recognized the risks and challenges.

In reality, puppies at six weeks of age haven't received their first round of vaccinations yet, so they are still very susceptible to a variety of health complications. The most concerning of these is parvo (*Canine parvovirus*), a massively contagious virus that can cause respiratory and cardiovascular failure if left untreated.

In order to avoid stress to the puppies, and to mitigate these risks, we insisted on traveling to the home of each litter individually (instead of having them come to the studio). Additionally, between shoots we changed our clothes, disinfected our equipment, stepped in bleach, sanitized our hands and other exposed skin, and used disposable paper backdrops. We took every precaution to ensure the health and well-being of the puppies during these shoots.

THE POLITICS

A conversation about puppies can be a controversial one—there are often two diametrically opposed sides. One side advocates for widespread spay and neuter programs and adoption. Their stance is that since there are so many dogs that need homes and are being euthanized every day in shelters, why would we support more breeding? The other side advocates for dogs bred selectively for health and temperament by responsible breeders. Their stance asserts that breed standards should be maintained. What would the world be like if you couldn't choose to have a Lab or a Frenchie or a Dachshund? Generally both groups are actively involved in rescue and other areas of the pet industry, but the divide between them remains.

It was important to me to represent both schools of thought in this book.

THE BREEDERS

Given the constraints of this book—all the puppies had to be the same age and photographed at their various locations—nearly all of the litters featured are purebred dogs in the homes of breeders. We were very selective about the individuals we contacted, and, as a result, we were able to work with wonderful people who truly adore their dogs. These AKC-certified breeders take every precaution with their puppies—some even slept next to the whelping box for the first few weeks to make sure Mama and pups were safe, fed, and content through the night. We're so glad they listened to our ideas, appreciated the concept we were shooting for, and ultimately welcomed us warmly.

Below is a list of many of the breeders whose pups are featured in this book. If you're seeking a purebred puppy, www.AKC.org should be your first stop. There you can research the breed that's right for you and find a reputable, certified breeder.

LABRADOR RETRIEVER
Jeannie Lamb-Parcels, www.meant2bepuppies.com

FRENCH BULLDOG / ENGLISH BULLDOG
Catherine Brigman, www.simplyelegantfarms.com

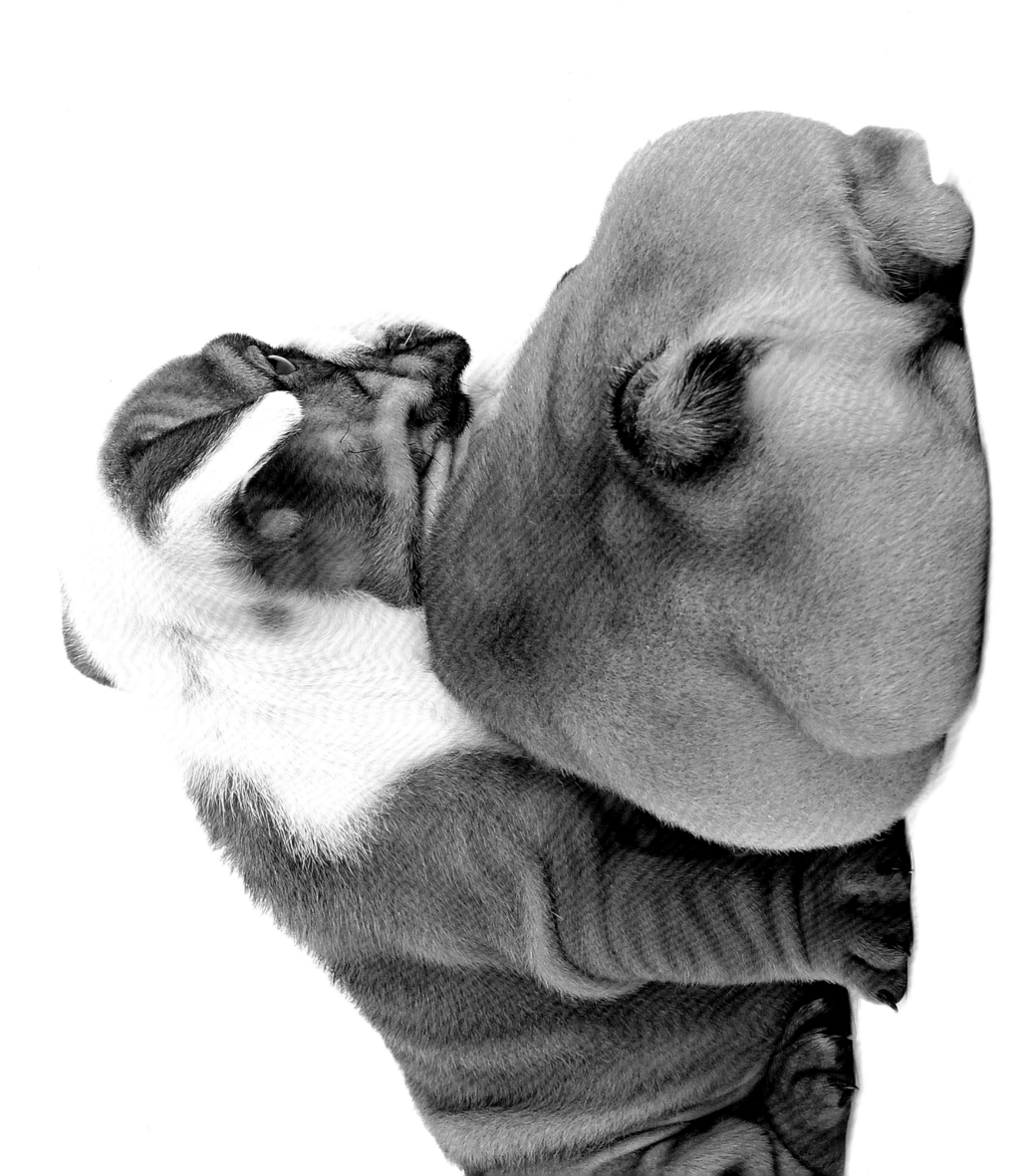

GREAT DANE
Cynthia Neet, www.neetdanes.com

GERMAN SHEPHERD
Vincent Tran, (714) 800-3422 / k9izzo03@yahoo.com

BASSET HOUND
Polly Filanc, (951) 696-7648 / pjfilanc@verizon.net

BULLMASTIFF
Carol Beans, (714) 544-1824 / anakari@aol.com

CAVALIER KING CHARLES SPANIEL
Sandra Harrison, (818) 702-0858 / sandybh@juno.com

LABRADOODLE
Curtis Harris, www.beaumondelabradoodles.com

LHASA APSO
Anne Sackman, (925) 686-5789 / anne.sackman@att.net

DACHSHUND
Judi Sohoenle, www.ladyjsdoxies.com

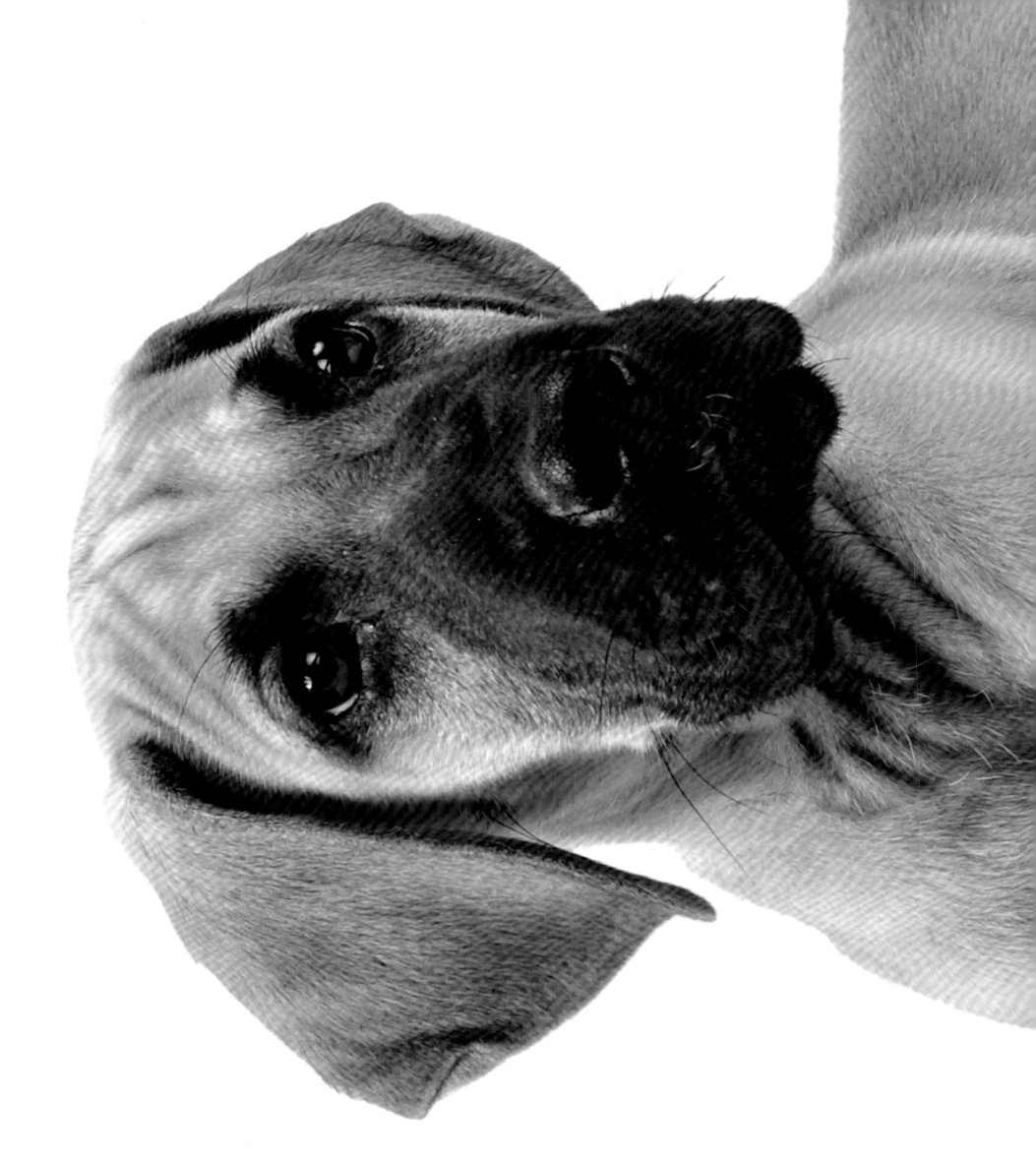

ENGLISH SPRINGER SPANIEL
Susan Navarro, (909) 734-5189 / hihosusie@hotmail.com

POMERANIAN
Lisa Murphy, (760) 364-2604 / argo.murphy@gmail.com

IRISH SETTER
Sue Mertens, (760) 519-1104 / heartsong@roadrunner.com

SAINT BERNARD
L. Jennene Johnson, www.palomarmountainsaints.com

COTON DE TULEAR
Becky Francis, www.olywacotons.com

WEIMARANER
Kinga Korta, www.shadowbayweims.com

GOLDEN RETRIEVER
Beckie Moore, www.ranchogoldens.com

*Not every breed in the book has a representative on this list. Some breeders
rarely have litters and/or opted out.*

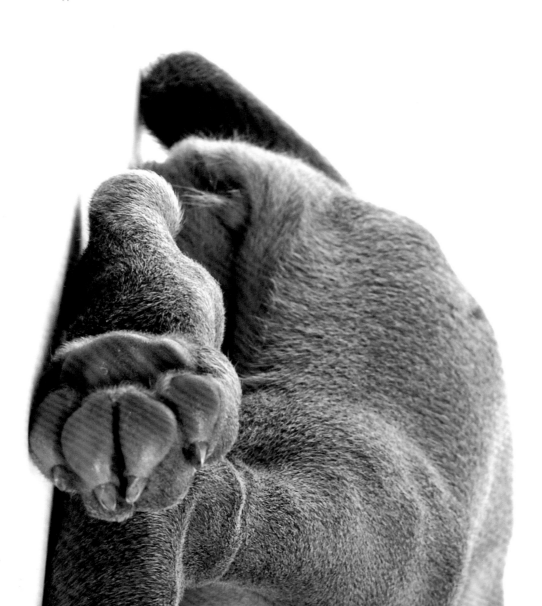

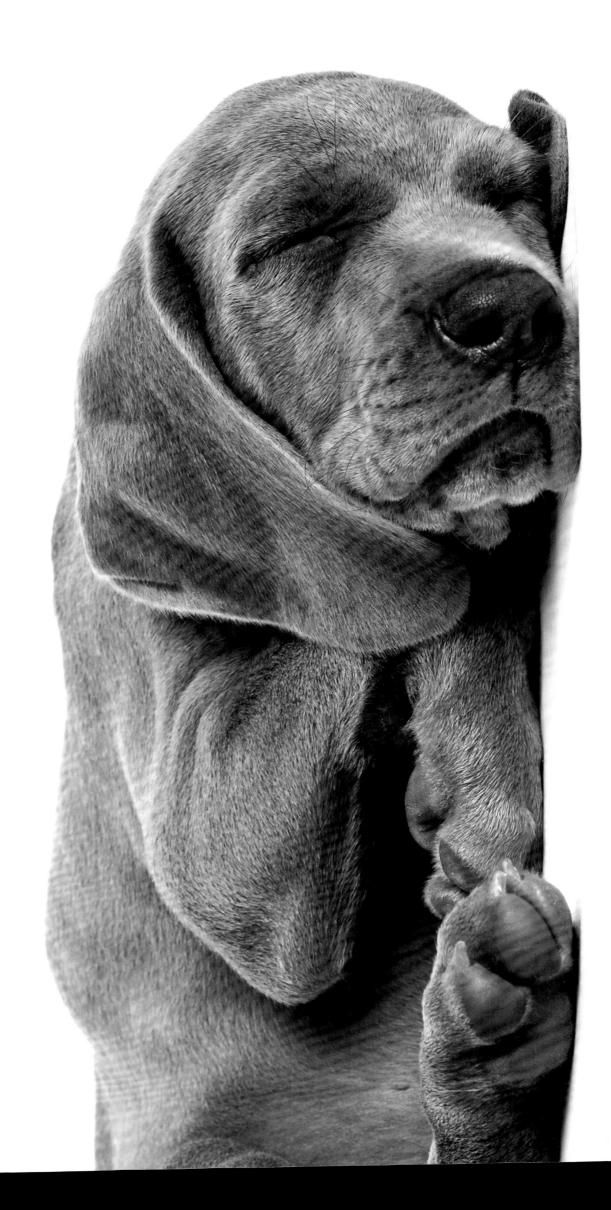

ADOPT

We made many attempts to find and photograph shelter pups for this project, but it was nearly impossible to know the age and/or breed blend of the pups, and the demands on volunteers, employees, and space were often so overwhelming that it negated their ability to book shoots.

It's important to note that the Humane Society of the United States reports that "6 to 8 million pets end up in shelters each year; half of those will probably not be adopted," and that "25 percent of pets in shelters are purebred."

Adopting a dog from a shelter or a purebreed rescue group is a great option for welcoming a new puppy. Below are some resources for finding puppies available for adoption through these organizations:

ASPCA — www.aspca.org
ASPCA stands for American Society for the Prevention of Cruelty to Animals. I had a chance to visit their headquarters in New York and get a personal tour of the state-of-the art facilities. This is a world-class organization.

HUMANE SOCIETY OF THE UNITED STATES — www.humanesociety.org
HSUS is the nation's largest animal protection organization and provides a vast network of shelters around the country. Chances are there's a Humane Society shelter near you—you can search for efforts in your state on the website.

BEST FRIENDS ANIMAL SOCIETY — www.bestfriends.org

Best Friends has played a major role in reducing the number of adoptable pets euthanized in shelters every year by advocating for education, foster homes, spay and neuter programs, disaster preparedness/response, and by providing their very own animal sanctuary in Utah. The Best Friends Network supports other humane organizations in their adoption efforts through their No More Homeless Pets campaign.

SPCA — www.spcala.com / www.sfspca.org / www.spca.org

There is no parent Society for the Prevention of Cruelty to Animals group, but individual cities (like Los Angeles, San Francisco, Houston, and others) each has its own. You can search by SPCA and your city to see if there's an organization near you.

PETFINDER — www.petfinder.com

You can search by breed, location, and even by welfare group. There are also resources here to learn about the adoption process and how to choose the dog that's right for you.

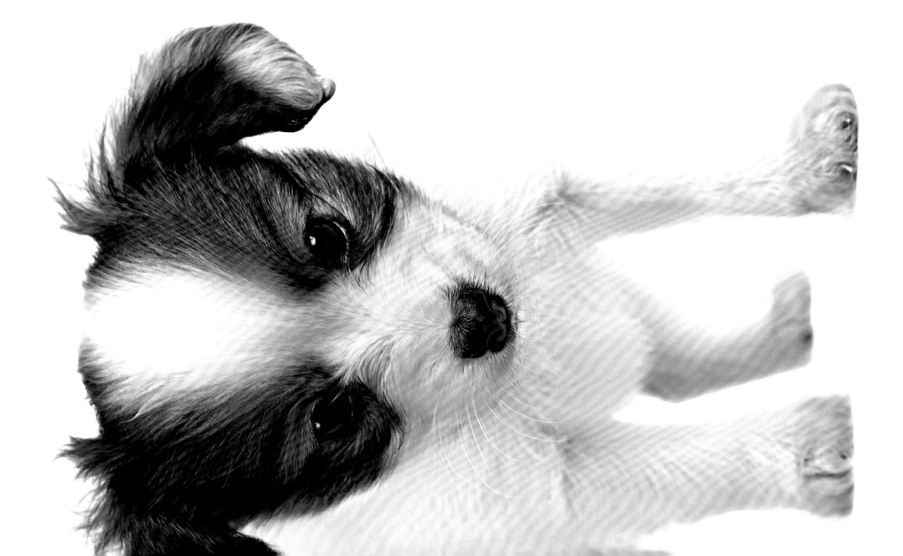

MORE IMPORTANT ADOPTION TIPS

BREED RESCUE

You can search by "purebred rescue" and your city to find an organization near you that specializes in breed-specific rescue and adoption. Also, the AKC has a list of rescue organizations by breed/breed club. For more info, visit www.akc.org/breeds/rescue.cfm.

SHELTER PET PROJECT — www.theshelterpetproject.org/shelters

The best use of this website is to search by zip code to find a shelter near you.

ADOPT A PET.COM (formerly 1-800-SAVE-A-PET) — www.adoptapet.com

Much like Petfinder, this website is good for searching by breed, location, and rescue group, but you can also search for volunteer opportunities. This site is sponsored in part by the North Shore Animal League of America (NSALA).

DO YOUR HOMEWORK

Be realistic about your lifestyle and the characteristics you'd like your dog to have (or not have). Do not just pick the cutest puppy. Research the breeds you're interested in before you even consider bringing a new puppy into your life. Animal Planet has a great "find the dog for me" tool—try it out! Visit www.animal.discovery.com/breed-selector/dog-breeds.html.

NEVER EVER BUY A DOG FROM A PET STORE

Gone are the days of the innocence of "how much is that doggie in the window." Do not fall into the trap of thinking you're "saving" the skinny, cross-eyed pug mooning up at you from a cage in a boutique pet store. This is the number one demand puppy mill proprietors fill, with sickly, neglected, and abused puppies.

AVOID CRAIGSLIST

Reputable breeders do not sell dogs on Craigslist, and reputable shelters and rescue groups have their own websites. Someone on Craigslist asking for a "rehoming fee" is not necessarily a Good Samaritan.

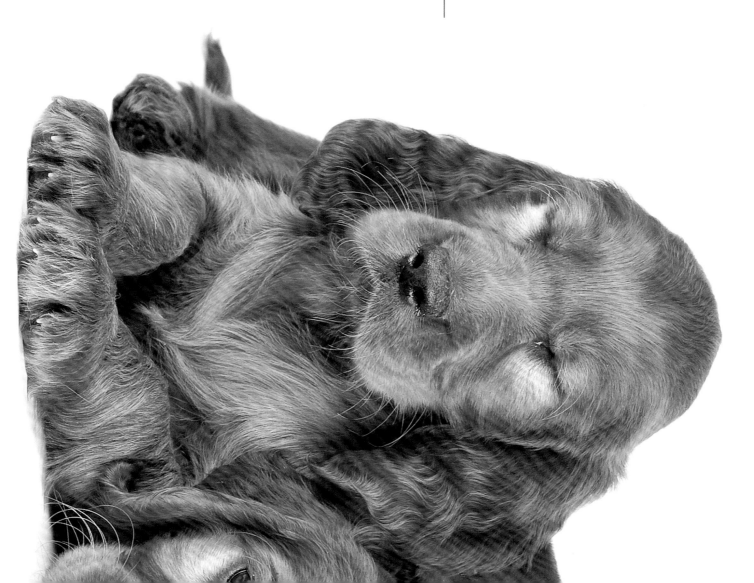

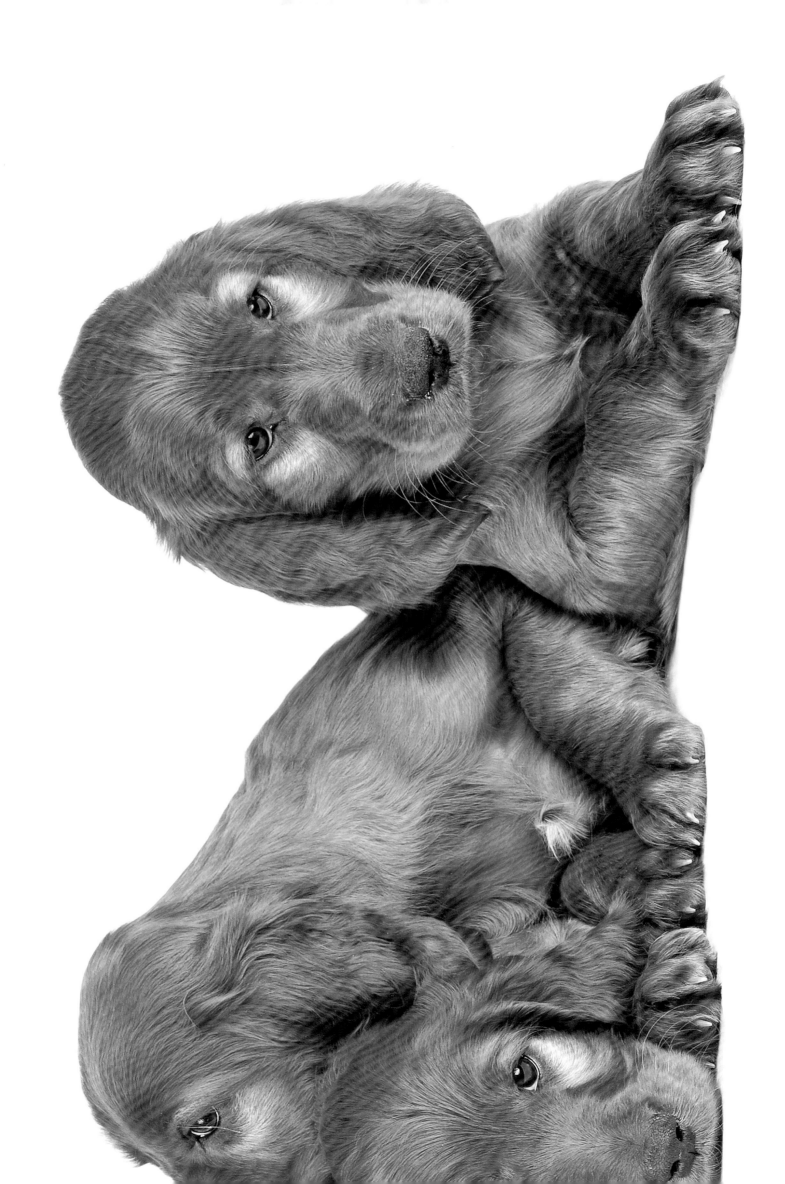

ACKNOWLEDGMENTS

The task: to find, travel to, and photograph twenty-five litters of puppies that were exactly six weeks old at the time they were photographed—within ninety days. Needless to say, this epic assignment was not accomplished alone.

First and foremost, I would like to say thank you to all the breeders and puppy raisers who invited me into their homes to photograph their very young and vulnerable puppies. It was such a joy to get to know you all, and this book would not exist without your trust, support, and enthusiasm.

I am indebted to Dana and Jessica and the rest of the crew at becker&mayer! who dreamed up this concept and graciously invited me to help realize it. Thanks to Katie for the simple, elegant design. It's been an absolute pleasure to work with you all.

Many thanks to the folks at Stewart, Tabori & Chang who saw the potential in this project and made it happen. I hope these photos have brought constant, irrepressible smiles to your office.

Thanks to Amanda for sitting in the passenger seat for all those hours of driving, hauling gear through narrow hallways, capturing some adorable "behind-the-scenes" video, and generally helping out along the way. You're a lifesaver!

Thank you to Luna, who helped find puppies, the most time-consuming task of all!

Much love and appreciation to my spectacularly supportive friends and family, most of all my darling Phil—who, when two of my hard drives crashed midway through the project, said, "Don't worry, girl. If I have to, I will find you fifty more litters of puppies." And meant it. I am sure glad I didn't have to take him up on his offer, but I will never forget the gesture.

Last but most of all, I am thankful every day for the floppy, oversized, cheese-craving diva of a puppy who came into my life at barely more than six weeks of age and inspired me to become a pet photographer: Olivia, I know someday you will no longer be lying on my feet while I type; there will

RIGHT: CHARLIE FOLLOWING: TANK & APOLLO

come a time when everything I own isn't covered in small white hairs; and at some point I won't wake up to your warm, dank breath on my face. But I hope that day is a very, very long time from now. Here's to another eight healthy years!

And of course, Charlie, the constant clown who keeps Olivia and me on our toes, hoovers food and other small objects off all flat surfaces indoors or out, has mastered the art of sleeping in literally any configuration, and generally brings a smile to all he encounters. You're the coolest dog I know. (Don't tell Olivia.)

ABOUT THE AUTHOR / PHOTOGRAPHER

J. Nichole Smith founded *dane + dane studios* (*www.dane-dane.com*), a boutique creative agency offering world-class pet photography, graphic design, and consulting services since 2005. Simultaneously, she cofounded Dog is Good,® (www.dogisgood.com), a lifestyle company that specializes in gifts and apparel for dog lovers.

Nichole's work has been featured in dozens of magazines ranging from *Bark* to the *ABA Journal*. She has contributed as a writer and photographer to some of the pet industry's most influential publications and book titles. Nichole has been featured in *Professional Photographer* magazine, was the subject of a prime-time TV special, and, in 2010, was listed as one of "'5 female entrepreneurs you should know'" by BrandMaker News.

Nichole is owned by Olivia the Great Dane and Charleston the French bulldog, and she spends as many mornings, evenings, and weekends as possible frolicking with them at their favorite place on earth: dog beach. She splits her time between Long Beach, California, and London, England.

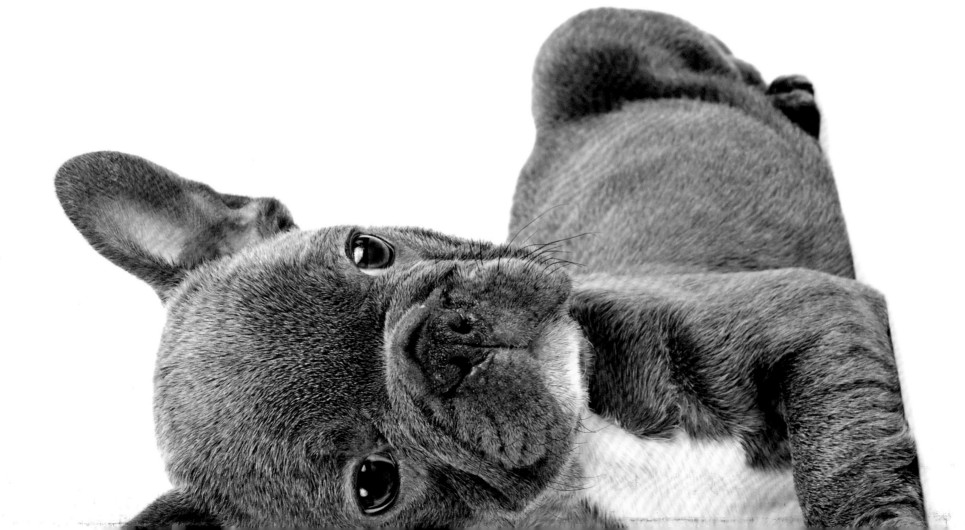

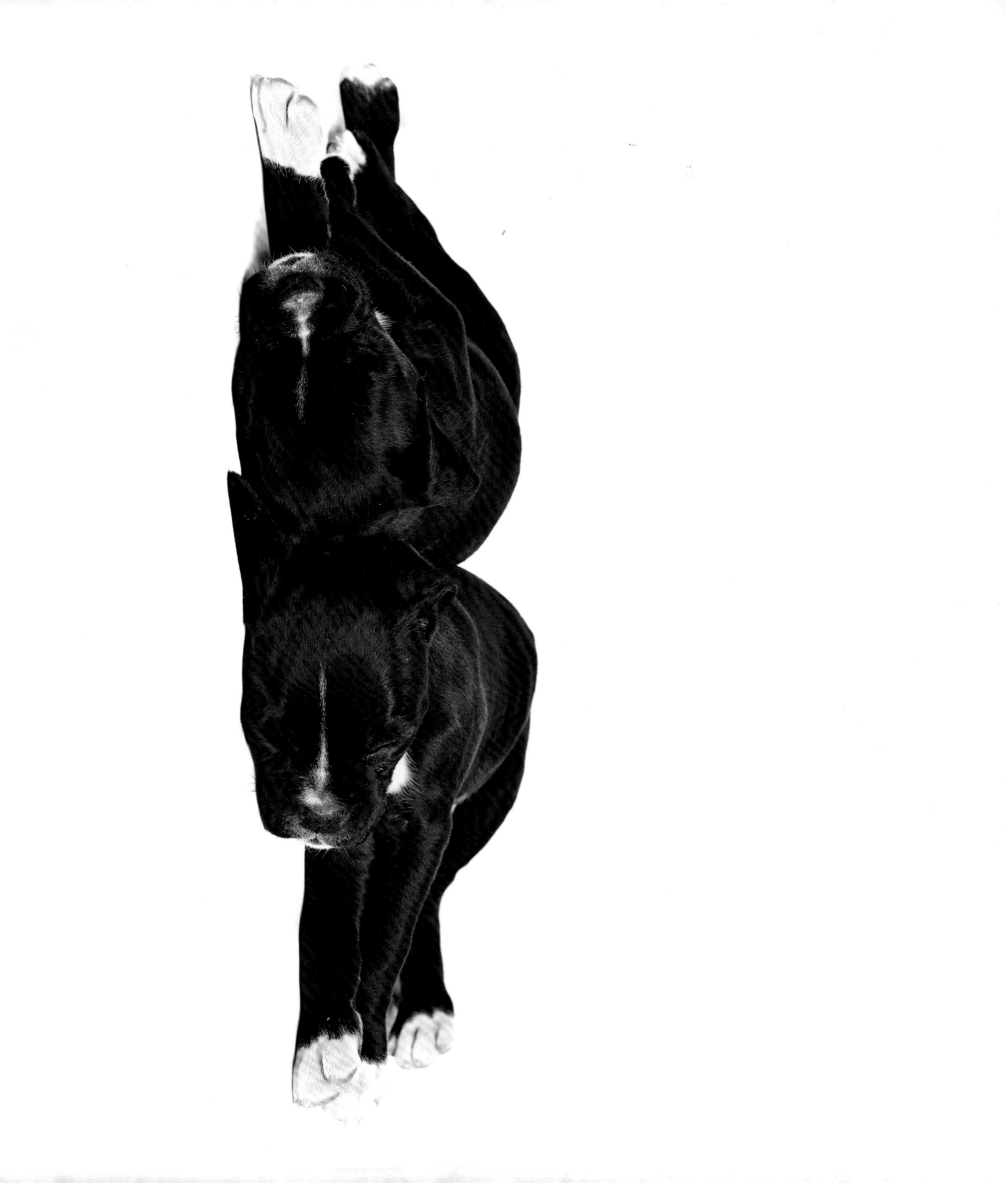